The Art of Caricature

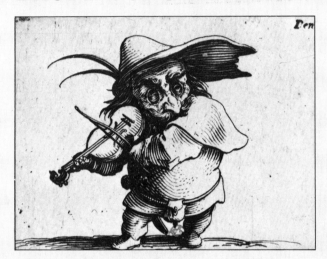

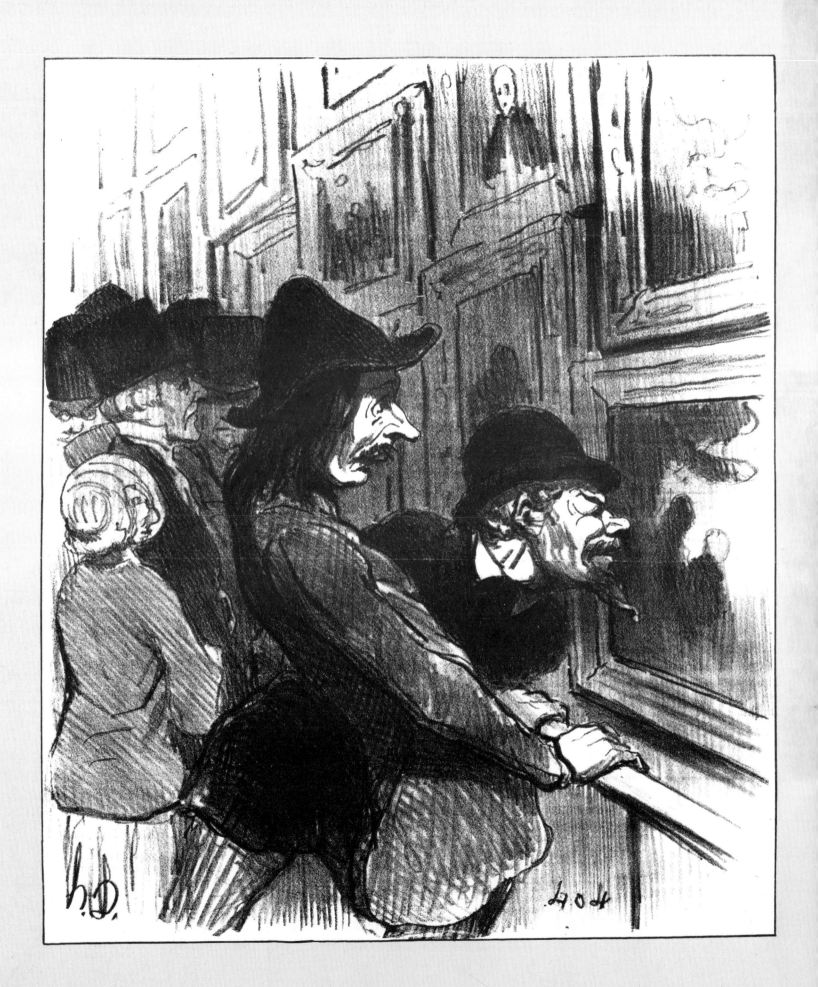

The Art of
CARICATURE

Edward Lucie-Smith

166306

Orbis Publishing · London

Previous page: 'The Public at the Salon', 1852, by Honoré Daumier. This caricature by Daumier is one of many by him which depict the public's response to the paintings exhibited at the Paris Salon. This one shows the painters obviously viewing a work by a fellow artist in the hope of finding defects and imperfections.

Page one: Violin player from Varie figure di Gobbi, *1622, by Jacques Callot.*

Opposite page: Cover for Punch, *1869, by John Tenniel.*

ISBN 0-85613-070-2 (hardback)
ISBN 0-85613-393-0 (paperback)

Contents

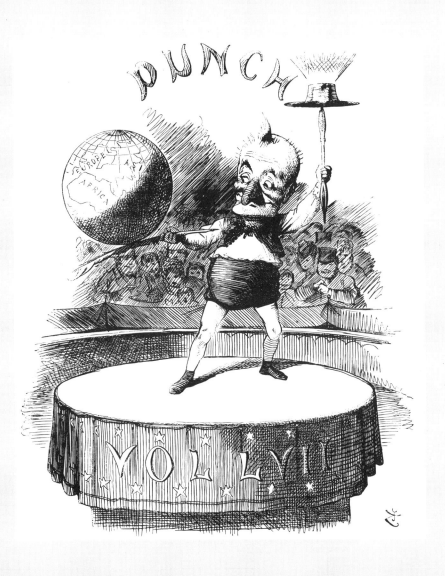

What is Caricature?

1 JAMES GILLRAY
(1757–1815)
The Gout, 1799
engraving

*Gillray's caricature
depicts the most talked-
about disease of the
eighteenth century. It
was believed to be a
particular affliction of
fat, wealthy, middle- to
old-aged men after a
lifetime of over-
indulgence in food and
drink. In the classic
attack a single joint,
proverbially at the base
of the big toe, is
suddenly inflamed and
extremely painful;
Gillray's caricature is
said to capture exactly
the feeling of such an
attack (which can be
brought on by a bout of
heavy drinking). The
disease, although now
known to be associated
with an inherited
biochemical anomaly,
was the subject of many
eighteenth-century
caricatures, as were
gout-doctors, mostly
quacks, with their
'cure-alls'.*

What is caricature? The question may seem so obvious as not to require an answer. When we are confronted with a caricature, we know what it is immediately. But are we able to define what we are looking at? Can we place it within a category?

If one begins at the lowest and simplest level, that of accepted dictionary definitions, one finds that one is dealing not with one word but with two, – 'caricature' and 'cartoon'. Standard dictionaries are muddled and unsatisfactory about both of them. For example, the *Oxford English Dictionary* offers the following:

caricature (noun)
1 In Art. Grotesque or ludicrous representation of persons or things by exaggeration of their most characteristic and striking features.
2 A portrait or other artistic representation, in which the characteristic features of the original are exaggerated with ludicrous effect.
caricature (verb)
1 . . . to make a grotesque likeness of.
2 To burlesque.

cartoon (noun)
A full-page illustration in a newspaper or periodical, esp. applied to those comic papers related to current events.
cartoon (verb)
. . . to caricature, to hold up to ridicule.

Chambers and Collins follow much the same line, though both are less rigid about the necessity of a cartoon occupying a full page. Both say that cartoons relate to 'current' or 'topical' events.

The OED definition of 'cartoon' when used as a verb suggests that there is often little basic

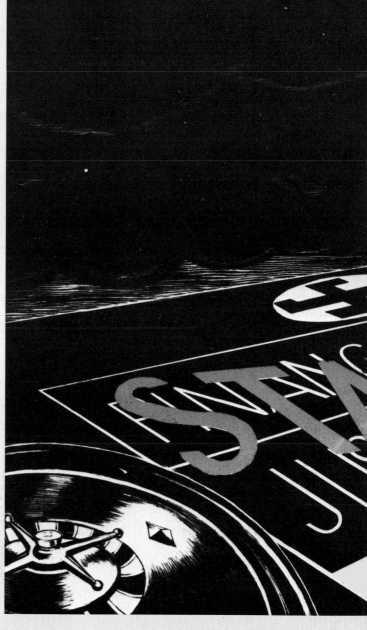

2

2 EDOUARD MANET (1832–83)
Emile Ollivier, Le Diogène, 1860
lithograph

Manet was just beginning to establish himself as a painter when he made this caricature of the French statesman Emile Ollivier, no doubt as bread-and-butter work. Manet uses the caricaturist's standard but effective means of exaggeration and distortion – the large head on a small body, grotesquely full lips and bushy side-whiskers – to achieve 'a truthful misrepresentation' of his subject. Ollivier, who later became Napoleon III's minister of justice, was at this time a republican who believed that liberal reforms could be achieved by persuasion.

3 PAUL IRIBE (1883–1935)
The Stavisky Affair, Parlons français, 1934
collage on scraper board

Although the power and drama of an image, so obvious in this caricature, will remain apparent, its topicality, that essential ingredient of caricature, is often lost with time. The Stavisky affair of 1933–4, which almost brought about the downfall of France's Third Republic, was a financial scandal that involved the fraudulent sale of bonds in a credit organization set up by a speculator of dubious reputation, Alexandre Stavisky. In January 1934 Stavisky was found dead and soon after a high official in the Public Prosecutor's department in Paris was murdered; it was alleged that both deaths were the result of

efforts to conceal the scandal, which almost certainly involved French ministers. Both Communists and right-wing groups exploited the crisis to the full, pointing to the obvious corruption of the parliamentary regime. France was brought to the verge of civil war after a general strike and a series of riots in which 15 were killed, and two successive prime ministers had to resign before a new government, whose members had not been in any way involved in the scandal, was successfully established. Iribe's caricature, with the roulette table marked with left- and right-wing symbols, uses the croupier's standard phrases as the die is thrown: 'The bets are made' (Les jeux sont faits), and 'Place no more bets' (Rien ne va plus).

3

difference between the two words – in fact 'cartoon' and 'caricature' are here regarded as exactly synonymous. It is plain that the two words, in common parlance, have now come very close to one another. A caricature no longer *has* to be a portrait, as its derivation from the Italian *caricatura* – 'a likeness which has been deliberately exaggerated' – suggests; while cartoons, including the majority of those currently published in the *New Yorker,* are certainly not always political, nor always strictly topical either. There is not much politics and not much topicality about the ghoulish fancies of Charles Addams, for instance.

Yet the matter does not stop here. While we automatically associate the idea of the caricature and the cartoon with humour, it becomes plain, when one looks through the vast mass of the available material, that many of these designs have only a tenuous connection with the idea of making a joke. Indeed, some of the greatest caricatures, such as Honoré Daumier's *La rue Transnonain,* rise to heights of tragic power which make them rivals in seriousness and in emotional impact to all other forms of visual art.

What we call a caricature can quite easily be an allegorical or emblematic drawing, whose purpose is not to make us smile but to make us think. What the label does usually imply is some degree of fantasy or exaggeration, plus an attempt to use a genuinely 'popular idiom'. This last point is crucial. There is plenty of evidence to show that the true definition of caricature is to be found, not by examining any particular manner the artist happens to adopt, but by trying to discover what kind of audience he has in his mind's eye.

Though the words themselves were for a long time lacking, material which we call caricature existed even in ancient times. Lack of words meant, nevertheless, that there was a continuing difficulty about description and hence discussion of the subject. The study of caricature is therefore itself also comparatively recent.

There are two ways in which the study of caricature can be approached. One is theoretical and the other historical. The former is linked to a theory of physiognomic types which in turn is related to the philosophical tradition of Plato. This, with certain Freudian trimmings, is the approach adopted by the most distinguished modern student of the subject, Sir Ernst Gombrich. The other

4 AUBREY BEARDSLEY (1872–98)
*Caricature of Queen Victoria as a Degas Dancer, c. 1893
pen and ink drawing*

Caricature, as a branch of the visual arts, has always been concerned with artists and their work, as well as with whole artistic movements. This caricature by Beardsley, for example, is one of the most memorable of all the parodies of the Impressionists, a group much lampooned by nineteenth-century graphic satirists.

4

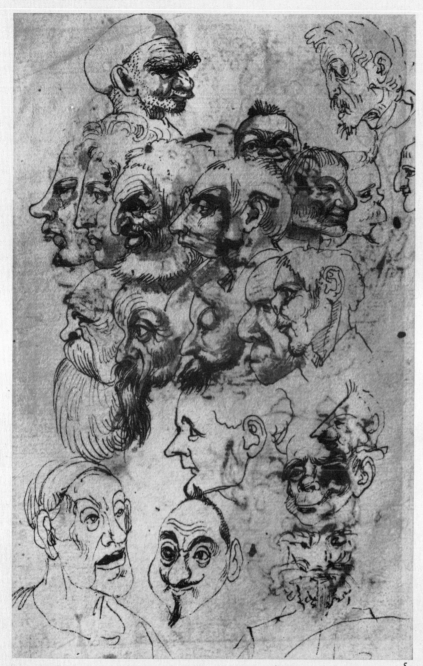

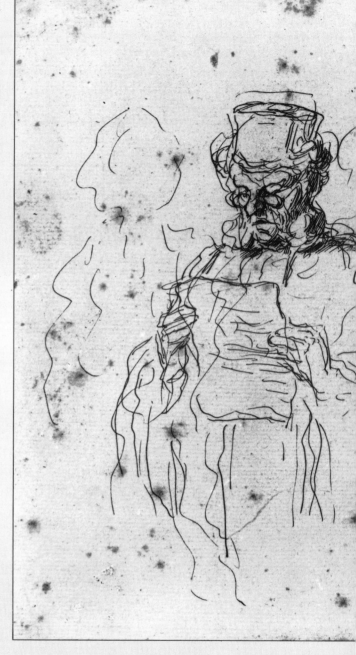

5

5 CARRACCI SCHOOL (mid-16th – early-17th centuries)
Study of Heads, c. 1590
chalk, pen and ink drawing

Contemporary accounts describe the Carracci circle's exercises in graphic mimicry as methods of relaxation from serious work. Certainly they produced hundreds of sheets like this one and were the first to whom the word 'caricature' with its specialized meaning of a 'charged' and 'loaded' portrait was applied. Although the work of the Carracci school is of central importance in the history of caricature, well-observed sketches like these lack the mastery of economy that Bernini was later to command.

6 HONORÉ DAUMIER (1808–79)
Two Lawyers in Discussion, 1860
pen and ink drawing

This typical Daumier sketch page showing a couple of lawyers – one reading a brief, the other in the full flight of eloquence – demonstrates how carefully the caricaturist must first observe his subject matter. The trembling lines used for the lawyers' gowns suggest the movements of the bodies beneath; while the faces, although rendered in more detail and with much greater firmness, also emerge from a tentative blur of lines which communicate the play of expression. Despite the acute feeling for character which the drawing conveys, it is not

really a caricature but only the raw material for one, because it does not concentrate its forces on some physical or psychological quirk.

7 PIERRE PUVIS DE CHAVANNES (1824–98)
Caricature Portraits
pen and ink drawing

Many great artists of the eighteenth and nineteenth centuries produced caricatures either as bread-and-butter work (Monet and Doré are notable examples) or, like Puvis de Chavannes, as a side-line. The link between serious art and caricature is an interesting one: in both, the idea behind the image is of central importance, even though the technical means of expression are

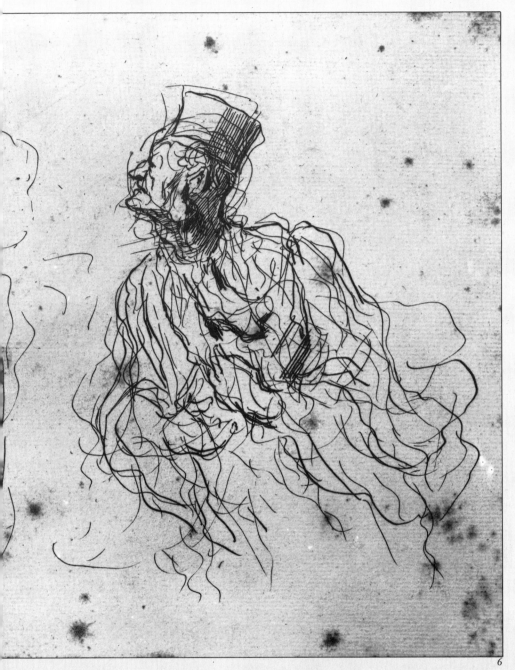

HIS NOTICE TO SECRETARY HAY THAT HE
WAS READY TO START FOR HIS POST

different. It is therefore not surprising that, from the sixteenth century onwards, most great artists also practised caricature from time to time.

8 THOMAS NAST (1840–1902)
Self-portrait, 1902
pen and ink drawing

The way the caricaturist sees himself can be particularly revealing. In 1902 Thomas Nast had already produced his most devastating cartoons on the American Civil War and, later, on the Tweed Ring for Harper's Weekly, *and had then fallen out with the editor. Then, destitute after the loss of his savings due to the* failure of a brokerage house, he was appointed consul general at Guayaquil, Ecuador. This self-portrait, included in a letter to the then Secretary of State, Colonel Hay, shows an untidy, somewhat ferocious and cantankerous little man (no longer the plump, prosperous well-dressed artist at his easel, as depicted in an earlier self-portrait etching of 1892), but still buoyant, travelling light and ready to take on anything.

9 JOHN TENNIEL (1820–1914)
Dropping the Pilot, Punch, 1890
pen and ink drawing

Tenniel joined Punch in 1850 and, in a
period of 50 years, produced more than
2000 cartoons, of which this is the most
famous. The dignified figure of Bismarck,
the architect of Germany's greatness, is
watched over by a smug, self-satisfied
emperor who had achieved his aim of
forcing the Iron Chancellor to resign from
German politics. The original sketch of
this cartoon was bought from Tenniel by
Lord Rosebery who subsequently
presented it as a gift to Bismarck; the
picture is said to have pleased both
Bismarck and the Emperor. Dramatically
and simply composed, it is probably one
of the best of Tenniel's cartoons which
mostly lack the inspiration of his
illustrations for Carroll's Alice in
Wonderland.

10 TERRY GILLIAM (b. 1940)
Animation for BBC's Monty Python's
Flying Circus, 1971
photo-montage over watercolour

Terry Gilliam's animations for this highly
successful television series are largely
derived from the animated cartoons of
Walt Disney and his numerous
successors, and are also indebted, to some
extent, to the Pop Art movement of the
1960s with its emphasis on the ephemera
of mass culture. The juxtaposition of a
multiplicity of absurd, often grotesque
images, presented in startling and
unexpected situations, is comic in a
highly original way, but it is in his
occasional indulgence in sophisticated
visual puns, witty anachronisms and
satirical flashes that Gilliam comes
closest to caricature.

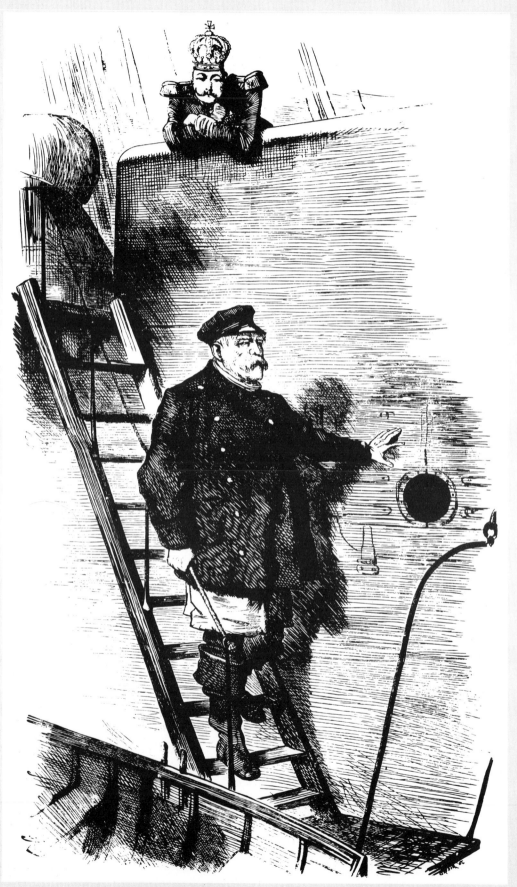

10

11

11 *JAMES THURBER (1894–1961)*
Women's G.H.Q., The War between Men
and Women, New Yorker
pen and ink drawing

*Thurber regarded himself only
incidentally as a comic artist and, indeed,
technically his drawings are crude;
Dorothy Parker aptly remarked that his
men and women resemble unbaked*

*cookies. Nevertheless, he is probably the
best known and loved of all twentieth-
century American cartoonists. His
sharpest and most consistent ironies are
found in the depictions of hapless men
and domineering women which he made
his speciality, but even in these there is an
absurdity and vulnerability about his
creations – as here – which stops short of
bitterness and implies forgiveness.*

method traces the development of caricature from
the sixteenth century and was fashionable in the
nineteenth century. At that time caricatures were
valued for their historical rather than their artistic
interest.

This descriptive approach is the one favoured in
this book. The material here comprises both
caricatures and cartoons, plus strip cartoons and at
least some references to the animated cartoon.
Though the caricature and the cartoon are largely
similar, there is a slight difference in the way we
use these two words. No one speaks of a strip
caricature or animated caricatures, yet certain
sequences of the *Monty Python* television series
which are animated cartoons are at the same time
animated caricature. Perhaps the difference is, *pace*
the dictionary definitions I have just quoted, that
caricature puts the emphasis on the satiric, while
cartoon puts it on the merely amusing. That is,
except when the cartoon's theme is political.

There is one simple but important feature that
the great caricatures share – works as diverse as
Tenniel's *Dropping the Pilot* (an allusion to Kaiser
Wilhelm II's dismissal of Bismarck), which places
the portraits in a somewhat unlikely setting but
contains no element of distortion; Daumier's *Peace*
(a comment on the situation of France after the
Franco–Prussian war), which uses the weapons of
traditional allegory; Thurber's series *The War
between Men and Women* in the *New Yorker*, with
its deliberately clumsy and childish type of
drawing; and portraits of contemporary statesmen
and other celebrities by men like Gerald Scarfe,
Ralph Steadman and David Levine. These
apparently different images have one basic thing in
common: they were designed for print. It is true
that one finds caricature as a mode of drawing, not
intended for publication, in the studios of Italy
from the end of the sixteenth until past the middle
of the eighteenth century. But drawings of this
type, though they eventually made a very important
contribution to the repertoire of the professional
caricaturist, do not stand at the very centre of the
story. Caricature is generally two things – popular
and public – and it is print which enables it to be
both. Print is, after all, a very special mode of
communication. It speaks to us privately, as
individuals, yet cheapness of material and rapidity
of production make it available to almost every
one. To enjoy printed images one does not even

have to be able to read. In this sense caricatures are as universal as music. They are also ephemeral, which is one of the essential and inbuilt characteristics of printed matter in newspapers and magazines. The printed image, therefore, has a bias towards not merely popularity, but topicality. It makes its comment on whatever is going on at the time.

The importance of the print medium is highlighted by comparing a great painting and a great caricature. Jacques-Louis David's painting of *Death of Marat* and Honoré Daumier's caricature *La rue Transnonain* both come from nineteenth-century France and attempt to make a similar point, even to the extent of using much the same imagery. David's painting, frequently described as 'a revolutionary icon', shows the moment after a crime – Charlotte Corday has just stabbed the Jacobin tribune to death in his bath. Daumier's caricature also shows the moment after a crime – government troops have just brutalized a working-class family. There is, of course, a difference in the actual style of depiction. David's image, though naturalistic, is still held within the severe disciplines of Neo-classicism. Daumier's composition, no less focused, is less formal. But the elements of exaggeration and distortion are barely, if at all, present. One can, however, easily imagine the Daumier executed in colour and on the same scale as David's painting.

The real difference is that Daumier has sacrificed being taken seriously as art in return for being taken seriously as propaganda. David is sure of the admiration of the educated spectator in the long term (indeed, his painting has been regarded as a model for revolutionary art ever since it was created). Daumier's caricature, on the other hand, has always been admired by those who study such things, but enjoys no such pivotal celebrity. At the time, however, it delivered a body-blow to the forces the artist was attacking, far more so than David's picture. The distinction rests as much on the choice of medium as it does on the style.

Out of these basic definitions and qualities of their art it is possible to discern several characteristics, all of which are present, to some degree, in any work accurately described as caricature.

First, caricature is genuinely popular, the most universal and democratic form of visual art in a

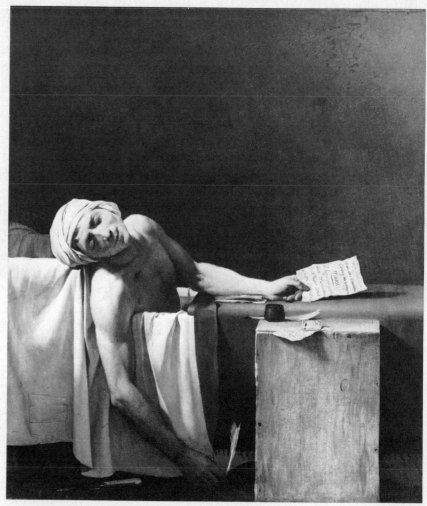

12

12 JACQUES-LOUIS DAVID (1748–1825)
Death of Marat, 1793
oil on canvas

David was in total sympathy with the aims of the French Revolution. He became a deputy and voted for the execution of Louis XIV; he was actively a propagandist for the Revolution and was involved with, among other activities, the design of commemorative medals and the organization of grandiose funerals for Revolutionary heroes. The Death of Marat *was conceived as one of three paintings of 'martyrs of the Revolution' (the other two were the* Death of Lepeletier, *now known only from an engraving, and the* Death of Bara *which was unfinished). This masterpiece, the 'pietà of the Revolution' as one critic has called it, completely typifies the spirit of the Revolution but its very grandeur distances it from its period in the way that caricature, however crudely executed, does not.*

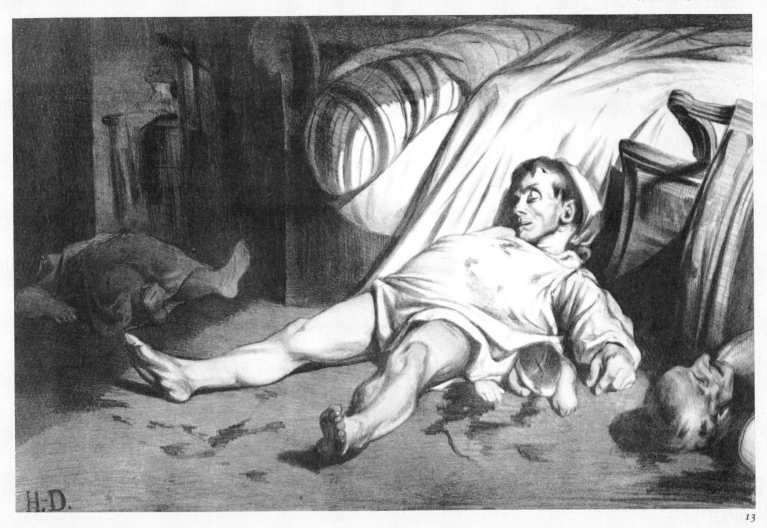

13

13 HONORÉ DAUMIER
La rue Transnonain, le 15 Avril L'Association
Mensuelle, July 1834
lithograph

This famous lithograph is one of five masterly
prints Daumier designed to be sold separately to
subscribers of Charles Philipon's journal
L'Association Mensuelle; another was Le
Ventre Legislatif, *Daumier's devastating*
comment on France's governing body. In the
early years of the 1830s riots were a frequent
occurrence in the working-class district of St
Martin in Paris. On 15 April 1834 one such riot
was suppressed with particular ferocity by
government troops, one of whose actions was
to murder an innocent family as they slept.
There were many eye-witnesses of this atrocity,
and the sense of outrage over the affair was
widely and strongly felt. Daumier's simple but
dramatic image is surely comparable to the
most shocking of Goya's Disasters of War.

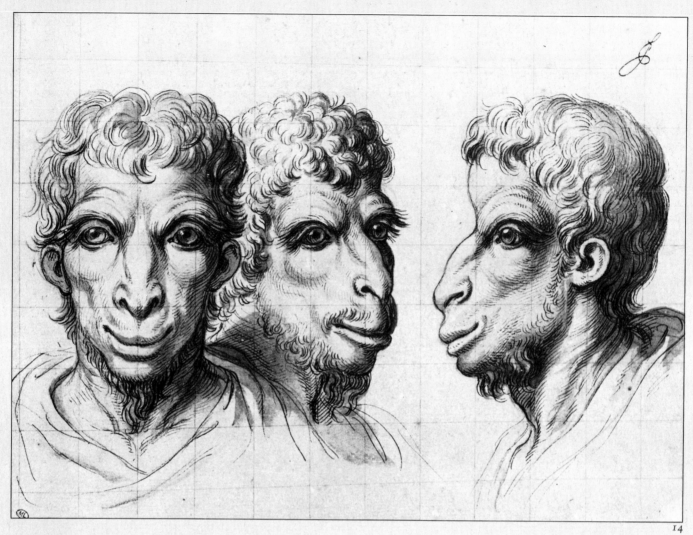

14

14 CHARLES LE BRUN (1619–90)
Physiognomical Study of Human Heads, The Lamb, 1668
pen, wash and pencil

The depiction of humans with animal features has roots in academic theory about the similarities between types of people and certain animals, and is traceable through a series of publications on the subject of physiognomy, dating from the late sixteenth century onwards. The idea occurs in Giovanni Battista della Porta's De humana physiognomia, *published in 1586, and turns up again in a series of drawings by the history painter Charles Le Brun, of which this finely drawn picture, of a man whose features resemble those of a lamb, is an example. He used the series to illustrate a lecture at the French Académie Royale in 1668.*

15 ABEL PANN (b. 1883)
The Defender of Paris, 1914
lithograph

Animal caricatures can have positive effects when they are used for patriotic purposes. This imaginative design shows General Gallieni, defender of Paris at the first Battle of the Marne in September 1914, as a kind of hedgehog whose spikes are a multitude of French bayonets, symbolizing French military strength. (The same tradition produced the portraits of Winston Churchill as a bulldog during the Second World War.) This caricature is, in fact, an offshoot of the Arcimboldesque tradition (p. 47), in that it shows a creature constructed of inanimate objects with their own separate identities.

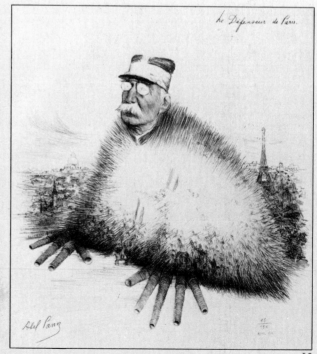

15

16

17

16 THOMAS ROWLANDSON
(1756–1827)
Physiognomical Study
pen and wash

The most influential of all
physiognomical studies were
those of Johann Caspar Lavater
(1741–1801). Lavater proposed
that it was possible to trace a
complete progression from the
lower forms of animal life to man
himself, and that it was possible
to read men's temperaments by
noting which animals they
resembled. The idea was a
godsend to caricaturists. This
physiognomical study by
Rowlandson, for example,
compares human features with
those of a hawk. Rowlandson
had seen and made copies of
della Porta's drawings and was
undoubtedly familiar with
Lavater's work which was
translated into English in 1789.

17 JEAN IGNACE ISIDORE
GÉRARD, known as
GRANDVILLE (1803–41) and
EUGÈNE HIPPOLYTE FOREST
(1808 – after 1866)
'Mon nez est le plus grand',
Le Charivari, 1833
pen and ink for lithographic
reproduction

Grandville used the animal
convention for both social and
political satire. His half-human,
half-animal figures are extremely
subtle: he transfers not only
animal features but animal
stances and mannerisms to a
human context. In fact he goes
further than any physiognomical
study, as his human and animal
creatures become indistinguishable
from one another; here one
birdman boasts to another, 'My
nose is bigger.'

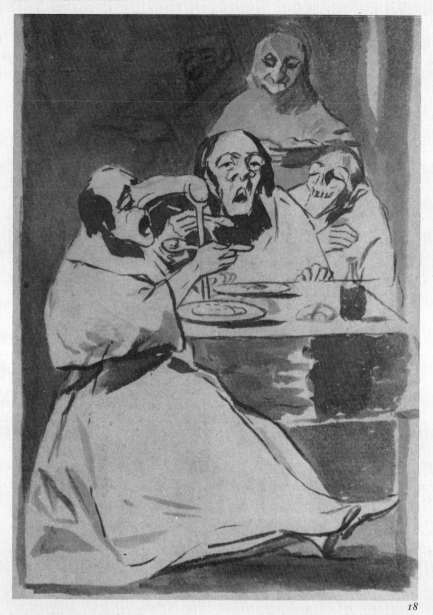

18

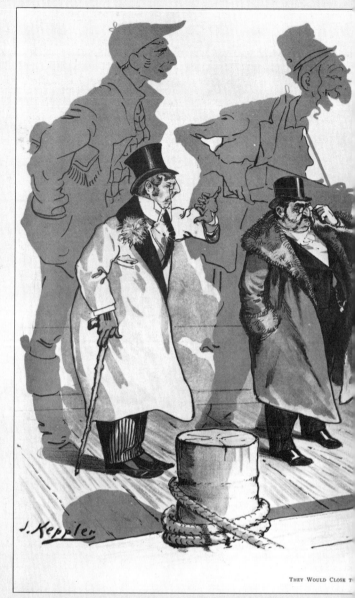

THEY WOULD CLOSE T

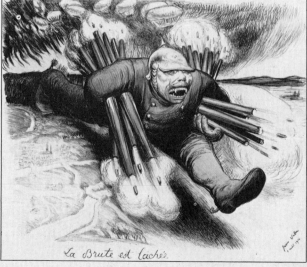

La Brute est lâchée.

20

18 FRANCISCO DE GOYA (1746–1826)
*Preliminary drawing for 'Estan
calientes', Los Caprichos, 1796–8
sepia and wash drawing*

This is a preliminary drawing for one
of Goya's eighty Los Caprichos
etchings, whose themes, as Goya
himself announced, were the
'extravagances and follies common to
all society'. They are, in fact, a series of
trenchant attacks on the political, social
and religious abuses of the time, grimly
humorous and often not far from the
macabre, but executed with a quite
remarkable dramatic vitality. Goya
labels his etching Estan calientes (they
are hot); the monks are in such a hurry
to gobble down the food that they
swallow it boiling hot. 'Even in

pleasure,' Goya remarks, 'temperance
and moderation are necessary'. He
uses the caricaturist's irony and satire
in a topical setting but his comments on
the human condition have a universality
that makes their effect still immensely
powerful.

19 JOSEPH KEPPLER (1838–94)
*Looking Backward
pen and wash for lithographic
reproduction*

Born in Vienna, Joseph Keppler
emigrated to the US in 1867, his parents
having preceded him after the
Revolution of 1848. This cartoon,
produced at the time of the pogroms in
Russia in the 1880s which resulted in a
wave of emigrations to America, is on a

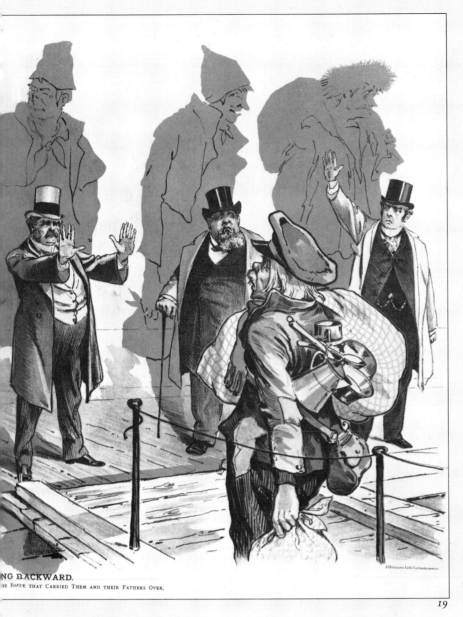

NG BACKWARD.

HE BRIDGE THAT CARRIED THEM AND THEIR FATHERS OVER.

19

modern society. Secondly, it often breaks through the artistic conventions of the time, be they realistic or otherwise. It makes use not only of wild distortions and exaggerations, but of incongruities of all kinds. It is not obliged to be consistent; it is set free from the demands of artistic decorum. All it has to do is to express an idea in a way which makes it accessible to large numbers of people. The caricaturist, in fact, is the servant of an idea far more than any other kind of visual artist. It may be an idea about somebody's appearance (the fact that their nose is too big) or it may be an ambitious moral concept – or anything that stands between these two extremes. Humour is only one weapon in the caricaturist's armoury. The caricaturist combines incongruous elements successfully by frequent use of allegory, and in this sense (allegory addressed to a mass public)the caricaturist can be seen as the direct heir of the great religious and popular artists of the Middle Ages, who lived at a time when the theory of genres – with history painting at the top of the ladder and still life at the bottom – had not yet been worked out, and when there was as yet no hierarchy of either presentation or subject-matter. The gross and the sublime co-existed within the same framework, just as they do in caricatures to this day.

Caricature can be the most cheerfully trivial of art-forms, the most light-hearted and irresponsible. Many caricaturists – and this is perfectly legitimate on their part – aim only to divert us for a moment, to help relieve us from some of the pressures of daily living. The greatest caricature, on the other hand, returns to its medieval origins by being essentially moral satire, by making some point about the nature of man rather than about the nature of individual men. If we laugh at caricature of this forceful and exalted sort (which is often what the artist intended), then the laughter is a genuine catharsis, a moral cleansing. This is one reason why caricature, as will be seen from the illustrations in this book, has so consistently attracted the attention of great artists.

theme obviously dear to Keppler's heart. The men depicted here, now prosperous, and respectable US citizens, are overshadowed by images of themselves or their ancestors. Have they forgotten their own origins? Keppler asks, saying that 'they would close to the newcomer the bridge that carried them and their forefathers over'. Keppler was the founder (in 1877) and chief cartoonist of Puck, and he took the place previously held by Nast as America's leading cartoonist.

20 JEAN VEBER (1864–1928)
*The Beast is Unleashed, 1914
lithograph*

La brute est lachée (The Beast is Unleashed) was published on 2 August 1914, the day before Germany officially declared war on France and invaded Belgium. By any standards it is an extraordinary image, one of the best works of a still much-underrated artist. But this savage depiction of German militarism is somewhere between a sigh of relief and a call to arms; the French had long expected to renew the struggle with Germany. Veber's design makes the coming war more acceptable (though no less ugly) by putting it in an emotional context.

19

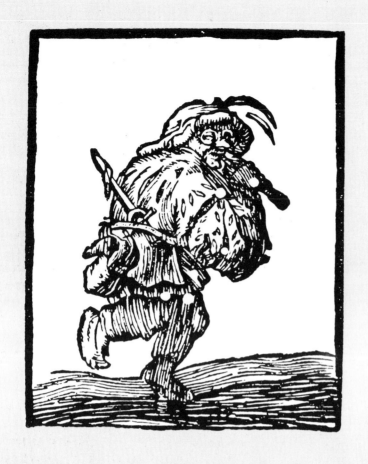

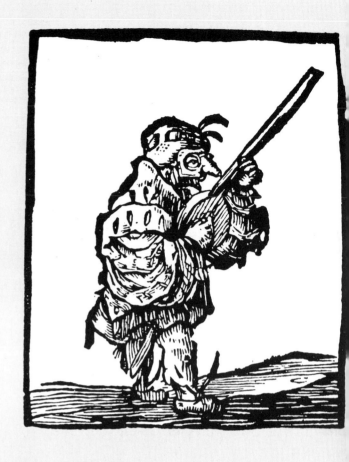

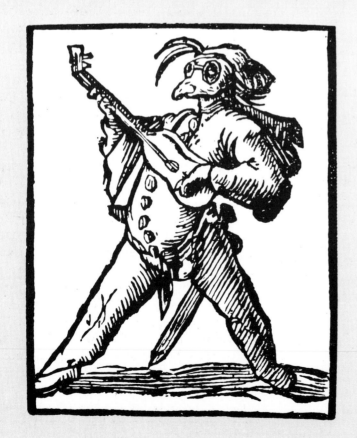

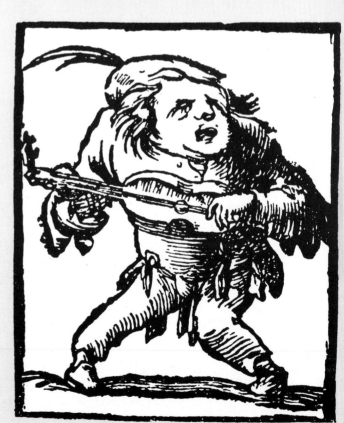

Caricature in Embryo

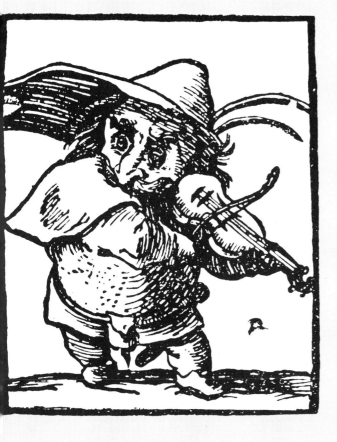

21 *JACQUES CALLOT*
(1593–1635)
Varie figure di Gobbi,
1622 etchings

*Callot's series of
twenty-one etchings of
dwarfs was based on
the companies of
performing dwarfs
popular at the Medici
court in the early part
of the seventeenth
century. Their act
obviously imitated some
of the balletic and
theatrical aspects of*
commedia dell'arte,
*itself derived from
theatrical traditions
dating back to classical
times. The figures seen
here are all playing
some form of musical
instrument; the masked
figure with buttoned
jacket closely resembles
the Capitano Zerbino of
Callot's* Balli di
Sfessania, *one of the
most delightful and
most complete pictorial
records of* commedia
dell'arte. *The connection
between these figures
and the dwarfs,
acrobats and masked
actors depicted in
classical art is a direct
one, although the
graphic style is
distinctively Callot's.*

Elements of caricature appear in both ancient and medieval art, without ever giving us the feeling that we are confronted by caricature in a fully developed and systematic form. Certain exceptions – the caricature statuette of the Emperor Caracalla in the Avignon Museum, showing him as a dwarf, holding a basket of cakes in one hand and distributing them with the other; or the famous sketch of Isaac of Norwich, which heads the English *Rotulus Judaeorum* of 1233 – are fascinating because they suggest latent possibilities which were never developed.

When one looks at Greek and Roman material, one sees that classical art has many of the externals of true caricature, but little of its genuine spirit. Medieval art, on the other hand, mixes true caricature elements with serious ones in such a way that we cannot really draw the line between the genres. The burlesque devil who tries to pull down the scale for the weighing of souls (the incident is part of the great judgement scene on the facade of Autun Cathedral) is nevertheless part of something deeply solemn and sacred.

Certain references in ancient literature suggest that the Greeks and Romans had some notion of what caricature was or could be. For example, the Roman writer Pliny tells a story about a painter called Clesicles, who insulted Queen Stratonice (who had not rewarded him properly) by painting her in the arms of a fisherman who was supposed to be her lover, and then exhibiting the picture in the port of Ephesus before fleeing for his life. There is also a reference in Philostratus's *Lives of the Sophists* to a man called Varus, who was nick-named 'the stork' because of his appearance, and who was – so Philostratus tells us – often represented in the form of that bird.

One of the most striking things about the art of

the Hellenistic and Roman periods is the delight that artists take in representing grotesque types. Historians see this as part of the reaction to the classical ideal which took place in the centuries following the death of Alexander. The beggars, slaves, hunchbacks, drunken old women, etc., associated in particular with the art of Ptolemaic Alexandria are, according to this interpretation, the mirror image of the types of heroic youth and beauty created by the Greek artists of the fifth and fourth centuries BC. But are they truly caricatures? Certainly they are meant to be comic and to show, at least on some level, the weaknesses of mankind. But they are comic types rather than caricatures of individuals. As Sir Ernst Gombrich has observed, in classical art 'to distort the image of an individual was, as it were, taboo; the comic might not intrude on civic dignity'.

There are, however, other elements in classical art which have contributed to the making of caricature. Some are apparently universals, others were lost and forgotten until they were once again fed into the mainstream of European art with the revival of classical learning at the Renaissance.

The best example of the first is the tendency to endow human beings with animal forms, or to show animals engaged in human activities. The beast-fable is one of the oldest of literary genres, and it has a continuous history from Ancient Egypt to the present day. Similarly, we find a continuous tradition of illustrations to such fables. There are, for instance, a number of Egyptian papyri which show animals engaged in human activities, and which are quite clearly intended to be humorous. The Greeks, and after them the Romans, took over not only the idea of humanized animals, but the slightly different one of combining human and animal forms. The grotesque Egyptian god Bes, an embodiment of good luck, is the ancestor of the mischievously anarchic Greek satyr.

The difference was that these combinations now tended to be fantastic and satirical, rather than reverent. As examples of pure fantasy, one can point to some of the human and animal combinations which appear on Roman gems, the so-called *grylloi* which seem to anticipate Surrealism. One famous example of the combination of human and animal forms, though in a different medium, is the Roman fresco

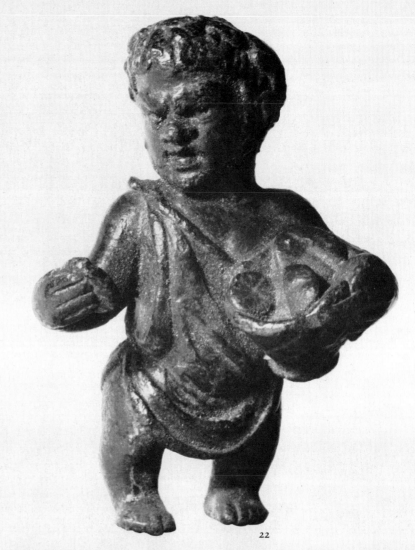

22

22 ANON.
Caracalla with a Basket of Cakes, 3rd century AD
bronze statuette

Caracalla is notorious for having been one of the most bloodthirsty tyrants in Roman history. In the many portraits of him his forehead is distorted by sharp wrinkles and his face is rather blunt and flat. He was said to be short of stature and to resemble a famous gladiator of the time, Tarautus, who was reputedly ugly as well as violent and bloodthirsty. That he was a figure of ridicule is possibly based on his obsessive identification with Alexander the Great, which he carried to ludicrous extents by imitating his behaviour, clothing, weapons and even his travel routes. Caracalla's mental instability also showed in his extremely unpredictable behaviour and his obsession with religion. He adopted the Egyptian practice of identifying the ruler with God and had himself represented as a pharaoh in a statue. This depiction of him as a dwarf is characteristically Roman: dwarfs were at this time particular figures of amusement and were highly prized as entertainers and jesters. Indeed, slave children were often deliberately maimed at birth in order to increase their value. That he should be distributing cakes as gifts is possibly ironic; Caracalla was hardly known for his generosity or kindness.

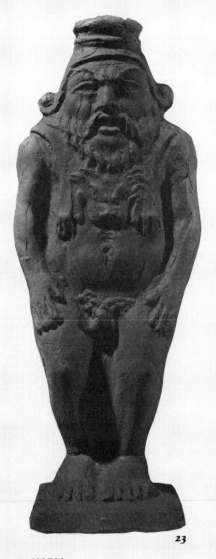

23

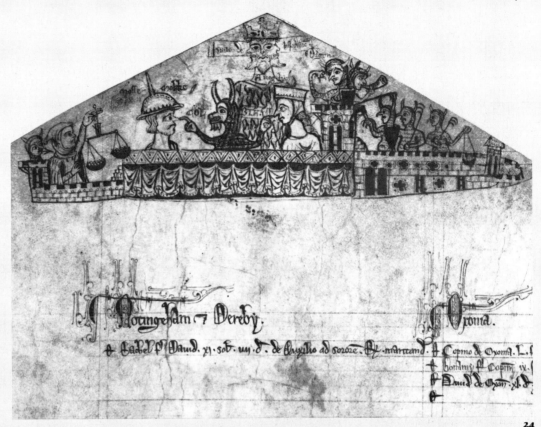

24

25

23 ANON.
Bes, Egyptian god
terracotta

The Egyptian god Bes is always
represented as a dwarf, with a large head,
popping eyes, protruding tongue and bow
legs. Although a grotesque figure, he was
said to be the bringer of good luck,
perhaps in the belief that his hideousness
would frighten away evil spirits. He is
also often associated with children and
childbirth. He may have been African or
Arabian in origin, but in appearance he
is not unlike the statues of dwarfs and
other grotesques so popular in Roman
times.

24 ANON.
Isaac of Norwich and other Jews, Rotulus
Judaeorum, 1233
ink on vellum

The central figure in this, the earliest true
caricature in English art, is Isaac of
Norwich, a rich Jew who owned
considerable property in Norwich in the
east of England, and was also the chief
creditor of the abbot and monks of
Westminster. Crowned and with three
faces (probably to indicate him surveying
his lands), Isaac is flanked on the left by
another Jew, Mosse Mokke, who was
later hanged for clipping coin, and below
by a Jewess called Avegay. A horned
devil has a finger on the nose of each and
in the turret on the right is Dagon, the
god of the Philistines.

25 ANON.
Animals Taking the Role of Humans.
Egyptian papyrus of the Dead, c. 1000 BC
body colour on papyrus

Animals behaving like human beings and
the related, though somewhat different,
idea of drawing figures which combine
human and animal characteristics are
among the oldest conventions in the
history of satiric and comic art.
Illustrations to beast fables seem to occur
in every culture that possesses any kind of
art form. This Egyptian papyrus which
shows, most notably, a rather gleeful lion
playing chess with a unicorn, as well as,
further on, a tiger or wild cat driving a
flock of geese to market, is one of the
earliest and most delightful examples of
such role reversal. Its intent is purely
comic.

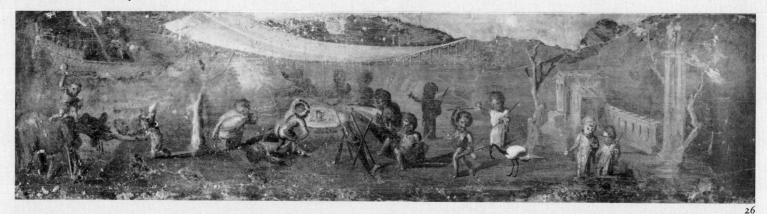

26

27

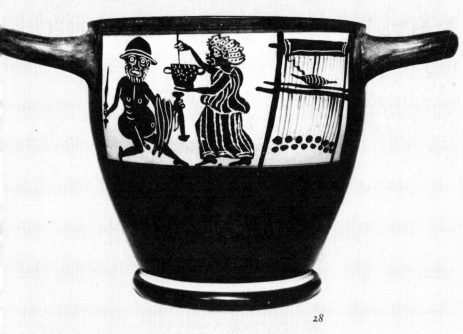

28

26 ANON.
Dwarfs and Cranes Playing and Sketching in a Garden, Pompeii, before AD 79
fresco

Homer, Aristotle, Pliny and other classical writers believed in the existence of a race of dwarfs, living possibly in India, and which they called pygmies. Availing themselves of this belief, artists employed them in a hundred ways to caricature the doings of men. As in this painting, they are mostly shown parodying ordinary activities; the incongruous element here is the presence of cranes, their enemies in Greek legend. So popular were the pygmies in Roman times that they are depicted in almost all the comic art of the period.

27 STEFANO DELLA BELLA (1610–64)
Dwarfs Playing Ball, c. 1635
etching

Sporting caricatures can be traced back directly to the Graeco-Roman world, where they are related to classical representations of pygmies participating in gladiatorial contests. Much later sporting caricatures show the same characteristics: they are concerned with organized spectator sports and derive their humour from showing feats of skill and physical prowess performed in an inappropriate way or by inappropriate people. This etching by della Bella, which was probably inspired by the tour of a group of itinerant dwarfs in Italy in the early years of the seventeenth century, is in exactly the same idiom as that established by the Roman muralists.

28 ANON.
Satirical drawing of Circe and Ulysses Boeotian drinking vessel, late 5th century BC
coloured slip with scraped and brushed drawing

Grotesque decorations on amphora, like this one showing a dwarfish Circe offering a magic potion to a pot-bellied Ulysses, were probably inspired by Greek satyr plays, which were farcical dramas presented in the same programme as a tragic trilogy and usually written by the same author. They traditionally involved the burlesque of some myth, with the legendary hero finding himself in a number of absurd situations. Such parodies are frequently represented in Greek vase painting.

discovered at Gargano in 1760. This shows Aeneas, Anchises and Ascanius fleeing from Troy. All three are provided with dogs' heads, and Aeneas and Anchises have outsize phalluses.

Thus, although great myths and stories were worthily illustrated by Greek and Roman artists, in sculptures, frescoes and vase-paintings, they were also parodied. A Boeotian cup now in the Ashmolean Museum – it dates from the fifth century BC – shows what is apparently a grotesque and dwarfish Circe serving a magic potion to an equally dwarfish Ulysses.

Dwarfs and pygmies, and also Cupids, play a special role from the developed classical period onwards. They appear whenever the artist wants to be playful. Sometimes the joke is simply that the pygmies are small, weak and ugly. Another fifth century black figure cup shows a giant female ape pursuing some pygmies who run to take refuge in a tree. But pygmies are more often used as a form of parody, either in allusion to some work of literature or else as a way of commenting on daily life. Sometimes, following Homer, they are shown fighting with cranes. They also fight farmyard animals, the wild beasts of the circus or aquatic monsters. They are shown as soldiers, gladiators and pugilists, and as dancers, and engaged in many of the occupations of daily life. In Roman times pygmies became so popular as a subject for the artist that it has been estimated that no less than four-fifths of the humorous representations in Roman art are concerned with them.

The popularity of these small misshapen figures is easily explained on psychological grounds – whatever was depicted was thus literally diminished and made grotesque. Scenes showing Cupids worked in a similar fashion, by implying an element of the childish in supposedly serious adult occupations. It is interesting that classical artists found it much easier to depict the lives of ordinary people in this way than they did to show them undisguised. What the Renaissance rediscovered in Roman paintings of pygmies was not merely the particular device of putting a large head on top of a tiny body, but the possibility of creating a special universe in which everything was grotesque or comic. It is in this sense that the *commedia dell'arte* hunchbacks (*gobbi*) of Jacques Callot in the seventeenth century, and the Pulcinelli of G. D. Tiepolo in the eighteenth, are closely related

to the dwarfs and hunchbacks of Alexandrian and Roman art. This is not to assert, however, that this classical world of pygmies carries with it all the weight and implications of fully developed caricature.

What is missing is not merely particularity – references to specific events and specific people – but a kind of moral weight. The classical artist may suggest that certain actions or events can be seen in a comic light, but seldom hints that these things matter very much or touch on life in more than a rather tangential way. Roman frescoes showing pygmies and Cupids are graceful decorations for private homes.

The place for making public statements in the classical world was the theatre, and we see in classical art the beginnings of a relationship, which has persisted throughout the ages, between theatrical representation and caricature.

The classical theatre, where actors played to vast audiences without such modern aids as artificial lighting, developed a number of characteristic devices. The most important was the use of the mask. Greek tragic masks, as well as comic ones, now seem to us grotesquely exaggerated. Tragic actors projected their *personae* by wearing high boots and dignified robes. Comic actors went to the other extreme. They wore a kind of padded bodice which exaggerated belly and buttocks; and, in the Old Comedy of Aristophanes, they still sported artificial phalluses. In fact, they were what we should now call walking caricatures.

Comic actors are frequently portrayed enacting standard roles. The stock types include the impertinent slave who has just had his ears boxed, the angry father, the gossipy old woman and so forth. (It was these stock types, as well as masked, elaborately costumed comic actors, who reappear in the *commedia dell'arte* many centuries later.) All have their own expressive body language, faithfully rendered by the artists.

There also existed at least one class of comic performer who did not wear masks. These were the actors in the Southern Italian *phylakes*, burlesque plays which often made fun of heroic epics and mythology. They are represented on South Italian vases, and convey a lively sense of the quick-witted ridicule and uninhibited clowning of such pantomimes. These vases show two things. First, that the vase-painter's picture often becomes a

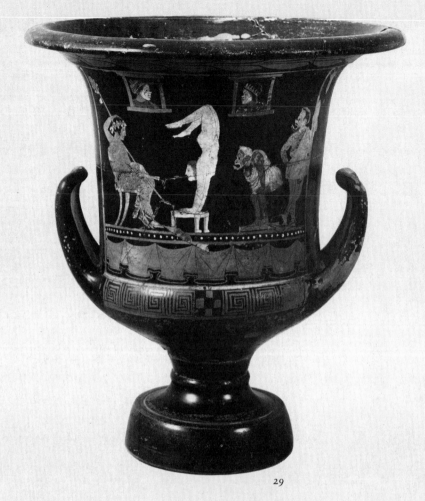

29

29 ANON.
Hunchback Studying an Acrobat
Greek vase painting

The grotesque hunchback on this vase stares, with open-mouthed amazement, at the physical agility of the acrobat balancing on a stool. Acrobats, jugglers and dancers, as well as dwarfs and hunchbacks, were often part of the troupe of entertainers kept in the households of rich Greeks and Romans. This tradition survived well into the Middle Ages when similar burlesque entertainers were to be found at princely courts and in the households of both spiritual and temporal lords.

30 ANON.
Characters from Terence's Adelphoe *(The Brothers), 9th century*
facsimile chalk drawing

Terence's plays, imitations of the New Comedy of classical Greece, were concerned with a number of stock characters – the swaggering soldier, the pedant, the comic slave – who were usually involved in some ingenious intrigue. As in Greek theatre, masks and costumes were used to exaggerate physical features and to make each character recognizably comic to the audience in the amphitheatre.

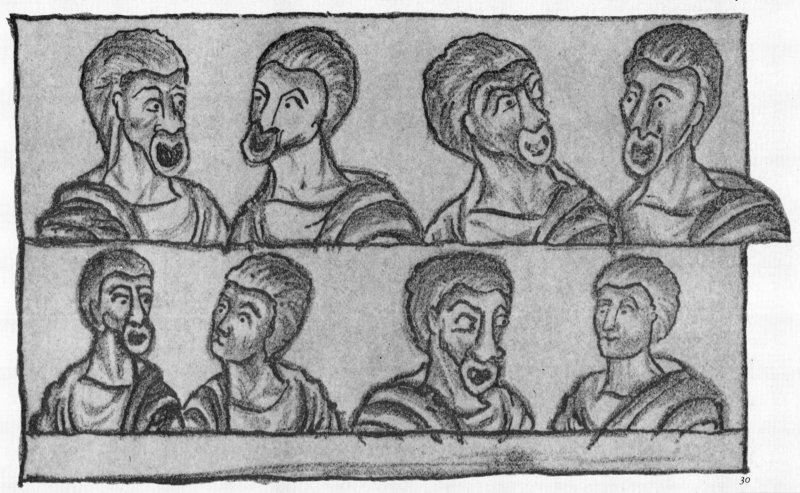

30

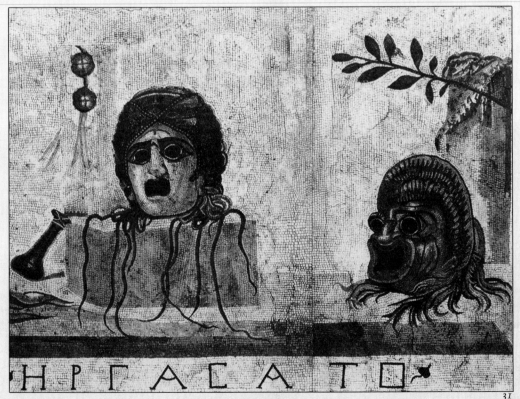

31

31 ANON.
Greek Tragic Masks, c. AD 130
Roman mosaic

Masks which exaggerate or distort the
human face have been used almost
universally in theatrical performance.
The purpose of Greek tragic and comic
masks, like these on a Roman mosaic,
was to make clear from a distance the
precise nature of the character. Since
realism was not a primary ingredient of
classical drama, the masks, mostly
elaborately coiffured, were often
ludicrous, grotesque or awesomely
imposing so that the actors became in
performance caricatures of the
characters they were playing.

parody of the myth in its own right, and, secondly, that these representations are uncommonly close to certain kinds of modern caricature. It is, in fact, the mythic basis which gives a point of reference, and makes these vase-paintings still seem funny today. And this is one of the great lessons to be drawn from classical art – that it may approach caricature from time to time, but this is really an illusion based on hindsight. What it usually lacks is the fixed point of reference which makes caricature truly effective.

When we move from classical to medieval art (I mean by this art created from about the tenth century AD onwards) we are confronted with a very different situation. We have moved into a world which has a single unifying myth, Christianity, and one in which men are as much concerned with the supernatural as they are with the ordinary and natural, where the grotesque and the sublime are intimately intermingled. This is especially true of the earlier medieval centuries, before the new scholastic doctrines which, while still accepting and even emphasizing the power of the supernatural, tried to resolve the conflicts of faith and reason. The great ecclesiastical reformers thrown up by scholasticism disapproved of humorous and grotesque incursions into sacred art. St Bernard, in a well-known letter to Guillaume, abbot of Saint-Thierry, condemns what he calls 'these ridiculous monstrosities' in the carved decoration of churches – things like the capitals at Vézélay, which intermingle biblical incidents, often of the most solemn kind, with high-spirited fantasies that appear to have nothing to do with the sacred nature of the building. One of these capitals shows a monkey playing the violin, faced by an ass who holds a music book in his hooves.

In fact, scholasticism never succeeded in suppressing the intermingling of solemn and comic elements in church art, and beast-fables remain one of the commonest kinds of comic representation in both buildings and manuscripts. But unlike similar fables in antiquity, they now take on a moralizing tone which is alien to the classical spirit. A capital dated 1298 in Strasbourg Cathedral (it was destroyed in the seventeenth century but is still known from an engraving) showed animals engaged in a parody of the Mass. This carving was an echo of incidents in the comic poem the *Roman de Renart*, and illustrated manuscripts of this and

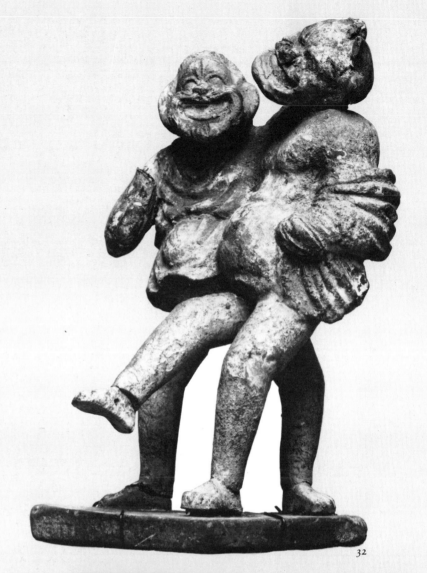

32

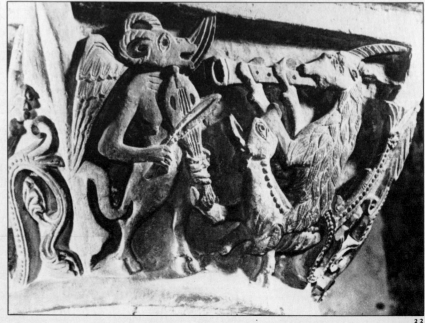

33

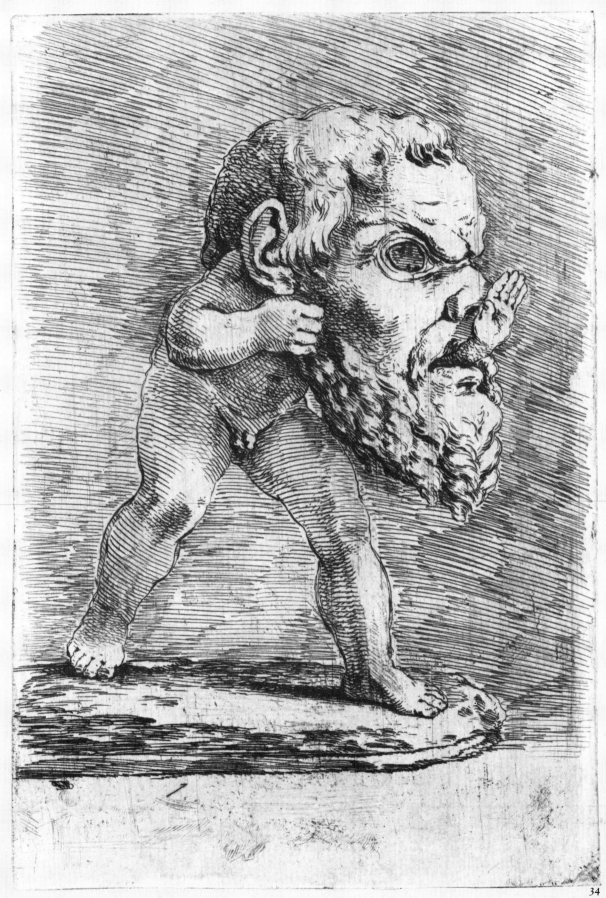

34

32 ANON.
*Comic Actors Behaving
Drunkenly*
bronze sculpture

*These Greek comic actors,
with their grotesque masks
and characteristic padding of
torso and buttocks, wear the
short tunics of the stage
lower classes and slaves. Such
characters often took
prominent roles in a play, as
drunken, interfering or
impertinent servants, or as
commentators – frequently in
bawdy and obscene style – on
the actions of such standard
characters as the foolish
miser and the ageing cuckold.*

33 ANON.
*Animals Playing Musical
Instruments, 14th century*
stone carving

*This crude portrayal of a goat
playing a violin on a capital
at Canterbury Cathedral is one
of several examples in
medieval ecclesiastical
architecture which depict the
sacred rites of the Church
being travestied by animals,
in an often remarkably
savage and satiric way.
Similar burlesque figures are
to be found at Autun
and at Vézélay.*

34 STEFANO DELLA BELLA,
Cupid with an Actor's Mask
engraving

*Della Bella's style is clearly
formed on that of Jacques
Callot and, like Callot, much
of his inspiration came from
watching troupes of travelling
players. The grotesqueness of
this engraving – the large head
placed on a diminutive body
with the cupid's hand
protruding through the
actor's mask – is reminiscent
of the depictions of actors or
pygmies found so frequently
in Greek and Roman art.
This engraving, of course,
makes no satiric point and is
merely mildly amusing; but it
does use that classic device of
caricaturists through the ages,
the exaggeration or distortion
of that most important
human feature, the face.*

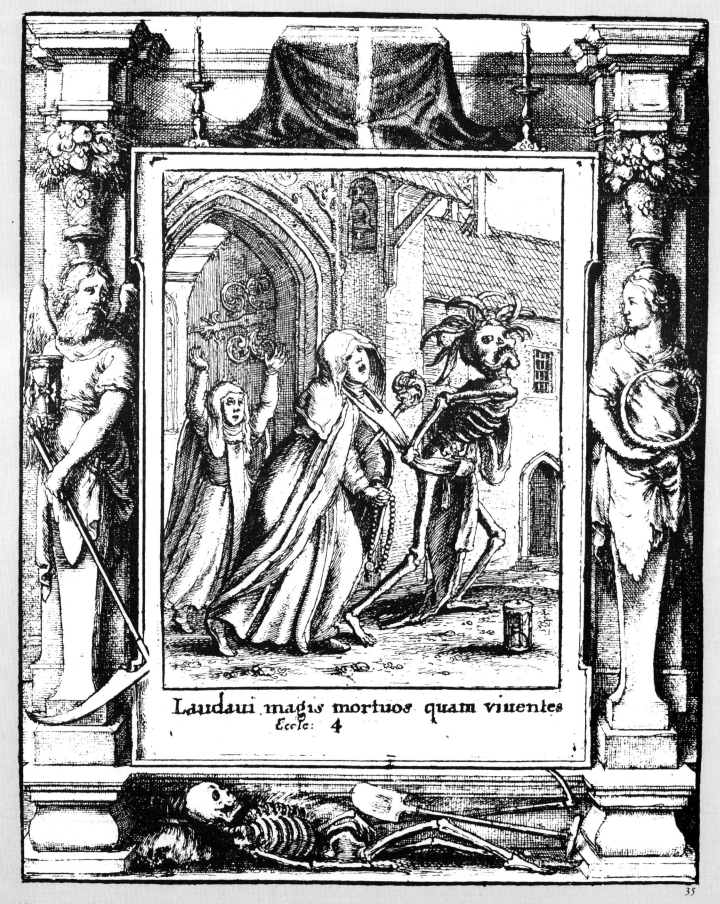

Laudaui magis mortuos quam viuentes
Eccle: 4

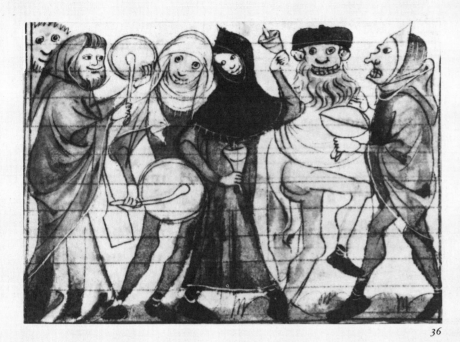

36

35 HANS HOLBEIN (1497–1543)
Death and the Abbess, Dance of Death,
1538
woodcut

*Caricature, and indeed all satire, is only
really effective when it makes reference to
a moral norm or centre. For this reason,
the medieval Dance of Death probably
marks the true beginning of caricature.
Holbein's series of fifty-one woodcuts of
the Dance of Death is perhaps the most
famous of all such representations. These
were produced between 1523 and 1526
and after their publication in 1538
enjoyed enormous popularity. The plates
show Death visiting both rich and poor,
laymen and clergy. His figure stands
ready to bring the men of this world
back to a sense of their responsibilities –
towards God and their fellows – and also
acts as a reminder of human nothingness.
This plate depicting Death with an
abbess takes its text from Ecclesiastes 4:
'. . . I praised the dead which are already
dead more than the living which are yet
alive'.*

36 ANON.

*Peasant merry-making Roman de Fauvel,
14th century
ink and body colour on vellum*

*Church feast days, although intended to
be a time for spiritual reflection, were in
the Middle Ages invariably associated
with dances, mummings and maskings, a
tradition going back to pre-Christian
times and linked with ancient pagan rites.
Farcical scenes, with performers wearing
grotesque masks and playing rudimentary
musical instruments, were often included
as interludes in religious drama, giving
scope for dramatic irony and
counterpoint. This fourteenth-century
miniature from the Roman de Fauvel
shows exactly the form this kind of
entertainment took.*

of the similar *Roman de Fauvel* show illustrations
of this type developing towards what is
recognizably caricature.

Where combinations of the human and animal
are concerned, there is an even more definite shift
of tone and intention in medieval art. Such
combinations form the basis for the visual
embodiment of medieval demonology, and are
often threatening and serious. The light-hearted
satyrs of the classical world are endowed with a
new moral energy for either good or evil.

The Middle Ages, far more than the classical
world, dealt in symbol and allegory. Personifications
of Peace, Fortune and Victory, the commonplaces
of Roman art, were replaced by emblems which
were both far more potent and far more complex
in their implications. These emblems developed
and transformed themselves as medieval society
developed, and new ones were created in response
to changing conditions. One of the most potent
and pervasive of late medieval allegories is the
Dance of Death, a reaction to the Black Death
which devastated Europe and changed the face of
medieval society. It is first recorded as a mime or
dramatic performance and a visual aid to the
histrionic preachers of the time who used it with
great frequency to warn their congregations of the
torments to come.

The Dance of Death was not merely gruesome
and apocalyptic, it also contained strong elements
of social criticism and sardonic humour. In all its
versions, it pointed the same moral – that death
was the universal leveller in a rigidly hierarchical
society. Many pictorial versions of the Dance of
Death make especially sharp criticisms of the
abuses of the church, and in this sense they already
foreshadow the social unrest of the Reformation.

It is significant that as soon as the new technique
of printing became available the Dance of Death
emerged as a favourite theme for illustrated books.
The first, heavily indebted to the moralizing wall-
paintings which had preceded it, was published in
Paris in 1486. The development of the Dance of
Death culminated in the next century with the
celebrated treatment of the subject by Hans
Holbein, first published in 1538, though perhaps
finished as early as 1526. The first appearance of
the Dance of Death in print marks the birth of
modern caricature in northern Europe, and it long
survived as a favourite theme for graphic satire.

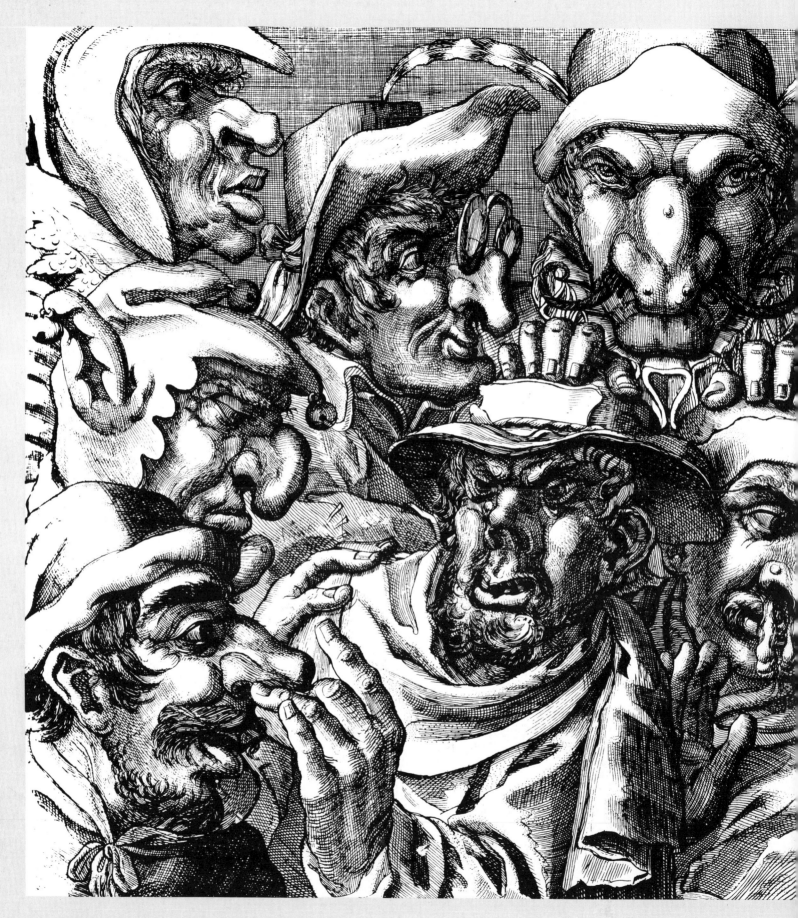

32

37

Popular Allegory and the Printing Press

The invention of printing in the fifteenth century gave the allegorical imagery of the Middle Ages a new tone. The earliest political caricatures appeared hot on the heels of the first printed Dance of Death. A satirical woodcut of 1499, *Le revers du jeu des Suysses*, comments on French political ambitions in Italy. It shows the Pope, the Emperor, and the Kings of France and England playing cards, while beneath the table a little Swiss soldier stacks the deck. Here the use of allegory has already developed into something which a modern newspaper reader would find familiar.

Printing secularized allegorical art, and also gave it a new ephemerality which in some ways actually added to its impact. Church imagery, carved in wood or stone, painted on walls, or shown in the brilliant colours of stained glass, was intended as a permanent, unalterable statement about the human condition. Prints, however, were produced in large numbers but were expendable, meant to be studied in private and passed from hand to hand; meant, too, to be concealed from those who would not approve of them and shown to those who would. For the first time art was free to comment without inhibition on topical themes.

Some early caricatures were topical in that they dealt with subjects which constantly preoccupied the medieval mind. For instance, the earliest extant anti-Semitic broadside was published even earlier than *Le revers du jeu des Suysses* – in Germany in 1475. It shows Jewish scholars, in the pointed hats they were forced to wear by law, being suckled by the devil's pig. But other handbills were quick to sound new notes of anti-clericalism and anti-papalism, even before Luther gave force and direction to the assault on papal authority. An attack on the Borgia Pope Alexander VI shows him as a devil wearing a flaming tiara. Inscribed

above, lest there be any mistake, are the Latin words *Ego sum Papa* – I am the Pope.

The growth of Protestantism and printing were inextricably linked, since printing made it impossible to check the spread of the new doctrines. Wittenberg, where Luther was based, became an important centre for the new industry – Luther's own works represented more than a third of all the writings in German published between 1518 and 1525. The flood of printed texts was accompanied by an equivalent flow of allegorical illustrations, and, as the religious controversy grew, so the imagery invented by the partisans of either side became more violent and extreme. For a modern audience such images have no recognizable connection with humour. It is nevertheless possible that Luther's followers may have found something grimly funny in Cranach the Elder's image of the terrified Pope being carried off to Hell, since this is based on one of those reversals of expectation which are among the humorist's chief weapons. A print of 1580 which, in lurid detail, shows the hated Jesuits being stuffed, larded and roasted by devils is Reformation satire in a much grimmer mood. Yet does it seem more savage than some political caricatures which have appeared in our own day – for example, those which expressed opposition to the Vietnam War?

Sixteenth-century caricature is often gross, but often effective. Erhard Schoen's *The Devil Playing Luther as a Pair of Bagpipes* is by any standard a brilliantly imaginative invention. It makes its point through metamorphosis, and therefore finds its place in a tradition founded by Hieronymus Bosch and continued by Pieter Brueghel the Elder.

Brueghel's prints are different because they tackle general themes, not particular topical issues. They are satires based on folk-sayings and folk-imagery. His *War between the Money Bags and the Strong Boxes,* an anti-capitalist satire of 1563, is very much in the main line of descent from Bosch, a wild fantasy whose multiple meanings only gradually clarify themselves. *Big Fish Eat Little Ones* is the direct translation into visual terms of a folk-saying – the artist, like Goya with some of the *Proverbios,* is relying on the shock effect obtained by taking literally what was intended metaphorically. *The Pedlar Robbed by Monkeys* is less complex. The robbers are men transformed into monkeys by their thievishness.

38

previous page
37 ANON
*Twelve Heads, early 17th century
engraving*

This anonymous French study of grotesque heads is one of many such pieces to appear in the early seventeenth century. The artist has here taken the nose as the most distinguishing facial characteristic, and with crude and embarrassing detail has assembled an absurdly exaggerated repertoire. A black and a Turk form part of the group, obvious comic characters to the contemporary audience simply because they belonged to another race.

38 ERHARD SCHOEN (1491–1542)
*The Devil Playing Luther as a Pair of Bagpipes, 1521
woodcut with body colour applied*

Satan and his demons figure frequently in sixteenth-century caricature. This was understandable because of the great religious controversies of the time, when each side hastened to depict the devil as the inspiration of the other. This anti-Luther caricature shows the devil playing bagpipes formed of Luther's head. Dated 1521, it marks Luther's examination before the Diet of Worms. The bagpipes were to remind the public of the unattractive nasal drawl of the preaching friars of the time. Luther himself was the first to use the simplified form of the popular satirical woodcut as a polemical weapon.

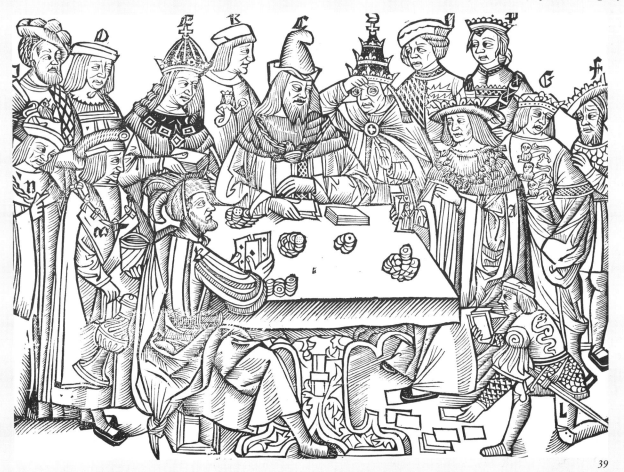

39

39 ANON.
Le revers du jeu des Suysses 1499
woodcut

This woodcut, the earliest political caricature, is entitled 'the other side of the Swiss game' and refers to the furtherance of France's political aims in Italy. The support of Swiss soldiers, at this time among the finest in Europe, was necessary to France; the Swiss, however, cunningly exploited the conflict to their own advantage.

40 ANON.
The Papist Devil, late 15th century
woodcut

This anonymous engraving satirizes the Borgia pope, Alexander VI by representing him as the devil in person, with the infernal attributes of clawed hands, grotesque goat-like face, grossly repeated on the torso, and flaming tiara. The legend clearly states 'I am the Pope'. Luther was the first person to call the Pope the Antichrist.

41 LUCAS CRANACH
(1472–1553)
Fall of the Pope into Hell,
from The Passionale of Christ and Antichrist,
1521
woodcut

Cranach's wood engravings for a book by Philip Melancthon contrast the simplicity of Christ's life with the worldliness of the Pope's. This illustration, the last in the book, depicts the Pope being carried off to Hell by Satan's enthusiastic demons; the engraving on the facing page shows Christ's Ascension into Heaven.

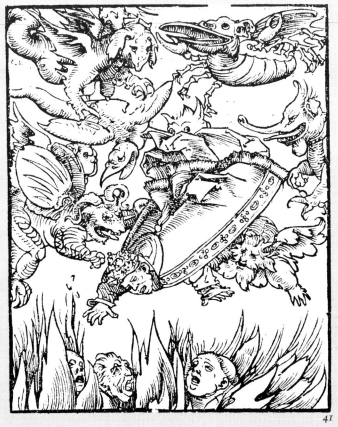

Ego sum Papa.

40

41

35

42

42 ANON.
Jesuit Priest with Wolf's Head, 16th century woodcut

A proliferation of animal allegories appeared, understandably enough, during the Reformation. This rather crude satire of the despised Jesuits is typical of the time.

43 URS GRAF (1485–1527)
Two Mercenaries and a Woman with Death, 1524 woodcut

Extremes of fashion have always aroused the ire of moralists, and late medieval preachers denounced such extremes because they typified worldly vanity. This woodcut intermingles various themes and impulses. The print alludes to the established theme of the Dance of Death and the transitoriness of worldly pleasure, but what chiefly interested the artist is the fantastic costume worn by many of the mercenary soldiers of the time, the landsknechte. Like the more elaborate kinds of cowboy costume today, this was an uninhibited assertion of virility, and demonstrated that they were not in the least afraid of decoration for its own sake. Here the landsknechte are almost transformed into gaudy insects, their swaggering figures seeming to mock the whole cult of military vainglory.

43

Popular Allegory and the Printing Press

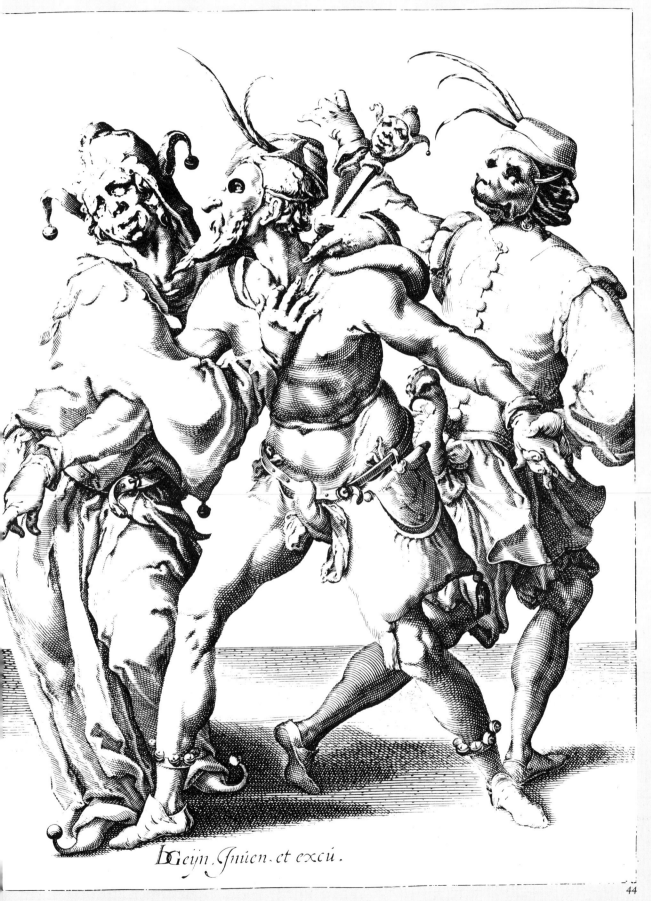

D'Geijn. Inuen. et excu.

44

44 JACOB DE GHEYN
II (1565–1629)
Comic Actors
Satirizing Human Folly,
The Masks No 4
engraving

The improvised Italian
comedy, with its parade
of fixed types and its
characterful masks and
costumes, provoked an
almost disproportionate
number of illustrations
in the sixteenth and
seventeenth centuries.
Jacob de Gheyn,
however, uses these
conventions to make a
moral point in this
engraving. The
bedizened actors are
allegorical
representations of
human folly and,
although the message is
abstract, such
compositions (and there
were many in this
period satirizing a host
of human vices) are
often remarkably close
to true satire.

Brueghel can be linked to a tradition of northern realism which often finds other and simpler forms of expression in early prints – for example in Amberger's *Rustic Couple* or in Leonhard Beck's *The Lady Cook and her Lover*. These comic studies of peasants are accompanied by simple domestic satires, among them Israel van Meckenem's *The Angry Wife*, Hans Schauffelein's *The Subservient Husband* and Hans Sebald Beham's *A Marital Quarrel*. These are the direct predecessors of the comedy of manners caricatured by Hogarth and Rowlandson and of the cartoons about the foibles of 'ordinary people' which amused readers of *Punch* and the *New Yorker*.

Italian artists, in contrast, at the end of the fifteenth and during the sixteenth century subscribed to the classical and humanistic ideals of the High Renaissance. Leonardo da Vinci and Michelangelo drew what are sometimes called caricatures but are more usually known as 'grotesques'. What links Leonardo's famous grotesque heads with the prints of the northern realists is that they both rely, to a greater or lesser extent, on the distortion of facial features. But Leonardo's heads are not caricatures in the modern sense in that they contain no satiric intent nor are they related to actual persons. Leonardo simply wanted to see if a vision of ideal beauty could be balanced by a corresponding vision of ideal ugliness. He was affirming the classical ideal. Leonardo's drawings were immensely popular and were much copied and imitated by his immediate successors. They thus probably provided the inspiration for the numerous caricatures of the Baroque and Mannerist periods.

A parody of the *Laocoön* as a group of monkeys, a Venetian woodcut based on a drawing by Titian, was similarly a contribution to the continuing debate about classical ideals and the artist's duty to conform to them. The print has this much in common with Brueghel's *Big Fish Eat Little Ones* – it too is based on 'taking literally': the artist suggests that his contemporaries ape approved antique models without bothering to think about them. It also seems to be involved in the then current controversy between different schools of anatomists. This print is one of the few genuine caricatures produced in Italy during the High Renaissance. Significantly, it concerns itself with art.

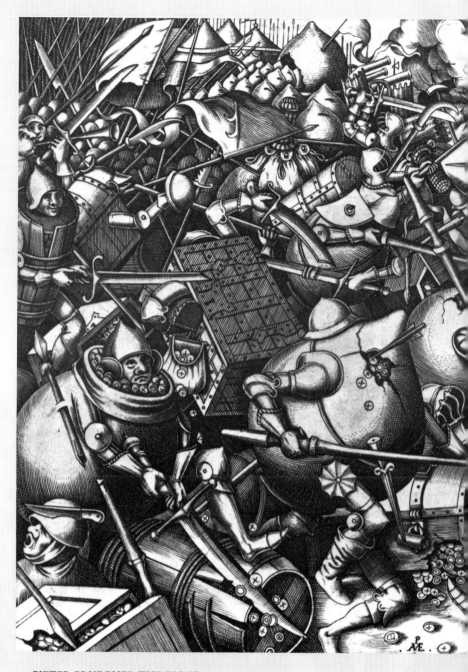

45 PIETER BRUEGHEL THE ELDER
(c. 1525–69)
The War between the Money Bags and the Strong Boxes, 1563
engraving

Avarice and greed are the main targets of Brueghel's criticism in this densely packed engraving depicting the War between the Money Bags and the Strong Boxes. Although the surface meaning is obvious, Brueghel's print, by its very busyness, forces the viewer to give it his close attention, thereby driving home the moral much more keenly – which was probably the artist's intention.

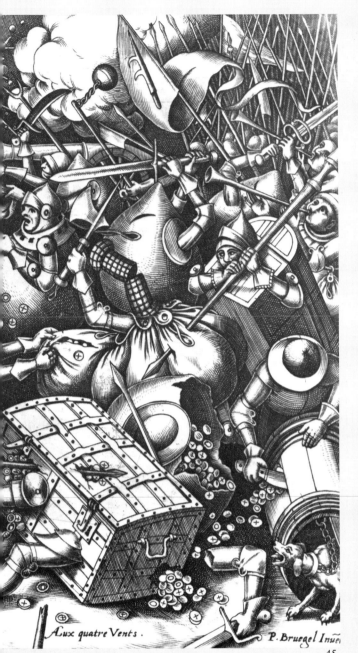

Aux quatre Vents.

P. Bruegel Inuē

45

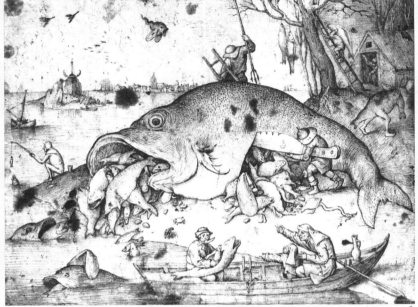

46

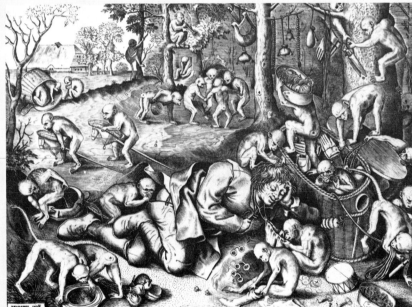

47

46 PIETER BRUEGHEL THE ELDER
Big Fish Eat Little Ones, 1556–7
engraving

*From 1556 Brueghel began working on a series
of satirical, didactic and moralizing subjects,
often in the manner of Bosch, whose works
were very popular and much imitated at this
time. This print is, in fact, directly inspired by
Bosch, its theme being how the weak are
exposed to the crushing brutality of the strong.
Here, Brueghel presents a very literal rendition
of this proverbial saying: in the boat an old man
points out to the child the enormous fish, whose
mouth and sides are pouring forth smaller fish
that have in turn swallowed even smaller ones.*

47 PIETER BRUEGHEL THE ELDER
The Peddlar Robbed by Monkeys, 1556–7
engraving

*This engraving's subject, a peddlar robbed by
monkeys as he takes his rest, was a common
one among fifteenth- and sixteenth-century
engravers. Like Teniers' The Monkey Barbers
(pl. 62) it uses mischievous, inquisitive near-
human monkeys to make its point – in this case
about man's avarice, a persistent theme with
Brueghel. Much of Brueghel's early fame rested
on prints like this one which were engraved by
Hieronymus Cock, Antwerp's foremost
publisher of prints.*

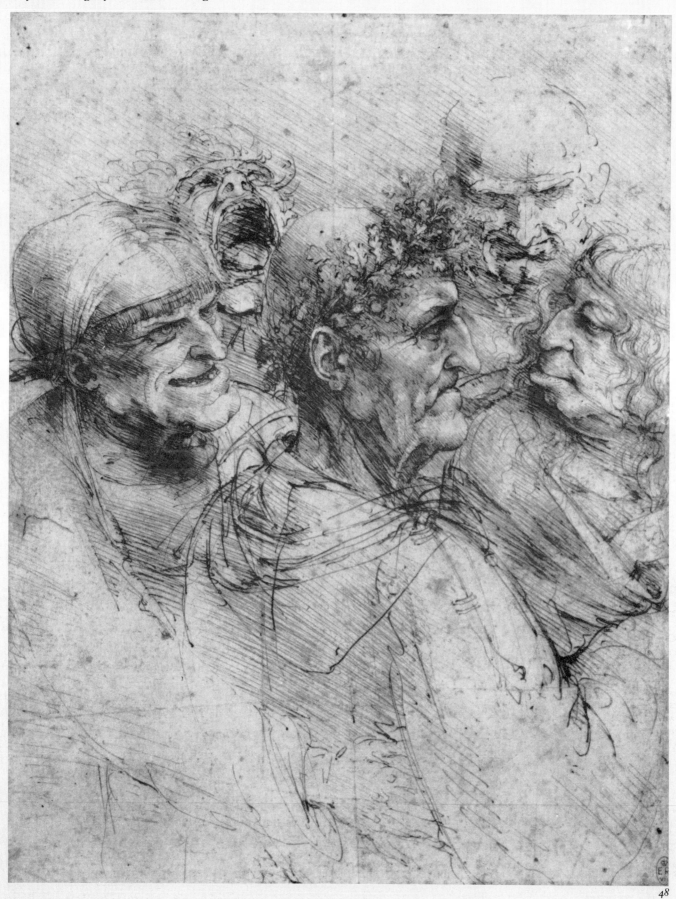

48

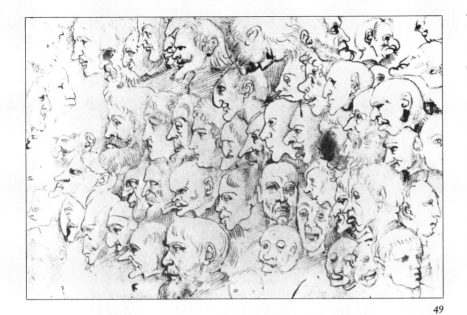

49

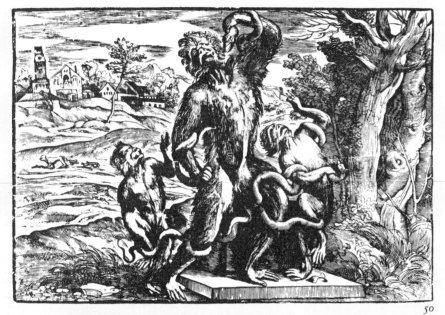

50

48 LEONARDO DA VINCI (1452–1519)
Five Grotesque Heads, 1485–90
pen and ink drawing

Leonardo's studies of grotesque heads are among the most famous of his drawings. It has been suggested by one scholar that they are academic exercises in which Leonardo searched for an ideal ugliness, and by another that they were made for some social pastime.

49 CARRACCI SCHOOL
Study of Heads, c. 1590
pen and ink drawing

The Carracci school executed hundreds, possibly thousands of drawings like this as a method of 'taking notes'. These

sheets of studies often intermingle serious sketches with caricature figures. It is probable that in this example the heads are portrayals of types rather than individuals, and therefore not true caricatures.

50 AFTER TITIAN (1477–1576)
Parody of the Laocoön, c. 1555
woodcut

Just as Leonardo's grotesque heads can be seen as a rebellion against the cult of absolute beauty, all early caricatures about works of art tend to be protests against the tyranny of the ideal. Titian's parody of the Laocoön attacks those artists who have been too stupid to interpret it correctly.

The next step forward from the detached aesthetic explorations of Leonardo and the commonsense protests of Titian is taken by the Carracci family in Bologna at the end of the century. It is worth considering the kind of context in which Annibale Carracci, his brother Agostino and his cousin Ludovico first appeared. They are generally thought of as painters in the grand manner, men who upheld, and indeed codified, the standards of academic idealism, as opposed to the raw naturalism of their contemporary Caravaggio. Yet in their early paintings, Annibale and Agostino are also naturalists, and the masterpiece of this phase is *The Butcher's Shop* now at Christ Church, Oxford, supposedly painted as a reminder of their own humble origins. Their caricature drawings can be seen not only as attempts to achieve the ideal of ugliness but as an expression of the same naturalist impulse. Unlike Leonardo's grotesque drawings they are, however sketchy and exaggerated, always portraits of perfectly recognizable people. They are almost always drawn from life, not type.

For the Carraccis, the key to a man's identity was to be found not in his religious beliefs, nor in his grosser animal appetites, but in his *amour propre*. (This is something which remains true of Italian society today.) The vulnerable point is not a man's feeling about himself, but his notion of the effect he has on others. The artist, by reducing a man's likeness to a few insulting lines, is able to exert a magical influence over the person he portrays. In caricature of the kind perfected by the Carracci we encounter a new twist on the idea of virtuosity, itself so typical both of Mannerism and Baroque.

Virtuosity could be the power to use materials with greater refinement and precision than any of one's rivals; it is talent of this sort to which Cellini lays claim to in his autobiography. In the caricatures of the Carracci and their successors it was the power to conjure up images in a moment, with only a few lines or strokes of the brush. The merit of these conjuring tricks lies in the artist's ability to seize the essentials of his subject-matter and to set them down as economically as possible. We find this economy and directness of execution not only in the work of Annibale and Agostino Carracci, but even more so in that of Bernini, Guercino and Pier Francesco Mola. Bernini, the greatest virtuoso of them all in handling his

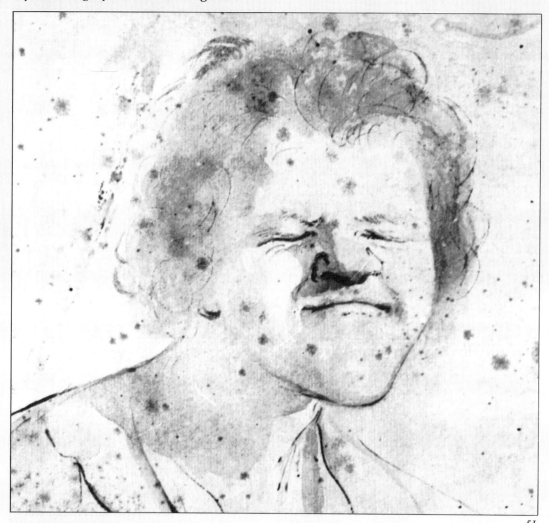

51

**51 GIOVANNI FRANCESCO
BARBIERI, known as IL
GUERCINO (1591–1666)**
Study of a Face, c. 1650
pen, ink and wash drawing

Like the Carracci, Guercino produced
numerous genre drawings of street
scenes and beggars throughout his life.
This study of a grimacing face is
drawn in meticulous detail and
suggests that Guercino was not
satirizing a real person but was
concerned with the manipulation of a
conventional type. Indeed, in the
latter half of the seventeenth century
Bolognese caricature did become more
mannered and abstract, and in the
hands of many practitioners it
returned to the study of physiognomic
types, but rendered in the abbreviated
style of caricature.

**52 GIOVANNI LORENZO
BERNINI (1598–1680)**
*Caricature of a Captain in the Army of
Urban VIII, 1644*
pen and ink drawing

Bernini has always fascinated writers
on caricature because his work in
several respects is so extreme. There
is, for example, the contrast between
these apparently rough drawings and
the suave sophistication of Bernini's
sculpture. And there is the contrast
between the hasty draughtsmanship
and its economical expressiveness.
This splendid caricature of an army
captain clearly represents an
individual and was probably made for
the amusement of the captain himself,
or one of his acquaintances.

**53 GIOVANNI BATTISTA TIEPOLO
(1696–1770)**
Caricature of a Plump Man, after 1740
pen, ink and wash drawing

Although probably at first inspired by
Zanetti, Tiepolo here abandons the
simple outline style of early caricature
and uses instead a pen stroke of
variable thickness to produce a
rounded effect which is further
enhanced by boldly applied daubs of
wash. One scholar has aptly observed
that his caricatures are 'streaked by a
rococo play of light and shade, alive
with all the decorative animation of
that style'. As with all Giovanni
Battista's caricatures it is not known
who the model was for this plump,
hunchbacked man, although he was
almost certainly drawn from life.
Caricatures like this were exactly the
kind of thing that discerning English
travellers brought home with them as
souvenirs, and one can see the
influence of Tiepolo particularly in
Rowlandson's works.

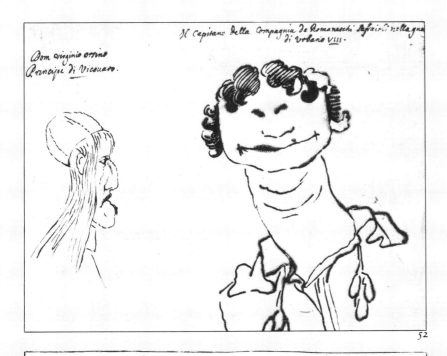

52

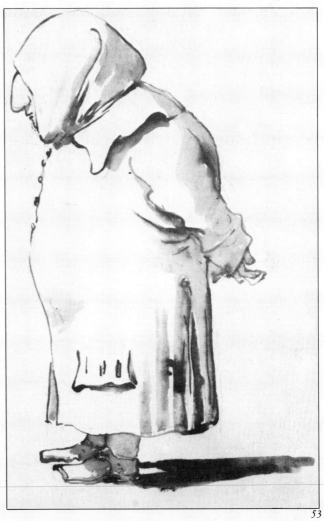

53

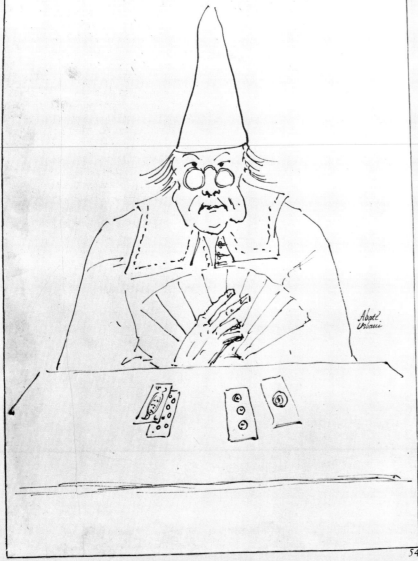

54

54 ANTON MARIA ZANETTI
(1679–1767)
The Abate Urbani at Cards, from
Consul Smith's Album of Caricatures
pen and ink drawing

Zanetti, who was by Bernini's stan-
dards a very minor and indeed clumsy
artist, had a gift for going straight to
the heart of the matter. Like Bernini,
he makes use of outline without
shading and without additional cross-
hatching, but this portrait of an
elderly cleric crouched over a hand of
cards, jowls quivering and eyes peering
over the top of his spectacles, is an
altogether stiffer thing than anything
drawn by Bernini. Nevertheless the
draughtsman does use the meagre
resources at his command to maximum
effect; indeed, he even contrives to
make a virtue of their paucity. It was
probably Zanetti, a collector of con-
siderable note in his day, who brought
caricature to Venice and introduced
the genre to Tiepolo and other Venetian
artists.

materials as a sculptor, is also the one who, in his caricature drawings, works with the fewest lines and produces what are evidently the most ruthless likenesses.

Bernini drew caricatures for most of his life. His numerous subjects were chance acquaintances as well as close friends and patrons. They were drawn chiefly for private and immediate amusement and were much esteemed in Bernini's lifetime. Louis XIV, for example, of whom Bernini did a bust, knew of his gift, and requested and was given a demonstration of the artist's talent. Regrettably, only eight of Bernini's original caricatures survive today. They are unusual for their time in that one drawing occupies a single sheet.

Italian portrait caricature, as invented by the Carracci and perfected by some of their successors, was limited and incomplete if we think of what caricature has been able to accomplish since. The German and Flemish moral, social and political caricature which preceded it perhaps had blunter weapons, but could be used more variously. After 1600 the story is really how the two different kinds of satirical art come together and intermingle, so that to draw portrait caricatures becomes just one of the things that a good satirical artist could do.

Drawing caricatures was not a source of livelihood or even a primary part of the artistic activity of the Italian artists of the sixteenth and seventeenth centuries. Their drawings were not made in secret; they were shown to others, eagerly discussed, and were even to some extent sought after by collectors, although more as curiosities than as independent works of art. This tradition of amateurism continued in Italy well into the eighteenth century although the genre was sufficiently appreciated in Rome to allow Pier Leone Ghezzi to make a living out of it. A. M. Zanetti, who had studied in Bologna and Rome, probably introduced caricature to Venice and to the last great master of the Italian Baroque, G. B. Tiepolo, who produced caricatures strictly as a relaxation from the vast decorative schemes he undertook, very much as his Bolognese and Roman predecessors had done before him.

As well as the development of portrait caricature there were other strands in sixteenth and seventeenth century art which were to influence the caricaturists of the eighteenth century and which helped to widen the range of both subject-matter

55

55 PIER FRANCESCO MOLA
(1612–1666)
Caricature Study of Heads
pen and ink drawing

Bernini's contemporaries and successors never quite manage to rival his devastating economy. Pier Francesco Mola, who is among the most powerful of seventeenth-century caricaturists, uses the abbreviated and humorous style of caricature in this study of heads, but never really breaks away from a sense of Baroque fullness in the way Bernini does, in order to produce something more original and drastic.

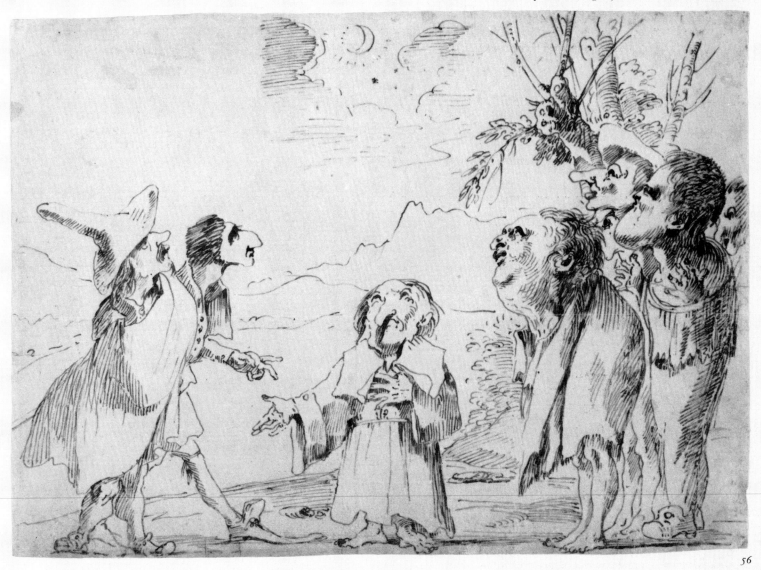

56

56 PIER LEONE GHEZZI (1674–1755)
A Discussion between Fools
pen and ink drawing

Although Pier Leone Ghezzi's style is not particularly distinguished, he was highly prolific and of the vast number of caricatures he executed between 1700 and 1755, 3000 still survive. He was an amateur musician and many of his caricatures are of singers and musicians as well as of leading figures in Roman society, while others, like this one, are simply genre caricatures. Ghezzi's caricatures were widely circulated throughout Europe and were largely responsible for the spread of the art outside Italy.

57 ANNIBALE CARRACCI (1560–1609)
Opera Singers
pen and ink drawing

Although the Carraccis' simple, rapidly executed sketches of actual people are playful in intention and were drawn possibly as a form of relaxation, they are by no means careless. This caricature of an Italian singer and his wife is surprisingly solid and detailed; the draughtmanship, though powerfully rhythmic, is far from abbreviated. It does not have the deliberately 'childish' element we meet in the drawings of Bernini, or the graphic 'shorthand' style of Bracelli's Bizarrie.

58 GIOVANNI BATTISTA BRACELLI
Acrobatic figures, from Bizarrie di varie figure
c. 1624
etching

The widespread fashion in the late sixteenth and seventeenth centuries for treating the human figure in an abstract or schematic way is typified in a series of ornamental prints by Giovanni Battista Bracelli. This one shows two figures who are entirely made up of geometric instruments. The design cannot be described as caricature since there is no evident satiric intention, but it demonstrates how artists could look at men and their gestures abstractly so that any personage or event could be rendered by a ready-made graphic formula.

58

59 JACQUES CALLOT
Drunken Dwarf, Varie figure di Gobbi, *1622*
etching

Although Callot's gobbi were directly inspired by a group of real dwarfs, they are thematically related to Roman murals and other classical works rediscovered by Renaissance artists. Like such depictions, Callot's little drunken dwarf is not caricature in the strict meaning of the word since he is not an individual, but is rather one of a comic type.

59

60 FRANÇOIS DESPREZ
Figure from Songes Drolatiques de Pantagruel, *1565*
woodcut

This curious grotesque figure of a staggering drunken dwarf is not a caricature but a work of fantasy in the tradition established by Pieter Brueghel. Like Bracelli's work, its style broadened the graphic repertoire available to later caricaturists.

60

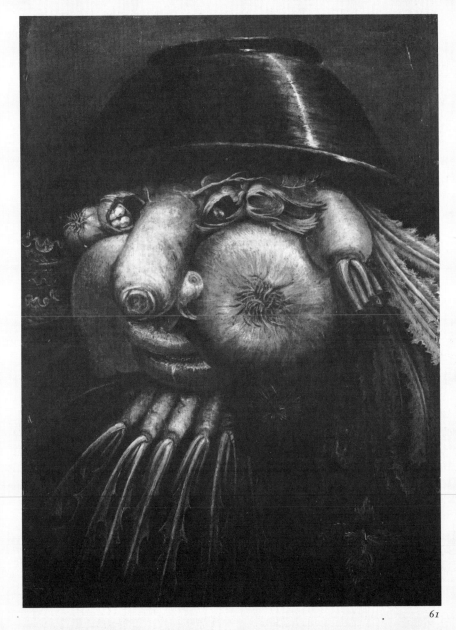

61

61 GIUSEPPE ARCIMBOLDO (1537–93)
Vegetable Man, c. 1590
oil on canvas

Arcimboldo's almost surrealist fantasy is a more elaborate affair than Desprez's quaint drolleries. This portrait of an old gardener, where the head is a conglomeration of different vegetables, is a typically Mannerist conceit – the various features actually become what they most

resemble. The rule of the game is that these resemblances must be discovered within the confines of a single appropriate category, in this case that of the kind of produce the subject of the portrait might be expected to grow. The long-established medieval fashion for monstrosities, which can be seen in prints depicting anatomical curiosities of all kinds, is obviously related to Arcimboldo's technique.

and graphic style so that caricature became a separate form of artistic activity, recognized on its own terms. One is the continuation and development of a kind of surrealist fantasy which makes an appearance in the sixteenth century with Francois Desprez's illustrations to the *Songes Drolatiques de Pantagruel* by Rabelais (1565), and finds its continuation in the grotesque heads of Arcimboldo, constructed of emblematic objects such as books or vegetables, in the *Bizarrie di varie figure* by Giovanni Battista Bracelli (*c.* 1624) and in the emblematic figures representing various trades by Nicolas de Larmessin. More human, and therefore more essentially humorous, are the figures of dwarfs by Callot and similar drawings by Stefano della Bella, both inspired by itinerant theatre groups and by the *commedia dell'arte*. These reflect not only the paintings of dwarfs and pygmies done in classical antiquity but the passion for these deformities which prevailed at the Grand Ducal court in Florence.

In Holland and in neighbouring Flanders the development of genre-painting also prefigured certain kinds of caricature that were to make their appearance in England during the next century. Tavern scenes by Adriaen Brouwer and David Teniers are a source for Hogarth, and brothel scenes by Jan Steen and other Dutch artists prefigure Hogarth, Gillray and Rowlandson.

Political satire also continued to appear, but only intermittently, since this was an age of absolutism. Artists were generally careful to attack only opponents who could not strike back in any practical way. Louis XIV's wars with the Dutch towards the end of the century inspired a number of bitter political caricatures, mostly directed at the king by such Dutch printmakers as Cornelius Dusart, Romeyn de Hooghe and Huguenot refugee artists. They include a series of scatological medals which pandered to the contemporary craze for medal-collecting. On those occasions when the king actually succeeded in laying hands on those who lampooned him, they could expect little mercy. In 1694, for instance, two men were executed for complicity in publishing a pamphlet which showed the statue of Louis XIV in the Place des Vosges in Paris surrounded by four women who were recognizably the royal mistresses La Vallière, Fontanges, Montespan and Maintenon, shown holding the king in chains.

47

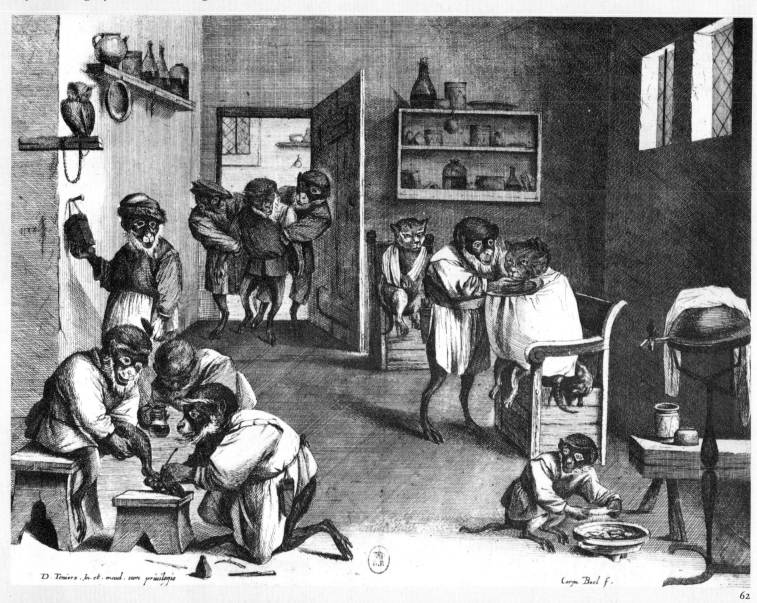

62

62 DAVID TENIERS THE YOUNGER (1582–1649)
The Monkey Barbers
engraving

The Flemish artist David Teniers is best known for his genre scenes, the style of which had some influence on such later caricaturists as Hogarth. This engraving, in which monkeys are cast as humans in a barber shop, follows a tradition of human-animal reversals that itself is as old as antiquity but which flourished particularly in the Middle Ages, when humorous graphic comment on the activities and foibles of human beings in this form was especially popular. In this example, the realistic depiction of the shop's interior and furnishings makes the serious-faced monkeys seem more than usually ridiculous. This work is also interesting in that a later caricature by Chardin is derived from it (p. 70).

Habit de Medecin.

A Paris Chez N. de Larmessin Rüe St Jacques, à la Pôme d'Or. — Avec Priuil. du Roy.

63

63 NICOLAS IV DE LARMESSIN (1684–1753)
*Physician's Dress, 1695
engraving*

Even after Arcimboldo's time,
the technique of constructing
a human creature out of
inanimate objects remained
popular with designers of
fantastic prints. This is one of
a fine series by the Frenchman
Nicolas de Larmessin, pub-
lished in 1695, which shows
figures of tradesmen, each
entirely constructed of objects
connected with his own par-
ticular activity. This physi-
cian's gown, for example,
incorporates not only the
works of Avicenna, Galen and
Hippocrates but also four
layers of other worthy
reference books.

Pub.d Oct.r 3.d 1818 by G.Humphrey, 27 St James's St.d

& — MONSTROSITIES

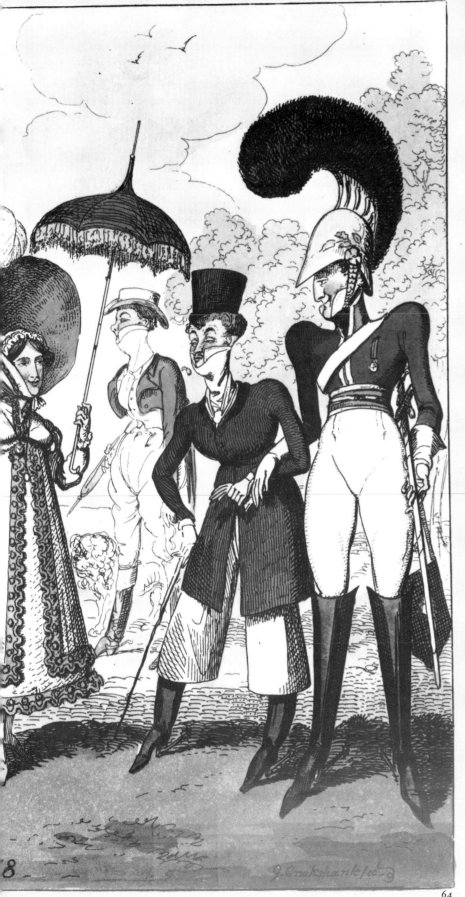

Caricature and the Beau Monde

Caricature was invented in Italy but it was in England during the eighteenth century that the graphic skills of the Italians were combined with the realist Dutch pictures of social content to form the modern cartoon. Throughout the century caricature became a recognized mode of public discourse. The reasons were partly traditional and partly political. England had long enjoyed greater freedom of expression than any other European country, since it had avoided monarchical absolutism. This, coupled with a series of turbulent political events and a popular need for information and comment, fostered the growth of caricature as we know it today. No subject was anathema: all phases of everyday life, all social classes, occupations and events were potential victims.

For all this, the taste for this artistic mode of political and social comment developed slowly, at least during the first half of the century. In the seventeenth century the Dutch king William III brought over with him a few artists, such as Romeyn de Hooghe, who already specialized in political satire. For the most part the satire was rather obviously and clumsily allegorical. They found little employment for their satirical talents in the England of the time. A little later the mysterious Francis Le Piper was apparently showing personal caricatures based on the Italian model in London coffee-houses.

It was not until the 1720s that the financial scandal of the South Sea Bubble gave a fresh impulse to graphic satire. From 1730 onwards there was a continuous production of satirical images, which became almost as important and interesting as the newspapers and pamphlets which commented on public events. Political caricature had not as yet, however, joined forces with written journalism, and examples were seen and

purchased separately at the shops of professional dealers in prints.

The English political caricaturists of the early eighteenth century relied more upon allegory than on skilful portrait caricature. They made use of a long-established corpus of traditional symbolism, built up in the course of the sixteenth and seventeenth centuries by a persistent interest in emblems – that is, visual representations of certain abstract ideas or qualities such as charity or matrimony. Collections of these symbols were published in emblem books. One such book, used as a source by many English caricaturists, was Cesare Ripa's *Iconologia*. The first appeared in Rome in 1593, but was not published in England until 1709. By the middle of the eighteenth century the traditional stock of emblems began to be augmented with newer ones. It was at this time, for example, that Britannia established herself as a firm favourite with political caricaturists.

The most important maker of satirical prints in the first half of the eighteenth century is indisputably William Hogarth, but he occupies a somewhat isolated position. He was a brilliant engraver, who used this medium in preference to others, while his successors were etchers. And he seldom dabbled in politics or in personalities.

Hogarth was, nevertheless, unrivalled as a commentator on the manners and morals of his time. His most famous series, *A Harlot's Progress* and *A Rake's Progress*, not only conjure up a whole panorama of eighteenth-century life but pass judgement on what is shown. Hogarth claimed that his works had nothing to do with 'that modern fashion, caricature'; he called them instead 'modern moral subjects', and further stated: 'I have endeavoured to treat my subjects as a dramatic writer; my picture is my stage, and men and women my players, who by means of certain actions and gestures, are to exhibit a dumb show.' The framework Hogarth used was one created for him by the Dutch genre-painters of a hundred years earlier, refined by a French Rococo influence. But it is the willingness to judge, and to guide the spectator's judgement, that marks Hogarth off from an ordinary genre painter. Under an apparently naturalistic surface, his prints and paintings are often moral emblems, one of the most important aspects of caricature, and one which is, for example, fulfilled equally well by Daumier.

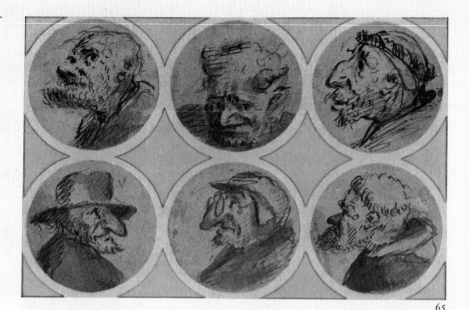

65

66

previous page
64 GEORGE CRUIKSHANK (1792–1878)
Dandies of 1817 & Monstrosities of 1818
coloured engraving

This is one of eight plates by Cruikshank satirizing the absurd fashions of his time as 'Monstrosities'. Along with the other plates in the series the setting is Hyde Park where London's fashionable society went to see and be seen. Obsession with fashion pervaded English upper-class life in this period after the Napoleonic Wars and reached its most ludicrous and extreme in the apparel (and manners) of the English dandy. A visitor to England, the Prussian prince Pückler Muskau, observed that 'the greatest triumph of the English dandy is to appear with the most wooden manners . . . to have the courage to offend against every restraint of decorum . . . to treat his best friends if they cease to have the stamp of fashion as if he did not know them'. Graphic satirists found them an easy target and Cruikshank, with James Gillray, William Heath and Thomas Rowlandson, produced a number of amusing prints on them. This one shows Cruikshank in his most refined style.

65 FRANCIS LE PIPER
(d. 1695)
*Study of Six Grotesque
Heads*
pen, ink and wash

These crudely executed
drawings by Le Piper,
based on Italian models,
were probably the first
personal caricatures to
appear in England at the
end of the seventeenth
century. Le Piper, an
amateur artist of Walloon
descent, was well-educated
and widely travelled and
appears to have spent
much of his time sketching
and making caricatures in
the taverns of Bermondsey.
Little of his work has
survived.

66 WILLIAM HOGARTH
(1697–1764)
*The Rake's Progress, Plate
8*, 1735 (retouched by
Hogarth 1763)
engraving

This is the last of eight
plates in the didactic,
satirical narrative cycle (on
what Hogarth called
'modern moral subjects')
that illustrates the life of
Tom Rakewell, a young
man who falls hopelessly in
debt through gambling and
dissipation, saves himself
by marrying an old maid
for money but inevitably
finds himself in a debtors'
prison and finally a mad-
house, comforted by his
mistress and surrounded by
lunatics, and viewed as an
exhibit by the well-dressed
tourists.

67

67 WILLIAM HOGARTH
Characters and Caricaturas, 1743
etching

This is possibly the most famous print in
the history of caricature. Hogarth later
explained his thinking thus: 'Being
perpetually plagued for the mistakes made
among the illiterate, by the similitude in
the sound of the words character and
caricatura I ten years ago endeavoured to
explain the distinction in the above print
. . .'. Hogarth regarded his figures as
'characters' not caricatures, and here
shows different types of heads for

comparison, notably those of Raphael
with the caricature drawings of Ghezzi,
Annibale Carracci and Leonardo. On the
print itself Hogarth refers the viewer to
Fielding's Preface to Joseph Andrews.
Fielding, the first to define this difference
in print, said that characters 'consist in
the exactest Copy of Nature . . . Whereas
in Caricatura we allow all Licence . . . and
all Distortion and Exaggeration are within
its proper Province.' In fact, the distinction
is not so easily discernible in this print of
Hogarth's, while in his other engravings
he makes frequent use of the caricature
of both faces and attitudes.

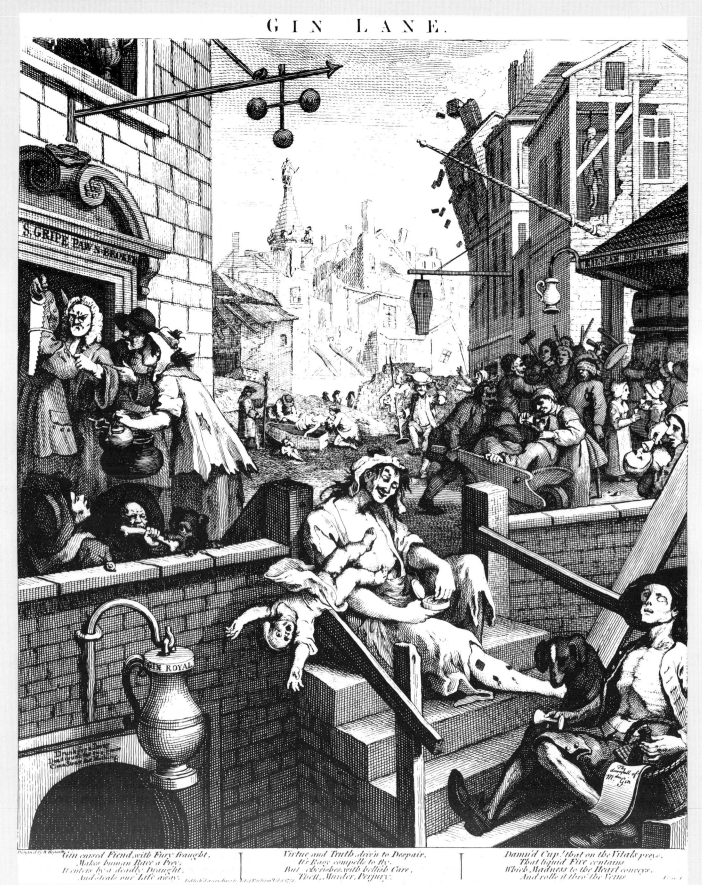

68

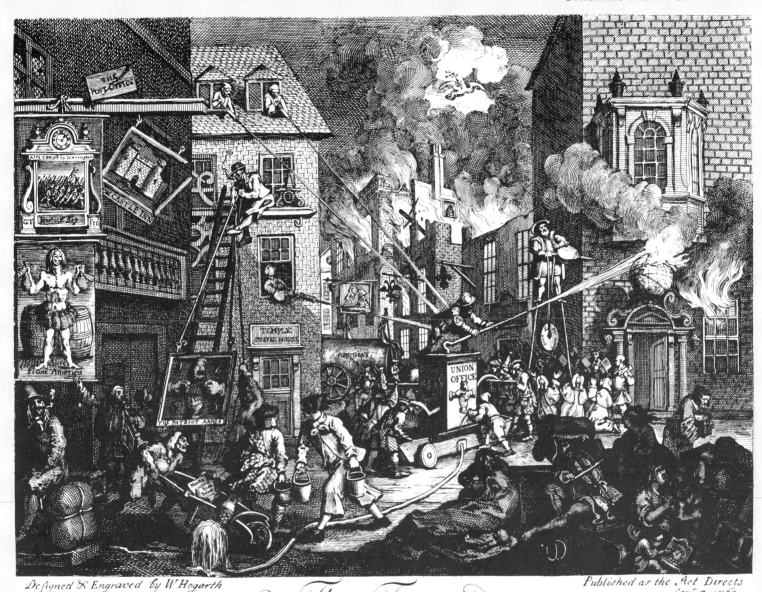

Defigned & Engraved by W Hogarth

The Times
Plate I

Published as the Act Directs
Sep.ᵗ 7 1762

69

68 WILLIAM HOGARTH
Gin Lane, 1751
engraving

This is another of Hogarth's best-known
engravings. The setting is laid in a slum street of
St Giles in Westminster. The central figure, a
drunken woman with syphilitic sores on her legs,
drops her baby in order to take a pinch of snuff
as she sits on the steps leading to the gin cellar
with its flagon emblem Gin Royal and the
characteristic inscription, 'Drunk for a Penny,
Dead drunk for Twopence, Clean Straw for
Nothing.' At the foot of the steps sits a dying (or
dead) gin-and-ballad-seller. Under the pawn-
broker's sign, Gripe, the owner, is taking a car-
penter's saw and coat as a pledge for gin money,
while a housewife waits to pawn her household

utensils. In the background a naked woman is
being buried and in the barber's shop (indicated
by the pole) the barber has hanged himself,
perhaps because there is no need for his services
in Gin Lane. The gin merchants on the right,
Kilman's Distiller, are, however, doing roaring
business. All these details, powerfully juxta-
posed, combine to make up one of the most
savage of all Hogarth's prints.

69 WILLIAM HOGARTH
The Times Plate I, 1762
engraving

This print, Hogarth's most important political
cartoon, was in conflict with public opinion
because of its support for Lord Bute, George
III's close adviser and prime minister: the

popular vote was firmly behind William Pitt the
Elder and his war party who wished to continue
the war with France. Hogarth's complex design,
filled with emblematic detail, was a protest
against warmongering and those factions who
sought to disrupt the peace negotiations then in
progress. Hogarth uses a burning street to
signify the flames of war. The chief fireman on
the fire engine is the King, whose efforts to
extinguish the flames are obstructed by Pitt
standing on the stilts of popularity and blowing
the flames with bellows. In the foreground,
among others, is Frederick of Prussia who
gleefully plays the fiddle as the street burns. This
print's publication caused a public outcry
(indicating Hogarth's power as the foremost
printmaker of his day) and Hogarth was bitterly
attacked for it.

55

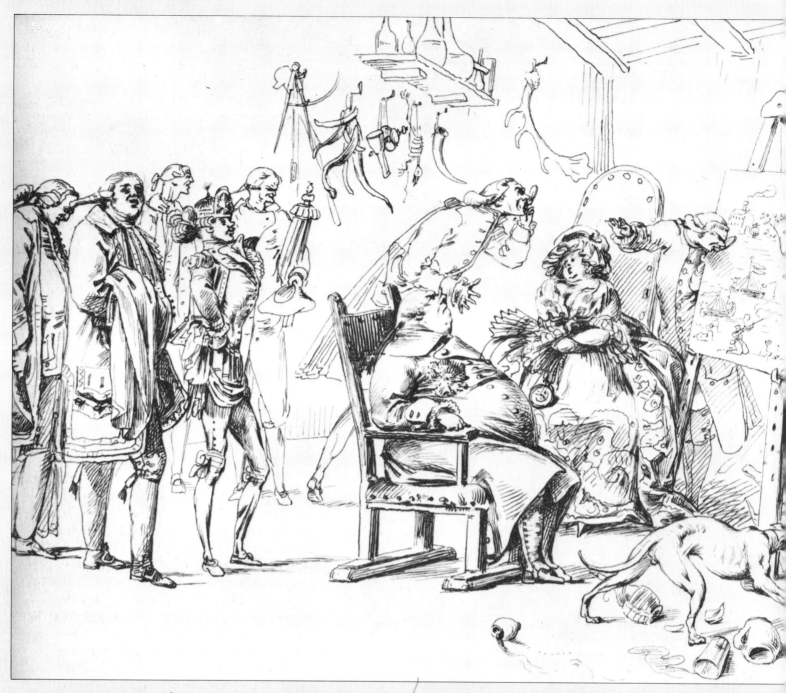

70 PIER LEONE GHEZZI (1674–1755)
An Artist's Studio
pen and ink drawing

Although a minor artist in comparison with his contemporary, G.B. Tiepolo, Ghezzi was probably the first caricaturist to make a living by producing pen portraits of important members of Roman society and visitors to Rome. His distinctive drawing style was particularly suited to engravings and, although he himself never engraved his works, others did, notably the English printmaker Arthur Pond. Pond's collection of twenty-five caricatures after original drawings by a number of artists was published in about 1740, and was largely responsible for familiarizing both amateur and professional artists with this hitherto exclusively Italian genre; a flood of imitations quickly followed.

71 JAMES GILLRAY
From Sir William Hamilton's Collection, 1801
coloured etching

This caricature by Gillray ingeniously combines a number of themes: one is to do with men's fashion, but the real joke is in making the man's shape like that of a Greek vase. The title alludes to the husband of the famous Emma Hamilton, a sometime ambassador to the Kingdom of the Two Sicilies and an enthusiastic collector of classical antiquities.

72 GEORGE, MARQUESS OF TOWNSHEND (1724–1807)
The Distressed Statesman, 1761
pen and ink drawing

Horace Walpole claimed that Lord Townshend was the first person in England to make caricatures of political figures and their causes in which the individuals themselves were satirized.

71

The Distrefsed Statesman.

70

72

Although clearly amateurish, and displaying little technical facility, Townshend's drawings are in the same tradition as the caricatures of Zanetti, Ghezzi and others of the Italian school, with whose work Townshend was obviously familiar. This caricature of William Pitt was one of many by Townshend which had a wide circulation.

More than this – in some of his more complex compositions (*Gin Lane* is a case in point) Hogarth breaks through the unity of action expected of a representational artist and fills his stage with events that have no apparent logical connection, but a purely symbolic one. Allegory is thus transformed to meet the needs of a new age, and the caricaturist's technique of irrational juxtaposition is given a fresh lease of life.

Hogarth did venture into the political field intermittently. He satirized those involved in the South Sea Bubble speculation, and defended Lord Bute's unpopular ministry in *The Times Plate I* – a print vehemently criticized by the radical, John Wilkes, who was later roughly handled by Hogarth in an engraving. He also made designs attacking Walpole and the court, and many of his social satires, such as the *March to Finchley*, contain obvious political allusions.

In 1740 English caricature had in any case started to change direction. Between 1737 and 1739 Arthur Pond published a successful album of twenty-five caricatures containing reproductions of works by the Caraccis, Ghezzi (fourteen of these), Guercino, Watteau and others. This made Italian caricature available to a cultivated audience in England – those noblemen, for example, who had made the Grand Tour, who understood the aesthetic theory which inspired the Bolognese and Venetian caricaturists, and who had already seen such caricatures in Italy. Hogarth was not best pleased by the sudden fashion for Italian-style caricature. His print *Characters and Caricaturas*, published in 1743 as a subscription-ticket for his *Marriage à la Mode* series, was intended as a reply to Pond. In it Hogarth contrasts three heads – one of them extremely grotesque and two nobly idealised – taken from the Raphael Cartoons, those touchstones of history painting, with caricatures borrowed from Ghezzi, Carracci and Leonardo. Filling the space above these is a great crowd of contemporary portrait heads expressing different varieties of character. Hogarth intended the design as a visual proof of the legitimacy of comic history-painting as a part of history-painting in general. He also meant to demonstrate the difference between his own practice, which was to concentrate on expression and never to stray beyond the frontiers of verisimilitude, as opposed to the models recommended by Pond. The deliberately

57

73 WILLIAM HOGARTH
*Credulity, Superstition
and Fanatacism, A
Medley, 1762
engraving*

Hogarth's chief targets
in this print are the
Methodists and the
preaching of hell and
damnation. The imagery
is complex, indicating
that the composition is
meant to be studied at
leisure. Hogarth attacks
not only religious
excess but sorcerers and
swindlers as well: there
are allusions to the
Cock Lane ghost which
caused a stir in mid-
Georgian London, to
one William Perry who
falsely accused an old
woman of having be-
witched him, and to
Mary Toft who claimed
that she had given birth
to several litters of
rabbits. The preacher is
the Methodist George
Whitfield who wears a
harlequin's costume
under his cassock and a
Jesuit's tonsure under
his wig; and the thermo-
meter gives the tem-
perature of his congre-
gation which can rise to
convulsions and mad-
ness. Hogarth's print is
about humbug and
chicanery and combines
allegory with realism.
As a moral satirist
Hogarth is not in-
terested in the aesthetic
unities but with con-
sistency of conduct, and
his engravings have to
be read, detail by
detail, rather than
contemplated as works
of art.

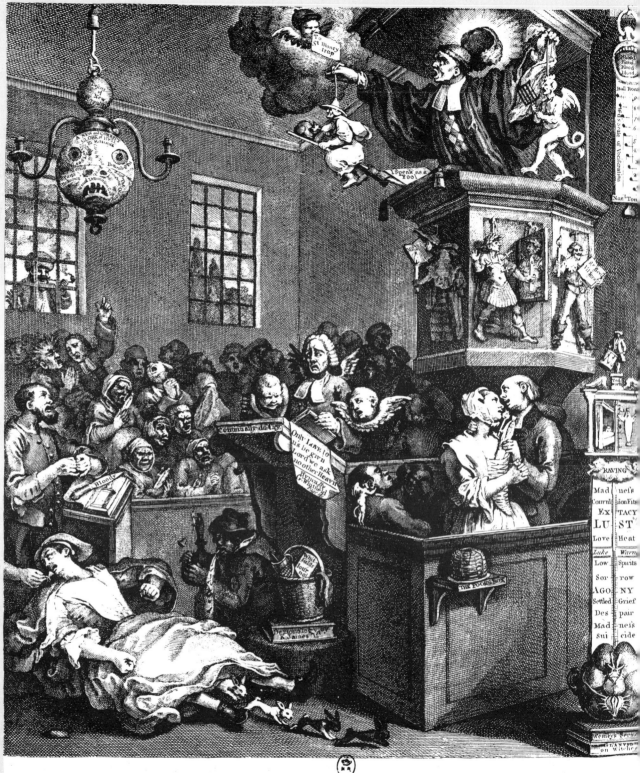

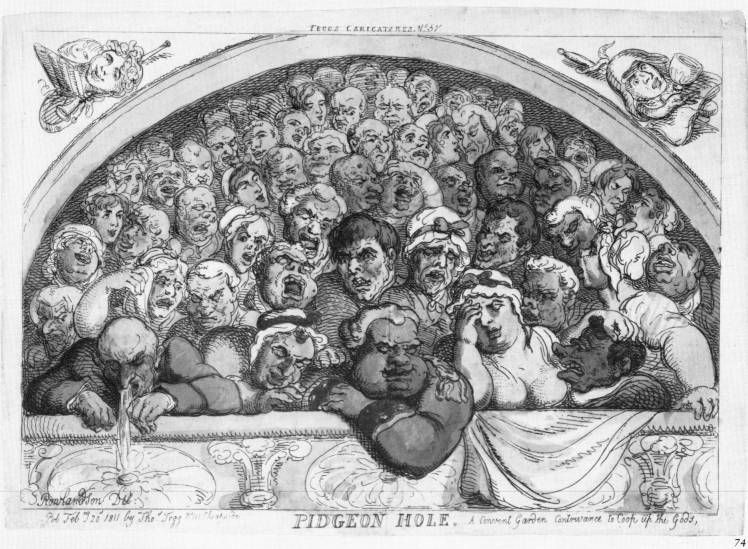

TEGGS CARICATURES. No 57

PIDGEON HOLE. *A Convent Garden Contrivance to Coop up the Gods,*

74

75

74 THOMAS ROWLANDSON
Pigeon Hole, 1811
coloured etching

Rowlandson's caricature is a comment on the conditions at the new Covent Garden theatre, whose reopening in September 1809 was followed by a series of violent public riots. Overcrowding, always a problem, was one of the many issues in dispute. The pigeon holes were the lunettes at each end of the theatre's top gallery, and Rowlandson depicts his audience overcome by heat, discomfort and suffocation. Public outrage first focused on the increase in pit and box prices, but in the resulting well-organized Old Price Riots the issues multiplied to include not only the overcrowding of pigeon holes but the abolition of private boxes and the banning of foreign singers who demanded outrageously high fees. After a climax of fury was reached, and many people were arrested, the actor-manager Kemble capitulated to the public. Among other concessions, he promised to raise the height of the roof above the pigeon holes.

75 SIR JOSHUA REYNOLDS (1723–92)
Sir Wm Lowther and Joseph Leeson, 1751
oil on canvas

Sir Joshua Reynolds, the great defender of the classical approach to painting, executed not only a number of caricature sketches but a series of caricature paintings, the most ambitious of which was The School of Athens, which showed twenty-three members of the British community in Rome arranged like those in Raphael's famous fresco. This is a repetition of one of the groups in that work. There is, however, a displeasing and uncomfortable quality about the caricature which perhaps lies in the fact that it is a painting, not a drawing. Reynolds himself was aware of this danger when he stated, 'From a slight undetermined drawing, where the ideas of the composition and characters are . . . only touched upon, the imagination supplies more than the painter himself could possibly produce; and we accordingly often find that the finished work disappoints the expectation that was raised from the sketch.'

76 EUGÈNE DELACROIX
(1798–1863)
*English Troops, Country
Baggage, July 1813*
engraving

*It is scarcely surprising that
the young Delacroix, the son
of a foreign minister under
the Directoire, should view
the English Peninsular Army
with distaste, and yet,
despite the bedraggled uni-
form and the rifle and
bayonet serving as a washing
line, he shows a certain
reluctant admiration in his
depiction of the weary,
dogged face of this infantry-
man, Wellington's 'scum of
the earth enlisted for drink'.
This soldier could well have
served in Spain since 1809,
accompanied by his now
care-worn camp follower
carrying yet another child,
and learnt to survive the
hard way. Delacroix's cari-
cature is particularly well
observed – there can be no
doubt that this is a faithful
exaggeration of the appear-
ance of such English troops –
and the title contains a neat
punning reference to this
soldier's female companion.*

76

LA FAMILLE ANGLAISE A PARIS.

Le Suprême Bon Ton, Nᵒ. 11.

A Paris chez Martinet, libraire, rue du Coq St. Honoré.

77

78

77 MARTINET
An English Family in Paris Le Suprême Bon
Ton No. 11, 1820
coloured engraving

*Race, class and nationality – those bitterly
divisive factors – have long been inescapable
subjects for the caricaturist who, in his
treatment of them, shows himself to be at
least as prejudiced as any of his fellows. So
fundamental is our suspicion of people from
different countries and cultures, or even from
a different part of the social hierarchy, that
these themes are found in every culture and
at every period. This French caricature of
1820, for example, is elegantly scathing about
a boorish English family in Paris. Their
lumpish, bovine faces are neatly juxtaposed
with the chic, slightly startled Parisian
figures.*

78 WILLIAM HOGARTH
*O the Roast Beef of Old England ('Calais
Gate'), 1748*
oil on canvas

*In England, caricatures expressing xeno-
phobic sentiments are almost as old as the art
itself, and nearly all major English carica-
turists have asserted a native superiority over
all comers. The trait is especially prominent
in Hogarth and Gillray, and nowhere more
so than in this painting of 1748 by Hogarth,
whose declared aim was to convey to his
countrymen 'the striking difference between
the food, priests etc. of two countries so
contiguous that on a clear day one coast can
be seen from the other'. Hogarth spared no
detail in denigrating the French to accom-
plish this aim. 'To sum up,' he said,
'poverty, slavery and innate insolence
covered with an affectation of politeness,
give you even here a true picture of the
manners of the whole nation'.*

'childish' element in classic Italian caricature inevitably inspired amateur artists to try their hands at it, and the ability to make drawings of this kind became a valued social accomplishment, like the ability to dance, or fence, or make polite conversation.

One such amateur was George Townshend (1724–1807), the fourth Viscount and the first Marquess Townshend who, according to Horace Walpole, was the first to apply portrait caricature to politics. In contrast to most previous satirical prints which had been engraved, Townshend's drawings were usually little more than outline sketches, and were most suitably reproduced as etchings. The freedom and lightness of his style of graphic satire were to influence many caricaturists who followed him.

Hogarth's two most important successors in late eighteenth-century England, Thomas Rowlandson and James Gillray, develop different aspects of his art. Rowlandson presents a lively panorama of contemporary life, commenting on men's foibles with exuberant humour and a sharp sense of the ridiculous. He is Hogarth's direct successor as a social satirist and the range of his subjects was enormous. His *Box Lobby Loungers*, for example, gives him the opportunity savagely to mock the theatre and fashionable theatre-goers of his day. But he is, perhaps, more frivolous than Hogarth, less interested in establishing a moral centre. When he takes over the old convention of the Dance of Death, with its strongly moralistic overtones, he seems fascinated by the grotesquerie of the image rather than by its potential horror. However, his elegant style, which owed much to the Rococo, and the delicacy of his watercolours brought a refinement to caricature which influenced later artists in both England and France.

Gillray, unlike Rowlandson, is a powerful political satirist, less light in touch and less light-hearted. His caricatures are not only crowded with elaborate inscriptions in order to make their meaning plain, but contain a mixture of emblematic images and portrait caricature. *The Plum-Pudding in Danger* (1805), for example, depicts a sharp-nosed Pitt and 'Little Boney', dwarfed by his hat, carving up the world in the form of a plum-pudding. Pitt holds his portion with a trident, a symbol of England's naval power. Independent of any party or cause, Gillray ridiculed both Whig

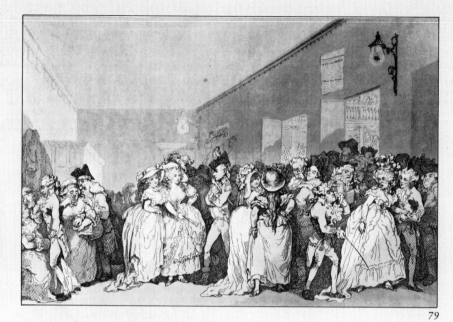

79

FASHIONABLE CONTRASTS; – or – The Duchess's little Shoe yielding to the Magnitude of the Duke's Foot.

80

79 THOMAS ROWLANDSON
Box Lobby Loungers, 1786
coloured engraving

From the mid-eighteenth century to the end of the nineteenth the great theatres were the universal metropolitan gathering places. They were a social microcosm, the places where members of all classes came to see and be seen – the poor in the pit and upper galleries, the prosperous in the tiers of boxes. London theatre was, however, disorderly; the audience believed it was their right to comment loudly on the play, while in the foyer rakes, beaux, courtesans and, as here, even an old procuress with her playbills and basket of fruit would frequent the theatre for purposes connected with another kind of play.

80 JAMES GILLRAY
Fashionable Contrasts, 1792
hand-coloured etching

This print is unusual in that it lacks faces, the essential ingredient in a vast number of caricatures. Gillray has used the caricaturist's prerogative of selective representation, to startling and elegant satirical effect. The print refers to the Duke of York's marriage to a Duchess whose most distinguished feature, it was widely agreed, was her small feet.

81 THOMAS ROWLANDSON
Frontispiece to The English Dance of
Death, *1816*
coloured engraving

*Rowlandson's interpretation of the Dance
of Death is a particularly interesting one.
Although his themes often include sinister
and even repulsive images, his rollicking
humour and sense of the ridiculous would
seem to preclude a moralizing and
didactic treatment in the traditional style
of the Dance of Death. In fact, Rowland-
son wisely rejects the universality and
levelling nature of Death as a theme and
instead takes as his subject the situations
in which Death appears. This anecdotal
and narrative approach deals with such
characters as maiden ladies, the antiquary,
the quack and the coquette, rendered in
his exuberant and flowing lines and
decorative use of colour. This image of
Death seated on a globe may be an
inverted reminiscence of the Last Judge-
ment in Holbein's* Dance of Death, *where
Christ sits on a rainbow resting his feet
on the universe.*

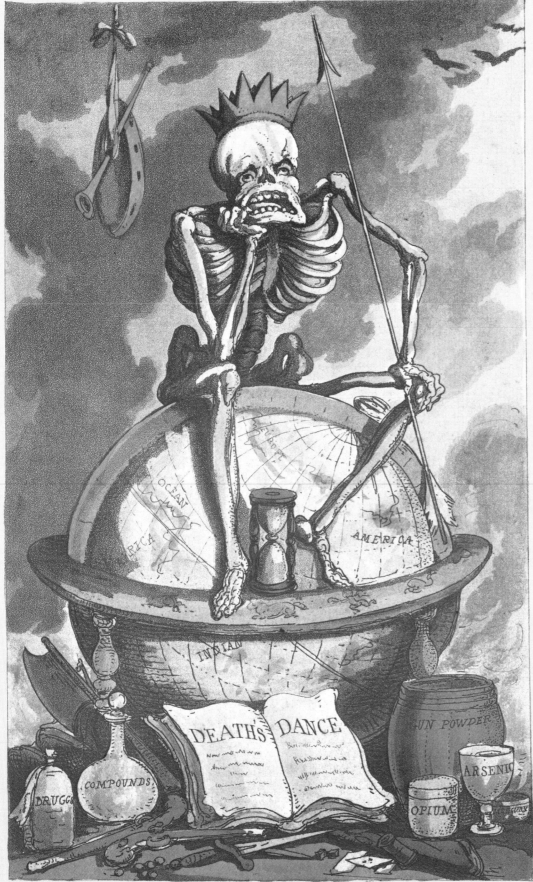

81

63

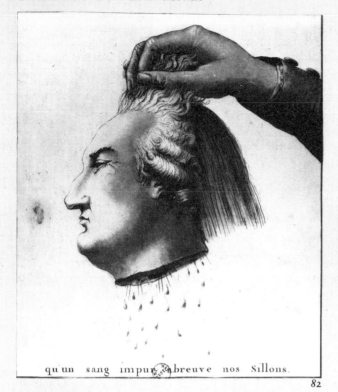

qu'un sang impur abreuve nos Sillons.

82

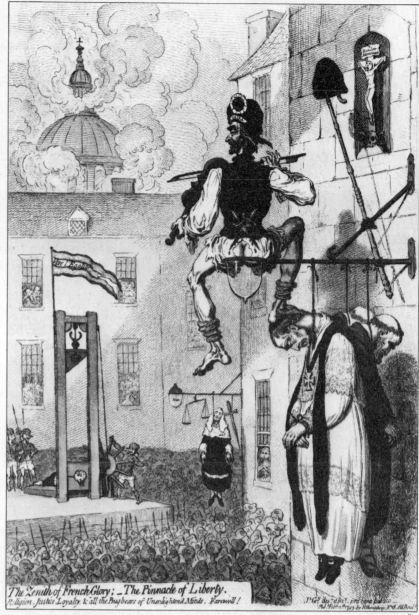

83

82 VILLENEUVE
'Matière à réflexion pour les jongleurs couronnés', 1793
engraving

French caricatures during the Revolution were, naturally
enough, concerned with applauding the course of events, for
however much the Reign of Terror from November 1793 to
July 1894 (in which 2600 people were guillotined in Paris alone)
may have appalled various sections of the population, it was
wiser and safer to keep quiet. This particularly sinister carica-
ture depicting the severed head of Louis XVI carries a warning
in its title 'Matter for reflection by other royal jugglers'; the
legend is a line from the Marseillaise, 'what an impure blood
courses through our veins'.

83 JAMES GILLRAY
The Zenith of French Glory, 1793
etching

Gillray, like many of his liberal-minded contemporaries in
England, was at first sympathetic to the aims of the French
Revolution but by 1792 he was disillusioned. The Zenith of
French Glory depicts, in the foreground, a ragged, bare-legged
sansculotte seated on a lantern bowl playing a fiddle and
looking with smiling triumph on the scene below; beside him
are the strung-up figures of a priest and monk. The King's
head is on the guillotine and a grinning sansculotte hauls at
the wheel which releases the blade on which is a crown; from
the guillotine flies a tricolour inscribed Vive l'Egalité. Gillray
has labelled this caricature 'A View in Perspective'. We are
intended to take it both literally and as an admission that the
noble principles of the Revolution have been abandoned.

RARE ANIMALS; OR, THE TRANSFER OF THE ROYAL FAMILY FROM THE TUILERIES TO THE TEMPLE. (Champ-
fleury, 1792.)

84

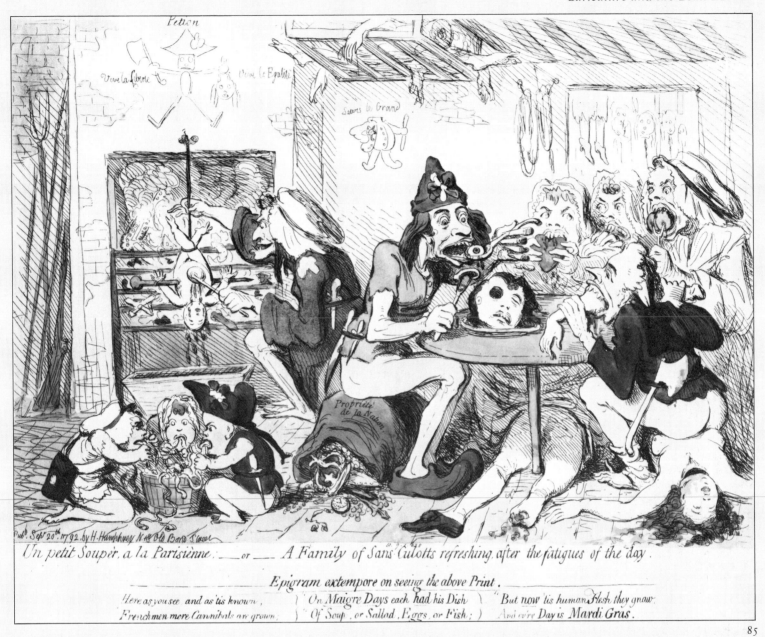

Un petit Souper, a la Parisiènne: — or — A Family of Sans Culotts refreshing, after the fatigues of the day.

_____ *Epigram extempore on seeing the above Print.*

Here as you see and as 'tis known, } *On Maigre Days each had his Dish* } *But now 'tis human Flesh they gnaw,*
Frenchmen mere Cannibals are grown; } *Of Soup, or Sallad, Eggs, or Fish;* } *And ev'ry Day is Mardi Gras.*

85

84 ANON.
French Royal Family Driven from the Tuileries to the Temple,
1792
engraving

The Revolution was not originally anti-monarchical but
became so after the royal family's attempted escape to
Varennes in June 1791 and after the King's insistence on
vetoing anti-clerical legislation, even though he had accepted
the constitution limiting his authority. After the Tuileries was
attacked in August 1792 the royal family was imprisoned in the
Temple. This caricature, which is typical of the way the
monarchy was viewed at this time, depicts them as a flock of
rare beasts.

85 JAMES GILLRAY
A Family of Sansculottes Refreshing after the Fatigues of the
Day, 1792
etching

This is one of the first of Gillray's prints on the excesses of the
French Revolution and, like The Zenith of French Glory, it was
one of a series that contributed much towards the hatred with
which the English people were to look upon the Revolutionar-
ies. It was inspired by the horrible massacres perpetrated by
the Parisian mob in September 1792 and is the most unre-
strained and macabre of all Gillray's caricatures of the
Revolution. It is as effective as it is disagreeable and repellent.

86 ANON.
A Little Man Alarmed at his own Shadow,
1803
engraving

This patriotic caricature was probably
produced just after the British declared war
on France in May 1803. Despite the Amiens
peace treaty between the two nations in
March 1802, Napoleon had continued his
expansionist policies and by the beginning of
1803 commanded the coastline from Genoa
to Antwerp. Britain, alarmed, demanded his
withdrawal, which was in effect an ulti-
matum. This caricature depicts Napoleon,
his knees flexed with terror, looking over his
shoulder at his own elongated shadow.
Particular emphasis is laid on his small
stature, a feature Gillray was to exploit so
savagely with his 'little Boney'.

87 ANON.
Departure for the Army, 1814
engraving

This caricature takes an ironic view of
Napoleon's last stand against the Allies in
March 1814. Mounted on the skeleton of a
horse with the symbol of his glory, the
eagle, now tattered and emaciated, he
brandishes a thunderbolt, declaring 'I am
going to fight my enemies. Raise 500,000
men' – a reference to his now-decimated
Grande Armée. By this time Napoleon's
views were no longer those of the French
nation, and even as he was outside Paris
with his army, with little hope of defeating
the overwhelmingly superior Allies, the
French, desperate for peace, had already
begun talks with the enemy.

88 ANON.
Napoleon after the Battle of Leipzig, 1813
engraving

This caricature shows Napoleon with
broken teeth, attempting to crack an im-
penetrable nut labelled 'Leipzig'; supporting
his pedestal are the bones and skulls of his
defeated army. The Battle of Leipzig was
Napoleon's greatest débâcle since he came to
power. His Grande Armée suffered heavy
losses at the hands of the forces of the
Austrians, Russians and Prussians, who out-
numbered Napoleon's troops by two to one.
Deserted by his allies, the Saxons, Napoleon
eventually withdrew to the Rhine with only
70,000 men, many of whom had typhus. By
this time discontent with Napoleon's regime
was being frequently voiced in France, and
many anonymous caricatures like this one
were in circulation.

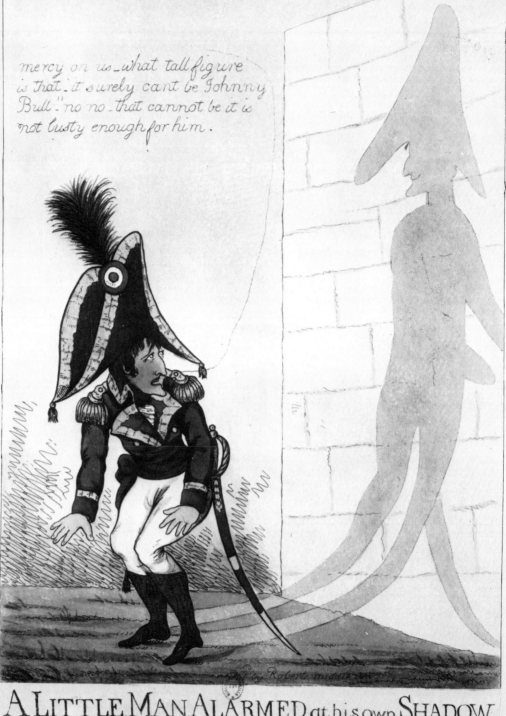

mercy on us _ what tall figure
is that _ it surely cant be Johnny
Bull " no no _ that cannot be it is
not lusty enough for him.

A LITTLE MAN ALARMED at his own SHADOW

86

66

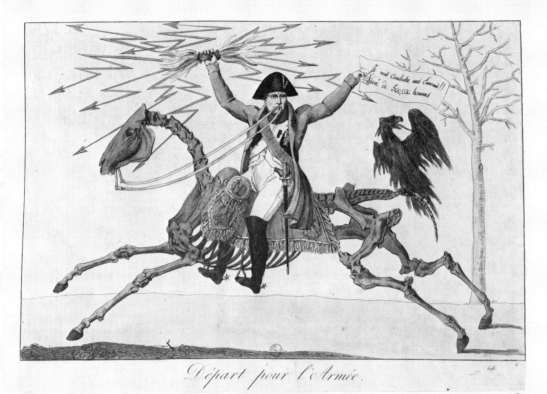

Départ pour l'Armée.

87

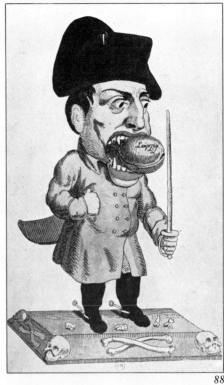

88

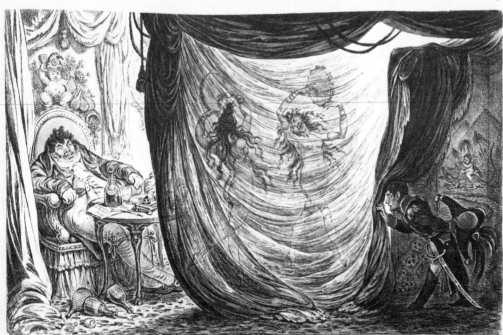

89

89 JAMES GILLRAY
Ci-devant Occupations, 1797
etching

One of the most famous of Gillray's
Napoleonic caricatures, Ci-devant Occupa-
tions *refers to the story that Napoleon was
allowed secretly to watch Mme Tallien and
the future Empress Josephine dance naked
before Barras, the chief man of the Directory
whom Bonaparte was eventually to replace.
The scene is drawn in Gillray's most elegant
style: the dancing nudes seen behind a
transparent curtain are worthy of Rowland-
son. Gillray convinces us that even this
trivial incident is worthy of public attention,
particularly when it provides the opportunity
for a piece of gratuitous spite against
Napoleon's wife (a subject about which
Napoleon was especially sensitive). Gillray
has, of course, taken a number of liberties:
the date given in the caricature is clearly
absurd since Napoleon's marriage and
promotion took place in March 1796; and
the use of crocodiles and pyramids is a
further absurdity since Napoleon was not in
Egypt until 1798.*

and Tory politicians with equal venom and was probably the first artist to make a career out of political cartooning.

The increasing enthusiasm for caricature in England was stimulated by the outbreak of the French Revolution and by subsequent English involvement in the Napoleonic Wars. In 1796 the *Morning Chronicle* complained that 'the taste of the day leans entirely to caricature. We have lost our relish for the simple beauties of nature . . . we are no longer satisfied with propriety and neatness, we must have something grotesque and dispro-portioned, cumbrous with ornament and gigantic in its dimensions.'

In Gillray's hands caricature became a weapon for political propaganda. Crowds gathered outside his publisher's window whenever a new print was put on view. 'It is a veritable madness,' noted a French emigré living in London. 'You have to fight your way in with your fists.' Another visitor to London, a German who arrived in 1803, noted that the established daily routine of an English man of fashion included a visit to Tattersall's, the horse-dealers, and another to the print-shops.

The French Revolution and what followed en-couraged the caricaturists, and Gillray in particular, to create a kind of mythology centred upon certain figures, often allegorical, but some-times living persons. Napoleon and Wellington were both subject to this process, and English caricature built up the myth of the little Corsican even as it derided him.

Italian caricature failed (with one exception) to renew itself in the eighteenth century. G. D. Tiepolo (1727–1804), the son of the great Giovanni Battista, created, apparently for his own amusement and that of his family, a series of large format drawings entitled *Le divertimenti per gli ragazzi* – Amusements for Children. The drawings deal with the life and death of the *commedia dell'arte* character Pulcinella, and the younger Tiepolo uses him like a mirror set at an angle, to reflect various facets of Venetian life. He also mocked the art of his time. G. D. Tiepolo did not scruple, for example, to poke fun at his great father. The scene showing the marriage of Punchinello's parents is a recognizable parody of the *Marriage of Barbarossa* painted by Giovanni Battista. The *Divertimenti* are a brilliant sunset, a farewell to the idea of carica-ture as a private amusement for intelligent and

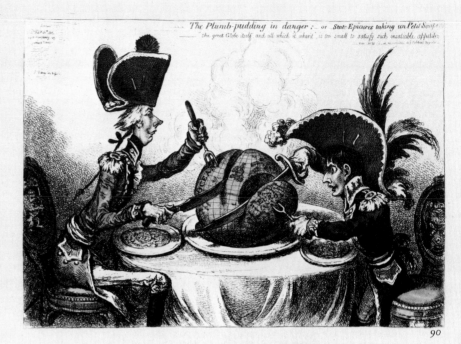

90

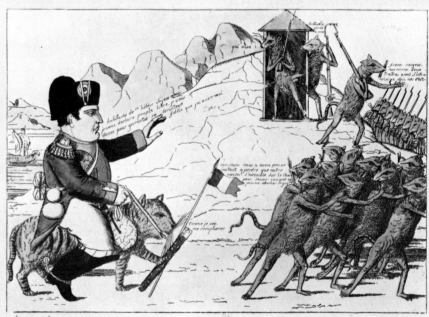

91

90 JAMES GILLRAY
The Plum-Pudding in Danger, 1805
hand-coloured etching

One of Gillray's most inspired caricatures, this refers to Napoleon's peace moves in January 1805 in which he suggested that England and France could share world power. Gillray presents the idea literally, showing Pitt carving his portion which he holds securely with a trident, the symbol of England's naval power. 'Little Boney', the caricature of Napoleon that Gillray had created in 1803, half stands to cut the pudding with a sword.

91 ANON.
The Triumphant Entry of Napoleon into his New Kingdom, St Helena, 1815
coloured engraving

Virtually no caricatures of Napoleon appeared in France during his reign, but only after his power was waning. This one, depicting him going into his final exile, shows Napoleon mounted on a cat offering liberty to the island's rat popula-tion which, as the legend states, 'takes flight at the sight of their new ruler'.

92 WILLIAM HEATH
(1795–1840)
The Prime Lobster, 1828
coloured engraving

Although animal caricatures are rarely complimentary, there is perhaps a certain reluctant admiration to be found in this caricature of the Duke of Wellington as a lobster ferociously waving its claws. Wellington is depicted with the Chancellor of the Exchequer's gown on his back, while his cocked hat and sword are on the ground. Wellington had just become prime minister of a Tory government but wished to retain the office of commander of the army. The cabinet was against it and in his absence voted on 25 January 1828 that he should resign the office, voicing the Whig contention that a military prime minister was unconstitutional. Impetus was given to this line of attack by Wellington's obduracy on such issues as Catholic Emancipation (he had resigned the government on this issue in 1827) and parliamentary reform (of which he was a strong opponent). 'Lobster' was a contemptuous term for soldier. Wittingly or unwittingly, this caricature conveys something of the old soldier's staunchness of character.

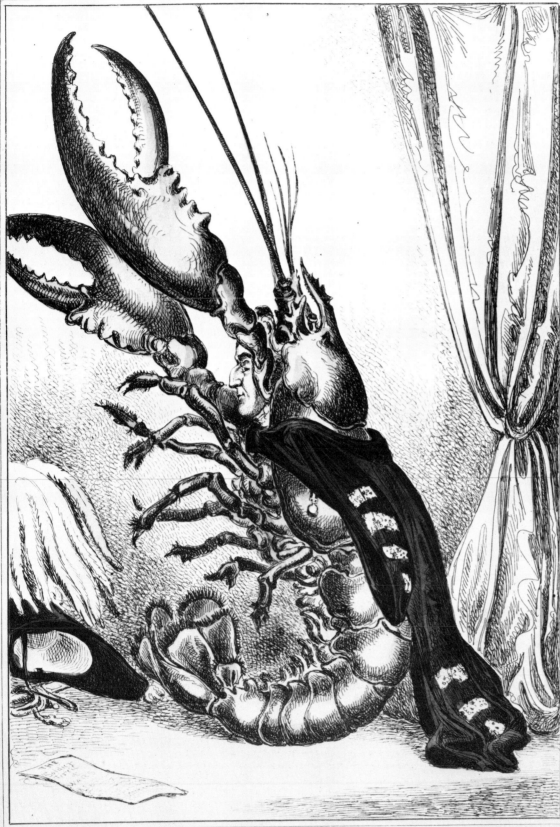

92

The PRIME *Lobster*

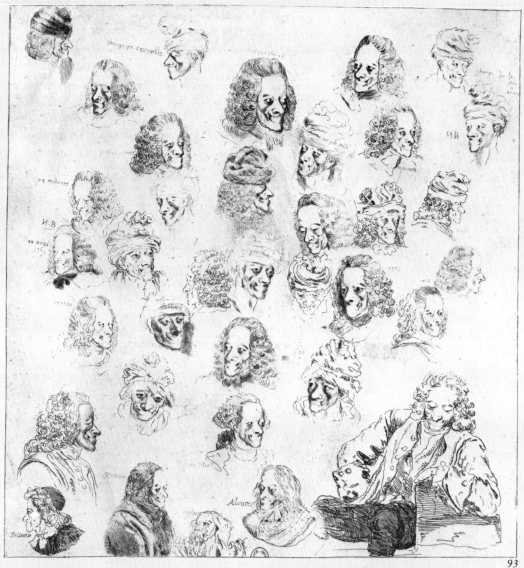

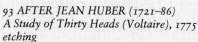

93

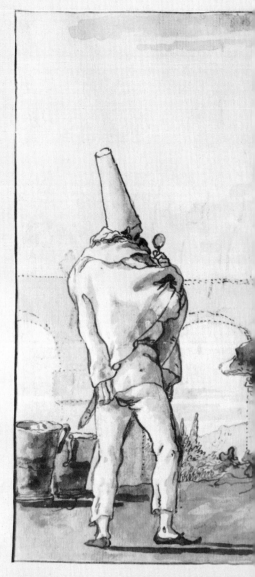

95

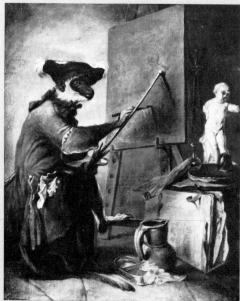

93 AFTER JEAN HUBER (1721–86)
A Study of Thirty Heads (Voltaire), 1775
etching

Huber produced a considerable number of carica-
ture drawings of Voltaire; indeed, his fame is as a
caricaturist of the philosopher captured in formal
and informal situations. Here Voltaire is seen with
and without his wig on, in a night cap and without
his teeth. The caricatures are neatly executed and
certainly had Voltaire's approval until Huber made
such a nuisance of himself that he was eventually
thrown out of Voltaire's household. Known to his
contemporaries as Huber-Voltaire because of his
leech-like attachment to the philosopher, Huber's
caricatures were widely circulated and copied.

94 GIOVANNI DOMENICO TIEPOLO
(1727–1804)
Honeymoon of Pulcinella's Parents, after 1791
pen, ink and wash

This is one of a series of 104 elaborate finished
drawings depicting the life of Pulcinella, which the
younger Tiepolo worked on from 1791 onwards.
Although based on the commedia dell'arte character
who is himself a caricature in the comedy of
manners tradition, the series, while frequently
humorous, is not really caricature but only related
to it. The masks and conical hats of his characters
make the figures somewhat absurd, but Tiepolo is
merely reproducing familiar theatrical devices. It
could perhaps be argued that narrative cycles like
this were the forerunners of the modern comic strip.

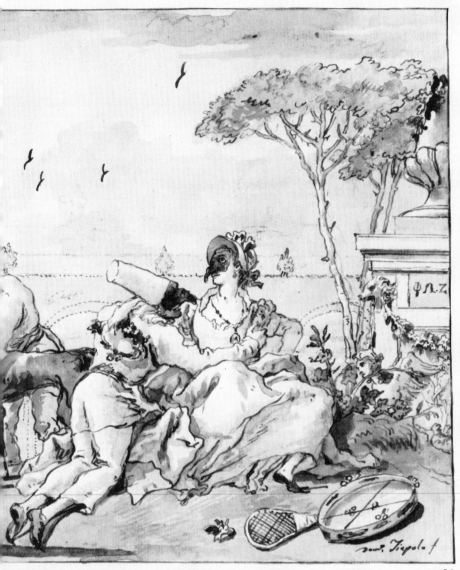

94

95 JEAN-BAPTISTE-SIMÉON CHARDIN
(1699–1779)
Le Singe peintre, 1726
oil on canvas

This painting can be seen as a parody on the works
of David Teniers the Younger who depicted
monkeys engaged in everyday activities (p. 48), and
also as a work in the eighteenth-century tradition of
using monkeys aping human ways in paintings and
decorations, a practice which both Claude Gillot
and Watteau employed. Like Teniers, Chardin is
chiefly remembered as a genre painter depicting
modest scenes of daily life with an uncomplicated
directness of vision and lack of affectation. This
painting could well be a gentle jibe at those
fashionable rococo artists with whose decorations,
using singeries, he was undoubtedly familiar.

cultivated people which had been invented in Italy
in the 1590s.

In France, under the Ancien Régime, caricatures
were either entirely social, like Louis-Pierre
Boitard's *L'Assemblée des vieilles filles*, dating from
1760, or were inspired by a few prominent but not
dangerous personalities, such as Voltaire. There
was also a little satire directly inspired by art. An
example is Chardin's *Le Singe peintre*, which
derives from the paintings showing monkey-
barbers and monkey-surgeons made by David
Teniers the Younger in the preceding century, and
afterwards engraved by Coryn Boel.

The French Revolution was more caricatured in
England than in France. Indeed, it inspired some of
Gillray's most savage, telling works such as *The
Zenith of French Glory* and *A Family of Sans-
culottes Refreshing after the Fatigues of the Day*.
French caricatures were mostly anti-royalist, like
David's cruel sketch of Marie Antoinette on her
way to the guillotine. But the most savage of all
the draughtsmen on the revolutionary side was
Villeneuve, whose terrifying *Matière à réflexion
pour les jongleurs couronnés*, published in 1793,
perfectly catches the spirit of the Reign of Terror.
Villeneuve did not remain a convinced revolution-
ary. He ended his days as an engraver of pious and
royalist images under the restored Louis XVIII.

Napoleon, with his superb instinct for propa-
ganda, deliberately intensified patriotic fervour
after his accession to power, and encouraged
French caricaturists to support his policies. Among
the eminent painters of the time to whom
Napoleonic caricatures have been attributed are
J. B. Isabey, L. L. Boilly, J. H. Vernet and Carle
Vernet.

The Napoleonic Wars gave a more serious tone
to caricature than it had possessed since the
Reformation. Goya's *Disasters of War*, inspired by
the cruelties of the Spanish campaign, are carica-
tures only in the most liberal interpretation of the
word, but they clearly develop from the often
satiric *Proverbios, Caprichos* (his attacks on
customs and manners and on the bigotry of
Spanish Catholicism) and *Disparates*. Graphic
satires sprang up everywhere in the wake of
Napoleon's armies, a tribute in one sense to the
political liberation brought by the invaders. They
include designs by the Swiss artist Anton Dinker,
done in 1797–8, and anti-Napoleonic caricatures by

Johann Gottfried Schadow and E. T. W. Hoffmann, two of the founders of modern German caricature.

Meanwhile, in the world of serious art, the ruling Rococo style was replaced from the 1760s onwards by Neo-classicism which, with its emphasis on order, regularity and seriousness, disapproved of caricature.

Yet three Swedish artists of the late eighteenth century, Elias Martin, Johan Tobias Sergel and Carl August Ehrensvard, all of them affiliated to Neo-classicism, produced for their own private pleasure fascinating and surreal caricature drawings which anticipate the best nineteenth-century caricature.

Neo-classicism, moreover, gave at least one artist a point of reference. J. H. Ramberg's parodies of the *Iliad* are effective not only because they make spirited fun of the text, but because they also satirize the formula (line drawings like sketches for relief sculpture) that Flaxman had invented for illustrating the epic.

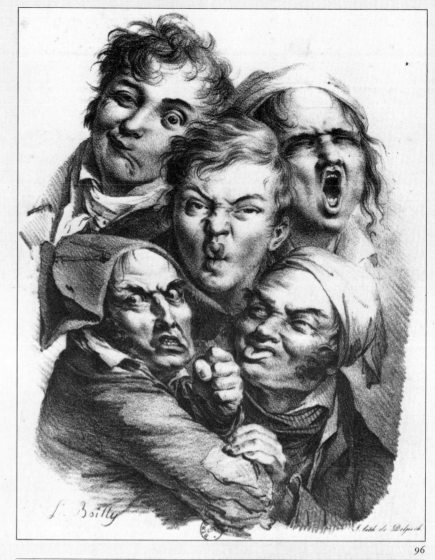

96

96 LOUIS LÉOPOLD
BOILLY (1761–1845)
Les Grimaces, 1823
hand-coloured lithograph

Boilly produced ninety-six lithographs of these curious grimacing faces at a time when there was a vogue for slightly grotesque images. One scholar has pointed out that mime was particularly popular on the stage at this period and it became a social pastime to play at making 'funny' faces. Boilly may have derived his work from Lavater's book on physiognomy, in which similar grimacing faces are shown as examples of how man's physiognomy reflects his moral character.

97 J. H. RAMBERG
(1763–1840)
Parody of the Iliad, 1822
engraving

In 1793 the neo-classical sculptor John Flaxman had published in Rome a set of illustrations, much influenced by Greek vase painting, to the Iliad and the Odyssey. These won him international fame, and the engravings were republished in several editions. Here Ramberg, a German artist resident in England, mocks not only the reverence accorded to Flaxman but also the solemnity of the whole neo-classical revival in England.

97

98

98 FRANCISCO DE GOYA
Preliminary drawing for
Hasta la Muerte, Los
Caprichos, *1799*
chalk drawing

*Goya shows us a woman
who, though advanced in
years, is still obsessed with
vanity. The title 'Until
Death' is followed by the
text 'She is right to doll
herself up. It is her birthday.
She is seventy-five years old
and her friends are coming
to see her'. Los Caprichos,
the first of Goya's great
series of etchings, was on
sale for only two days
before it was withdrawn;
the bitterly satirical nature of
the series did not show the
established church, for one
thing, in a favourable light.
In one version of this design,
now in the Bibliothèque
Nationale, the vain old
woman strongly resembles
Queen Maria Luisa.*

Le Goût du Jour Nº 1.

99

99 ANON.
Fashion of the Day, 1790
coloured engraving

Fashion caricature can be regarded as a specialized depart-
ment of social caricature based on the comedy of manners.
Like the comedy of manners, it assumes there is a norm
from which sensible people do not willingly depart.
Because fashion is itself visual, it is easy for the caricaturist
to satirize its excesses. Moreover, extreme fashions require
the wearer almost masochistically to abandon his or her
sense of humour. The English dandies of the Regency
period and their French equivalents, the Incroyables,
provided plenty of material for the caricaturists. Some, like
this French caricature, are parodies of the fashion-plates
which were one of the principal sources of information
about the latest modes of dress. This gave them an added
piquancy for a contemporary audience, as they mock not
only the fashion but the dictators of fashion.

100

101

Monstrosities of 1825 & 6

102

100 F. W. FAIRHOLT
Settling the Odd Trick from England under the House of
Hanover, *1848 (from an 18th century original)*
engraving

The eighteenth century, with its almost obsessional interest
in fashion, was prolific in fashion caricature of all kinds.
The elaborate female hairstyles of the period sometimes
reached almost surrealist heights of embellishment: women
actually appeared wearing model ships and other unex-
pected items as part of the vast structures that adorned their
heads. They inspired many of the prints of the time, as
draughtsmen took an especially keen delight in what these
towering hairdos did to the proportions, as can be seen in
this caricature of an acrimonious card game from a book by
Thomas Wright.

101 JOHN LEECH (1817–64)
Men's Fashionable Collars Meet from Some Distance
pen and ink drawing

Caricatures making fun of the latest fashions continued to
be popular well after Cruikshank had, as it were, perfected
the fashion caricature, and the vogue continued well into
the nineteenth century. John Leech uses fashion to make a
gentle ironic point in this drawing. Here the two men
wearing ridiculously high neck-cloths are turned into a pair
of long-billed birds solemnly inclining towards one
another, and the result is a wordless joke which is half-way
to the kind of animal caricature practised in the same
period by Grandville. As with all Leech's caricatures
('always the drawings of a gentleman', as Dickens com-
mented) the tone is light and affectionately humorous.

102 GEORGE CRUIKSHANK
Monstrosities of 1825 & 6, 1826
hand-coloured etching

George Cruikshank caricatured the fashions of the day in
a series of eight plates entitled Monstrosities, *beginning in*
1816. The setting for this one, dated 1826, is Hyde Park on
a windy day. Parks such as St James's and, later, Hyde Park
were open to all Londoners and it was here that fashionable
society promenaded, 'mingling in confusion', as one
foreigner observed with distaste, 'with the vilest populace'.
This is an amusing but rather gentle caricature typical of the
cartooning style of the Regency period, which was more
restrained and decorous than that of a previous generation.

The Age of Daumier

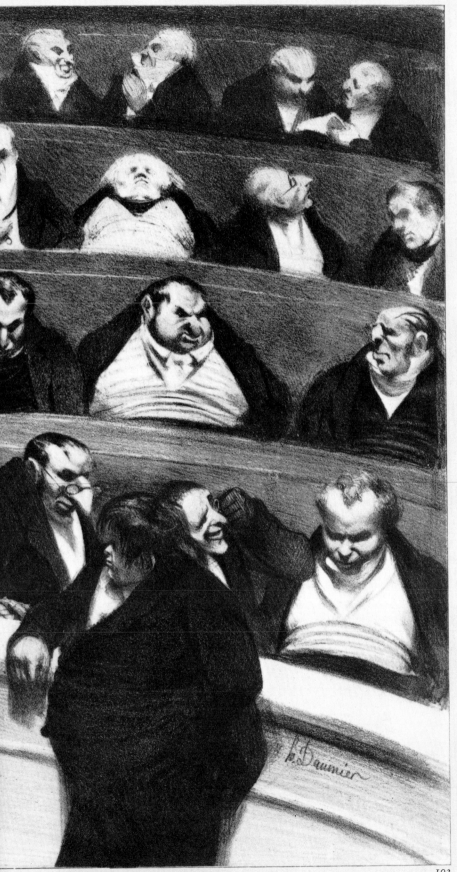

103

The development of caricature in the nineteenth century was affected by two practical circumstances. One was its alliance with the press. Satirical images at last ceased to appear on separate sheets, and became illustrations in newspapers and periodicals. The other important innovation was lithography (invented in 1798), which enabled a draughtsman of genius like Honoré Daumier to use form and colour which could be accurately and rapidly mass-produced in print. When Baudelaire spoke of Daumier's line as being 'naturally coloured', he really spoke of his mastery of the lithograph as a means of communication.

It was now France and not England which gave the lead in caricature, and Daumier is the most eminent caricaturist during the whole middle stretch of the century.

Under the restored Bourbon regime caricaturists already enjoyed a certain degree of liberty – certainly more than they had had since the early days of the Revolution. The defeated Bonapartists took advantage of governmental leniency. They invented the *Eteignoirs*, or extinguishers, symbolic figures who stood for the obscurantism of their opponents the Ultras.

But the French caricaturists had to wait until the July Revolution of 1830 before they were given their heads. In many respects the reign of Louis Philippe was the golden age of French graphic satire. There was for a time almost complete freedom of the press – although Daumier was imprisoned in 1832 for representing Louis Philippe as Gargantua in *La Caricature*. After 1835 censorship laws forbade direct references to particular persons and institutions so caricature became less specifically political and more subtle in its approach. There was certainly enough injustice and

corruption in Louis Philippe's shoddy regime to arouse indignation. Daumier, with his courageous publisher Charles Philipon, unmercifully harried the regime. (Philipon was himself a caricaturist and inventor of the famous sequential image which shows the king's portrait gradually turning into a pear – '*poire*' being the French slang term for 'fathead'.)

One of Daumier's most effective satirical tricks is the use of type-figures, especially Ratapoil and Robert Macaire. Ratapoil was what Henry James (who loved Daumier) called 'the ragged political bully, or hand-to-mouth demagogue', while Macaire, originally a character in a popular melodrama, epitomized the arch swindler who can turn his hand to anything. Macaire – like Monsieur Prudhomme, a character typifying the complacent bourgeois invented by the caricaturist, actor and author Henri Monnier, and afterwards taken up and used by other artists – presents a fresh aspect of the already age-old alliance between caricature and the theatre. These invented characters gave a narrative coherence to drawings published regularly but separately in the satirical journals, and encouraged a kind of complicity as readers followed their adventures week by week.

Towards the end of his career Daumier turned more and more to allegorical and symbolic themes, such as Peace, War, Prussia, France, producing works with a sharpness and universality unequalled in the history of caricature.

Though Daumier dominates the age, he was not without rivals, and some of these were distinctly meritorious artists. Two of the most gifted were the pseudonymously named Gavarni and Grandville. Gavarni is to Daumier as Rowlandson is to Gillray, a much lighter artist specializing in the comedy of manners. Baudelaire rather unjustly dismissed him as too literary. 'He is always looking', Baudelaire said, 'for intermediate ways of bringing his ideas over into the realm of the plastic arts.' Grandville is best known as the follower of that tradition in graphic satire of ridiculing persons by depicting them as animals. He was a prolific political cartoonist until 1835, after which he became a book-illustrator. Often the texts he used were specially shaped to suit his purpose – as in his two most famous publications, *Scènes de la vie privée des animaux* (1842), and *Un Autre Monde* (1844). These combine the satiric with the fantastic

104

previous page
103 HONORÉ DAUMIER
The Legislative Belly, L'Association
Mensuelle, *1834*
lithograph

L'Association Mensuelle *was one of the radical journals produced by Charles Philipon which attacked Louis Philippe and his ministry, and this was one of five lithographs Daumier donated to be produced as single prints and issued to raise money for Philipon's constant legal expenses. This print depicts the Chamber of Deputies, the highest legislative body in France, in 1833, and twenty-seven of the twenty-nine figures have been more or less identified as members who were consistent supporters of the King. The print was not drawn from life but probably evolved over a period of time; Daumier was frequently in the Press Gallery and had the opportunity of closely observing the legislative assembly and, in fact, modelled a series of witty, often brutal, clay busts of individual members before executing this celebrated composite view.*

104 CHARLES PHILIPON (1806–1862)
Louis Philippe as a Pear, 1831
pen and ink drawing

Philipon, *the editor of the satirical journal* La Caricature, *was the first to make use of the resemblance of Louis Philippe's heavy-jowled face to a pear and to employ it as a symbol of the July Monarchy. Since* poire *also had a slang meaning of simpleton it was a particularly apt and irreverent image that immediately captured the public imagination. This is still, perhaps, one of the best-known political caricatures of the nineteenth century.*

105 HONORÉ DAUMIER
A Literary Discussion in the Second Gallery, Le Charivari, *1864*
lithograph

This caricature is one of a series of eight lithographs illustrating scenes from the theatre (croquis pris au théâtre) *which were published irregularly in* Le Charivari *from February 1864 to June 1865.*

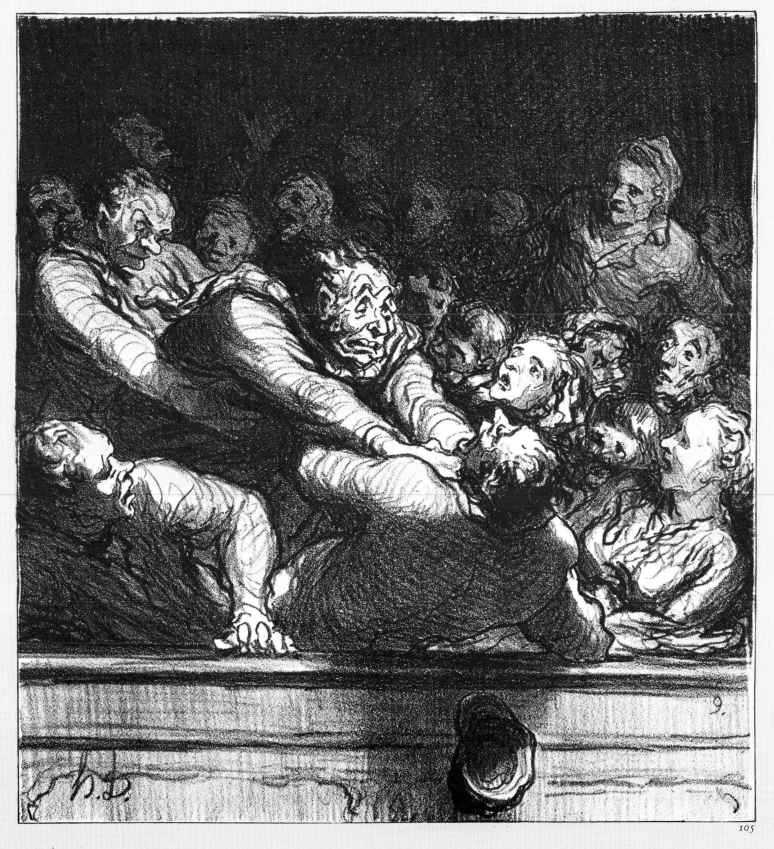

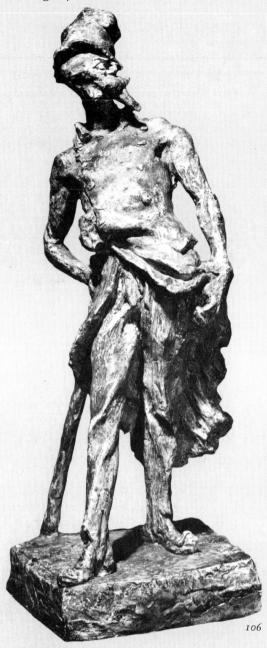

106

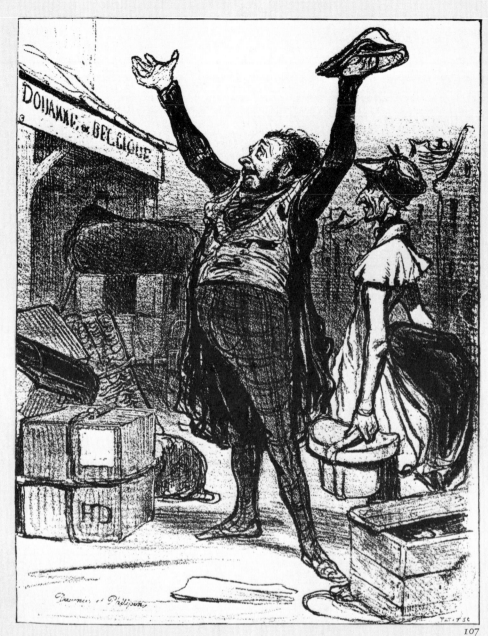

107

106 HONORÉ DAUMIER
Ratapoil, 1850
original plaster for bronze statuette

One of the interesting features of French carica-
ture, especially after overtly political subjects
were largely forbidden by censorship laws, was
the creation of certain imaginary types who
soon became recognizable symbols of Louis
Napoleon's regime. Their appearance in a series
of lithographs was welcomed with increasing
public delight. Ratapoil was one of the most
successful of Daumier's types, along with
Macaire. A sinister, unscrupulous figure, with
his features partly derived from Louis Napoleon,
he was, in the words of one critic, 'the Pied
Piper of Bonapartism', committed to advancing
the causes of the new Prince-President.

107 HONORÉ DAUMIER
Hail! Land of Hospitality . . ., Le Charivari, 1840
lithograph

This is the first plate in the second series charting
the adventures of the arch-swindler Robert
Macaire and his sly, stupid accomplice Betrand.
Here Macaire and Betrand have found it
expedient to make a hurried departure for
Belgium in order to evade French justice. On
reaching the frontier the eloquent Macaire,
never at a loss for words, hails the hospitality of
Belgium. The character of Macaire was appro-
priated by Daumier and Philipon from a highly
successful play of the time and was used by
them as a caricature of the type of speculator
and imposter who flourished in those corrupt
days.

80

Que diable! mon neveu, il est bon d'être laborieux mais on ne peut pas toujours travailler aussi! à la campagne on s'amuse, fais comme moi.

108

108 SULPICE GUILLAUME CHEVALIER, known as PAUL GAVARNI (1804–66) 'Que diable! mon neveu . . .' lithograph

Gavarni was more purely a comedian of manners than Daumier and his graceful style is characterized by careful attention to details of costume, setting and gesture, reflecting his apprenticeship as a fashion illustrator. This gentle caricature is one of a series entitled Paris Students, and depicts a rather foppish young student who has temporarily retired to the country to escape the expenses of Paris. The text reads, 'What the devil! nephew, it is good to be industrious but also one is not always able to work! in the country one must amuse oneself as I do.'

in a dry, meticulous style quite different from other French caricaturists of the nineteenth century.

The Revolution of 1848 brought Louis Napoleon and the Second Empire to power. Caricature was more severely limited by censorship than under the July Monarchy, and tended to turn away from serious social and political issues. The result was a much lighter kind of caricature, obsessed by novelties of all kinds – new inventions such as photography (and some leading photographers, such as Nadar and Carjat, were also caricaturists), changes in fashion and metropolitan amusements. Despite their retreat towards the shallows the French practitioners of the art retained much of their verve and inventiveness, largely because there was no one dominant publication, such as *Punch* in England, and all the satirical and humorous journals vied to outdo one another.

Caricaturists regained some of their impetus with the collapse of the Second Empire after the humiliating defeats of the Franco-Prussian War. This produced a savage satirical outburst. The fallen emperor was the subject of many intensely cruel lampoons, and in March 1871, when the fortunes of France were at their nadir, Daumier published *Peace*. The imagery is traditional. Death, in the form of a skeleton, presides over the battlefield. But he is crowned with flowers like a Greek shepherd, and is playing the pipes of peace. The irony is simple, crushing and unanswerable, and the design transcends any simple categorization.

Some of the German satirical periodicals of this period were short-lived. *Leuchtkugeln,* for example, only lasted until 1851 when it was crushed by heavy fines imposed by the Bavarian government.

Others became more reactionary during this second half of the century and turned more from political cartooning to social satire. In the work of such caricaturists as Oberlander, Meggendorfer and above all Wilhelm Busch there is a new stylistic approach characterized by a concise, often abbreviated use of line, which echoes Neo-classicism. But the culmination of German carica-ture was to come many years later with the typically powerful and muscular images published by *Simplicissimus*.

No fewer than four satirical magazines were founded in Italy in 1848. In order of appearance they were *Il Don Pirlone* (Rome), *L'Arlecchino* (Naples), *Lo Spirito Folletto* (Milan), and *Il*

109 HONORÉ DAUMIER
Nadar Elevating Photography to the Height of Art, Le
Boulevard, 1862
lithograph

In 1856 Felix Fournachon, better known as Nadar, took the
first aerial photograph, a view of the Étoile in Paris, from a
balloon. Nadar was a friend of Daumier's and photography
was just beginning to make its mark as the most accurate
reproduction of reality ever achieved. Whether the tech-
nique of photography was an art form was hotly debated,
and this is the point of Daumier's gentle pun. Le Boulevard
was an illustrated journal founded in 1861 by one of
Daumier's friends, Étienne Carjat, a journalist and photo-
grapher-artist. Daumier supplied ten lithographs for this
publication after he had left Philipon's Charivari in 1860;
these were later revised under the title of Les Souvenirs de l'
Artiste (Artist's Recollections).

110 JEAN IGNACE ISIDORE GÉRARD, *known as*
GRANDVILLE
Beastly Humans at Table
lithograph

Grandville was the most productive of the early carica-
turists on La Caricature and, although he is overshadowed
by Daumier, his works still have a bite and power today
which outclass those of the more gentle Gavarni. His
speciality was, of course, animals, which he used to lam-
poon both social follies and political miscreants. This cari-
cature depicting animals at table manages to convey, by
gesture as much as by the carefully chosen animal species,
the behaviour of a group of bourgeois gentlemen at meal-
time. Grandville's most successful political caricatures were
his three lithographs called Cabinet d'histoire naturelle,
published in La Caricature, in which he satirized the col-
laborators of Louis Philippe as being a museum of curious
beasts.

111 HONORÉ DAUMIER
Peace, An Idyll, Le Charivari, 1871
lithograph

Although at this late date Daumier's lithograph's were still
caricatures, his prints were now dealing with such abstract
themes as war, peace, the arms race, France and Prussia.
This was partly because of the strict censorship laws under
the Second Empire, which meant that he was not able to
indulge in personal attacks and the nakedly political car-
toons of earlier days, and partly because national preoccu-
pations were dwarfed by the growing tensions of European
politics. Daumier's cartoons from 1860 to 1871 show a
growing sense of foreboding as the artist saw the inevita-
bility of the Franco-Prussian War. This caricature entitled
Peace, An Idyll was published in Le Charivari just after
peace terms concluding the Franco-Prussian War had been
agreed.

The Age of Daumier

*112 ALPHONSE
JACQUES LEVY,
known as SAÜD
(1843–1918)
The Plucked Eagle, 1870
lithograph*

This caricature refers to
Napoleon III's capture
after the French army's
humiliating defeat at
Sedan in 1870. He is
shown here as a eagle
plucked of its feathers,
his helmet askew and
chained to a perch held
at either end by posts
saying honte *(disgrace)*
and infamie *(ignominy)*.
The irony is empha-
sized by a pun on aigle
(eagle), which was a
well-known Napoleonic
emblem.

*113 ROBERT
GAILLARD (1822–85)
'Un cochon engraissé . . .',
1871
lithograph*

In this caricature, one of
the many crude depic-
tions of Napoleon III
which appeared after
France's overwhelming
defeat in the Franco-
Prussian War, the
Emperor is seen as a
'pig fattened over
twenty years for the
King of Prussia'. Nap-
oleon III had always
been sympathetic to the
idea of the extension of
Prussia's power in north
Germany but he had
reckoned without Bis-
marck's much wider
ambitions. Both because
Napoleon III felt
cheated by Bismarck and
because of Germany's
desire for war, the
Franco-Prussian War
was inevitable, although
the magnitude of
France's defeat was not.

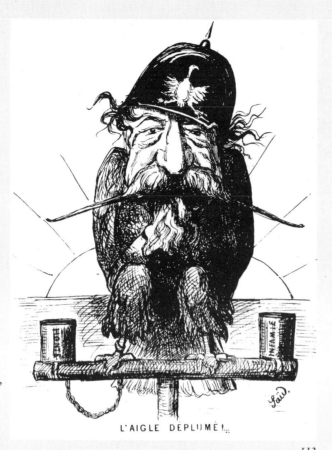

L'AIGLE DÉPLUMÉ!...

112

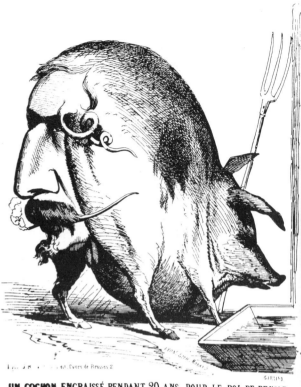

UN COCHON ENGRAISSÉ PENDANT 20 ANS POUR LE ROI DE PRUSSE

113

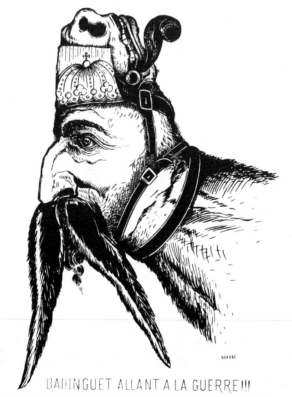

BADINGUET ALLANT A LA GUERRE!!!

114

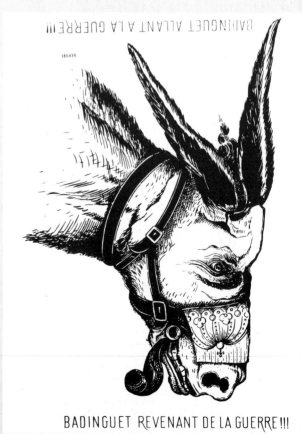

BADINGUET REVENANT DE LA GUERRE!!!

114

84

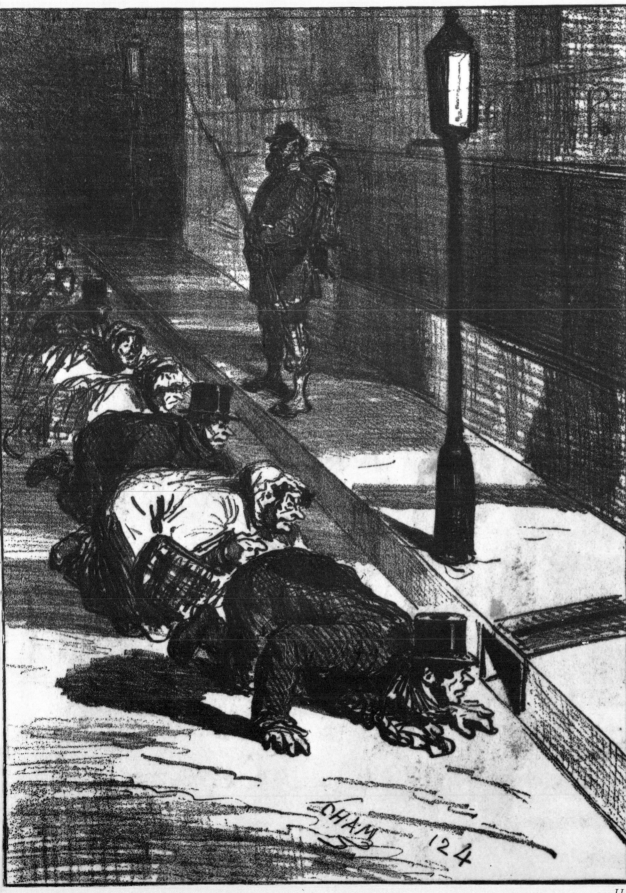

114 ANON.
Buffoon Going to the War, Buffoon Returning from the War, c. 1870
lithograph

Reversible heads with animal counterparts were a popular device with caricaturists from medieval times. Here, Napoleon III is depicted as a determined 'buffoon' going to the war, but reversed becomes a buffoon or ass returning from the war.

115 AMÉDÉE DE NOÉ, known as CHAM (1819–79)
Queue for Rats' Meat, Album du siège, 1871
lithograph

From 10 September 1870 to 28 January 1871 Paris withstood a grim siege after victorious Prussian troops had surrounded the city. With the city completely cut off food supplies dwindled rapidly, and as conditions worsened Parisians took desperate measures. Horses, other beasts of burden, and even domestic pets were slaughtered for food. As the siege wore on scenes like the one depicted here became common.

115

AFFAIRS AT SALT LAKE CITY.

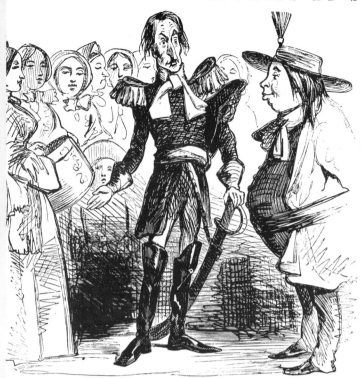

Brigadier-General BOMBSHELL, of the Mormon Army, before leaving his home to exterminate the ruthless Invaders from the States, confides the care of his Twenty-seven Wives to his Chief—Brother YOUNG.

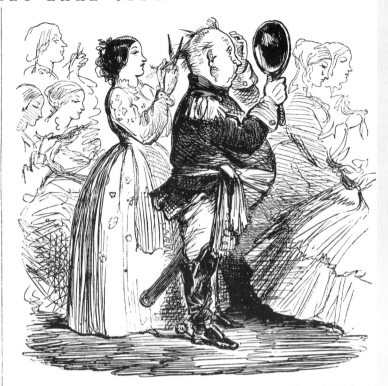

Major BAYONET, of the Mormon Irregulars, consents, in a rash moment, to give each of his devoted Wives a Lock of his Hair. The result is very painful to behold.

116

116 ANON.
Affairs at Salt Lake City, c. 1857
lithograph

The Mormons were a popular subject with American cartoonists in the second half of the nineteenth century, as their discipline, orderliness and moral probity, along with the practice of plural marriages, represented something of a paradox to both the federal administration and the great majority of the American people. Polygamy had been formally introduced in Salt Lake City by Brigham Young in 1852; pressure from the federal government to abandon the practice led to the Utah War of 1857–8 in which a Mormon militia was organized in order to meet the advance of federal troops. This caricature shows two such militiamen, one leaving the care of his wives to a portly but sensuous looking Young, the other almost bald after distributing a lock of hair to every one of his wives.

117 THOMAS NAST
The Brains of the Tweed Ring, 1871
lithograph

Thomas Nast's most effective and most famous cartoons were his attacks on 'Boss' Tweed, a New York politician who, with his 'Tweed ring' associates, systematically plundered New York City of an estimated 30 to 200 million dollars. After occupying various posts, Tweed gained absolute power in Tammany Hall, the headquarters of the New York Democratic Party, and from then on controlled both nominations and patronage. As state senator he forced through legislation in 1870 that gave him power of audit on the city's accounts, a trust he almost openly manipulated to his advantage. Nast's cartoon is devastatingly economic in style, its meaning simple and direct; his series of virulent attacks on Tweed was one of the chief factors in the downfall of the politician and his gang.

118 MELCHIORE DELFICO (1825–95)
Viva Verdi; Baron Genovesi greets Giuseppe Verdi, 1862
pencil and wash drawing

Giuseppe Verdi was one of a handful of great men of the nineteenth century who so impressed his contemporaries that he became the subject of a caricature anthology which documented all aspects of his personality. Verdi became the unofficial musician laureate of the cause for Italian unity. The success with the public of such of his operas as Nabucco and Ernani was partly because of the stirring patriotic sentiments they expressed and Verdi's name became synonymous with the nationalist movement. This was also because 'Verdi' is an acronym for Vittorio Emmanuele, Re d'Italia, the man who was to become King of a united Italy. Delfico's drawing shows him being greeted by Baron Genovesi in 1862 after the proclamation of a Kingdom of Italy.

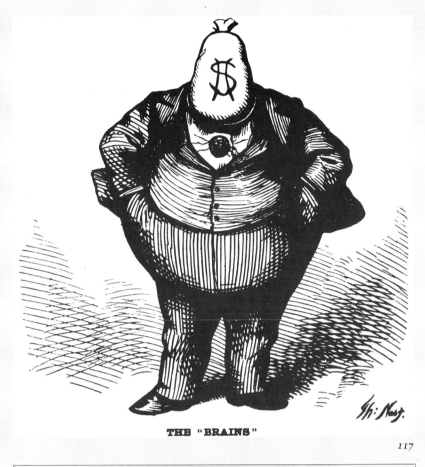

THE "BRAINS"

117

118

Fischietto (Turin). Of these *Il Fischietto* was the most combative and important, not least because it was published in Turin, the headquarters of the Risorgimento. A favourite subject was the composer Verdi, not merely because of his own titanic personality, but because he was associated with the struggle for national independence. Even his name became a slogan. 'Viva Verdi!' was shorthand for the phrase 'Viva Vittorio Emmanuele, Re D'Italia!'.

The first great flood of caricatures in the United States came in the period 1828–36, during the Jackson administrations. The reasons were twofold. One was Jackson's forthright personality, which never shrank from controversy. He once said of himself, 'I have an opinion of my own on all subjects, and when that opinion is formed I pursue it publicly regardless of who goes with me.' The other was the introduction of lithography. In 1841 the *American Comic Almanac* appeared, and the success enjoyed by *Punch* in England soon led to the publication of an American imitation, called *Punchinello*. However, the first magazine to establish itself firmly in the field of political caricature was *Harper's Weekly*, founded in 1857. It was followed two years later by *Vanity Fair*.

Thomas Nast, the first major American caricaturist, is associated with the Union cause during the Civil War and with the dismantlement of the corrupt Tweed ring in New York. Lincoln called Nast 'our best recruiting sergeant', and General Grant said he had done 'as much as any one man' to preserve the Union. As Tweed's adversary he was equally effective. *The Brains of the Tweed Ring* shows Tweed himself with a bag of dollars for a head; it is one of the most devastating indictments ever created by a satirical draughtsman. Nast also invented the Republican party elephant and the Democratic donkey, symbols still used in American politics today.

The subject-matter for social satire was wideranging. Negroes were a favourite theme as were the Mormons, whose multiplicity of wives fascinated satirical draughtsmen. There are also comments on the feminist movement, which troubled nineteenth-century American opinion almost as much as women's rights troubles it today.

In England nineteenth-century caricature was dominated by *Punch* (founded in 1841), the most famous as well as the longest-lived satirical journal in the world. Yet English nineteenth-century

caricature has almost certainly been over-rated. There is no English Daumier; and for that matter there is no real English equivalent for Thomas Nast. The novelist Thackeray, closely concerned with the development of *Punch* in its early days and a practising caricaturist himself, summed up English satirical draughtsmanship after the departure of Rowlandson and Gillray. 'We have washed, combed and taught the rogue good manners', he remarked complacently. John Leech, the quintessential early Victorian caricaturist, was indeed welcomed by his contemporaries as the 'antidote' to the coarse humour of the preceding age. 'His works', said Dickens, 'were always the drawings of a gentleman.'

There were, however, excellent draughtsmen like John Tenniel, Harry Furniss, Charles Keene and Phil May. Yet their caricatures, while often witty, poignant and acutely observed on all manner of social and political themes, lack savagery, a sense of moral outrage, an intensity of feeling inherent in the works of great caricaturists. Tenniel's illustrations for *Alice in Wonderland*, for example, work so much better than his caricatures because he was projected into Lewis Carroll's fantastic world.

Indeed, originality and fantasy were seen most freshly and clearly in work not intended for publication – in Lear's scrawled illustrations to his own limericks, and in the charming drawings made as a relaxation from more solemn tasks by the Pre-Raphaelite painters Dante Gabriel Rossetti and Edward Burne-Jones. In the 1890s, with the emergence of Beardsley, the situation changed. Beardsley was not primarily a caricaturist, but his occasional efforts in this direction could be devastating, as with the portraits of Wilde incorporated into the illustrations for the latter's *Salomé*. Beardsley's decorative, bizarre and often shocking effects forced complacent Victorian artists to recognize a new visual language.

In France, the change to the *fin de siècle* took place more gradually, but also earlier. Caricature increasingly fascinated serious artists. It is probable that Daumier, with his very personal *mise-en-page*, influenced the Impressionists almost as profoundly as the newly fashionable Japanese prints. Many of the leading Impressionist painters tried their hands at caricature, and what is more they were prepared to sign and publish these efforts. Manet, for

120

THE DARKTOWN GLIDE.
Aint dis jes lubly!

119

121

119 ANON.
Woman's Emancipation, Punch
engraving

Jokes about, or rather against, women are
closely related to jokes about class and race.
Eighteenth- and nineteenth-century caricature
had a strongly anti-feminist strain which sug-
gested that women, besides being a different sex,
were also to be regarded as members of a dif-
ferent and inferior race. This Punch satire on the
Feminist Movement, which began in America in
the early nineteenth century, plays on the notion
of role reversal and can still be appreciated
today.

120 JOHN LEECH
Heartless Practical Joke, Punch
engraving

Founded in 1841, Punch ruled over English
caricature for more than a century, its humorous
comments on the world reflecting the self-
confidence of the educated classes of Victorian
England. John Leech was, from the first, one of
its leading caricaturists. This gentle caricature
has the text line, 'Here they come, Blanche. Let's
pretend we don't recollect them'. It is an
affectionate joke on the coyness of Victorian
courting rituals. It was Leech who gave the
word cartoon its present meaning: in 1843
fresco designs for the new Houses of Parliament
were the subject of a competition, but when the
cartoons (full-scale drawings for paintings) were
exhibited it was obvious that many of the
designs were inadequate. Punch parodied these
in six 'cartoons' by Leech.

121 NATHANIEL CURRIER (1813–88) and
JAMES MERRITT IVES (1824–95)
The Darktown Glide, 1884
lithograph

Negroes and negroid types are often the subject
of painting on Greek classical vases and
Alexandrian bronzes and terracottas, but they
did not become a regular subject of post-
classical caricature until the nineteenth century.
In America they were of course associated with
the slavery issue, while in Europe caricatures of
negroes were part of the fabric of turn-of-the-
century colonialism. Particularly popular in
America in the 1880s were the Darktown litho-
graphs, travesties of negro life, several series of
which were published and sold as individual
prints. No saloon, poolroom or barber-shop
was without one of these, although the vogue
for them died out in the following decade.

89

The M's at Ems

122

122 DANTE GABRIEL ROSSETTI (1828–82)
The M's at Ems
pen and ink

Portrait caricature originated in the artist's studio as a form of relaxation from more serious artistic endeavours. Thus there are many telling caricatures of artists, some self-portraits, others by their colleagues. This delightful caricature depicts William Morris reading his famous narrative poem The Earthly Paradise *(based on classical and medieval sources in the manner of Chaucer's* Canterbury Tales) *to his wife, the beautiful and enigmatic Jane Burden, a painters' model and daughter of an Oxford groom. Caricatures like this are genial and high-spirited* jeux d'esprit, *never intended for publication but part of the everyday exchange of studio gossip.*

123 MAX BEERBOHM (1872–1956)
Caricature of Oscar Wilde
pen and ink

It was not until the coming of the Japanese vogue and, after it, Art Nouveau that professional caricaturists like Max Beerbohm produced a good lampoon which was also a strong

design in its own right. The rhythm and organization of the design itself would then reflect the artist's impression of his subject matter, as in this caricature of Oscar Wilde by Beerbohm. Wilde is flabby and opulent; the curves of his waistcoat echo the curved lines which have been used to render his hair; the long diagonal of the walking-stick is contrasted with a series of U-shapes stacked one above the other, comprising Wilde's chin, the top of his double-breasted waistcoat and its bottom edges. His coat is rendered with a long flourish of fine lines, suspended from the huge cabbage-like flower in his button-hole; and this diagonal flourish, in turn, opposes the line of the walking stick. As a whole, the design is masterly in its composition.

124 MAX BEERBOHM
Caricature of Aubrey Beardsley, Pall Mall Budget, 1894
pen and ink

Beerbohm's caricature of Aubrey Beardsley is almost imitative of Beardsley's own style, in that it has the combination of clear lines and solid blacks so characteristic of Beardsley's work. Max employs the caricaturist's age-old device of placing a large head on a small body, the nose

distorted out of all proportion to the rest of the face and the human figure typically elongated. The elegant, sinuous style of Art Nouveau is used with epigrammatic skill to capture precisely Beardsley's appearance and personality.

125 EDWARD LEAR (1812–88)
Self-portrait, 1862–3
pen and ink

Many of Edward Lear's engaging nonsense drawings have a surreal quality that is encountered only rarely in the works of his predecessors. This self-caricature shows the artist as a bird-like creature which nevertheless retains most of the regular human attributes. Lear considered himself to be an ugly man, and as he grew older became increasingly self-conscious about his nose and his large spectacles – two features exaggerated here. The economy of line in Lear's draughtsmanship, reminiscent of Bernini's, is matched by a truly comic, often absurd style of drawing that leads the viewer into realms of delightfully amusing fantasy.

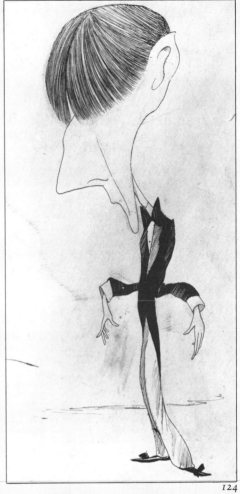

123

124

125

example, published a caricature portrait in *Le Diogène* as early as 1860, while Monet was working as a professional caricaturist at the age of fifteen. But it was the rise of Symbolism which really prompted French satirical draughtsmen to extend the boundaries of their art. It provided a rich mine which could be worked both humorously and seriously. The solemnity of Symbolism provided the humorous draughtsman with a valuable irritant and contrast. At the same time, Symbolism itself dealt, at a basic level, in much the same currency as the art of caricature. Its ambition was to create visual emblems which would reverberate in the mind and memory of the beholder.

It is no surprise therefore to discover that the ranks of French caricaturists in the period 1890–1910 include not merely a large number of distinguished names, but the names of those who were already, or were to become, notable in other fields of art. Among those who published caricatures in various French journals at this period were Toulouse-Lautrec, Jacques Villon, Kupka, Félix Valloton and Juan Gris.

In Germany, the foundation of *Simplicissimus* in 1896 gave the artistic lead to German caricaturists. Its pre-war issues showed, in particular, a strong Art Nouveau current derived from a study of Beardsley. But *Simplicissimus* was able to strip Art Nouveau of much of its preciosity. The drawings made for the magazine by artists such as Gulbransson and Thomas Theodor Heine are in the great tradition of German graphic satire, in direct line of descent from the work done in Germany in the early sixteenth century. The humour has a curt economy which is unrivalled, and which was to develop after the war into the harsh cynicism typical of Weimar Germany. In many respects *Simplicissimus* is the greatest of all satirical magazines, with a consistent quality of draughtsmanship and a cutting edge which no other periodical has been able to rival.

The First World War, with its passions and its horrors, gave fresh opportunities to caricaturists on both sides. Forain's *Le Borne*, an evocation of the French will to resist at Verdun, was printed in thousands of copies and scattered behind the enemy lines. In Germany *Simplicissimus* took the lead in propaganda against the French and English. One of the great war cartoonists, however, was a Dutchman Louis Raemackers who, after the

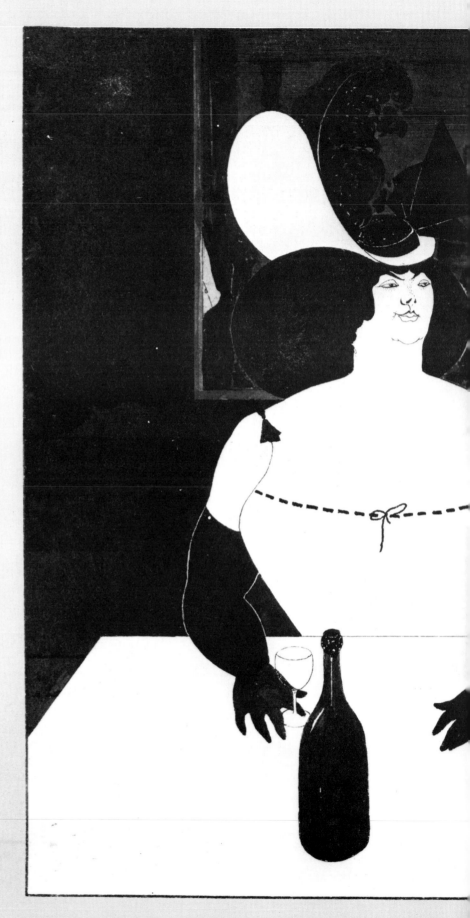

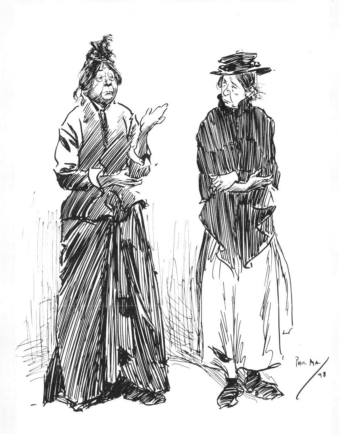

126 AUBREY BEARDSLEY
The Fat Woman, To-Day, 1894
pen and ink

Beardsley's masterly use of black
and white for pattern and grotesque
effect is typified in this drawing. His
bold sense of design was influenced
by Japanese woodcuts, and the
curvilinear style of Art Nouveau is
also apparent in this work; yet
Beardsley transformed these in-
fluences into a new style which was
to have a lasting effect on the art of
illustration. Although he used the
simplicity and directness of the
caricaturist, little of his work was
actually caricature; this portrait
however, has the distortion of the
human figure and succinct style
characteristic of caricature.

127 PHIL MAY (1864–1903)
Two Cockney Ladies, Punch, 1898
pen and ink

Punch *abandoned the vulgarity of
Regency caricatures and, as one
critic has observed, from 1841
onwards '"comedy of manners"
became subjective as well as objec-
tive.* Punch *became an upper-class
weekly and continued as such for
three or four generations, reflecting
. . . the delight of the upper class
in seeing its own foibles and those
of its attendant servants, tradesmen,
lame ducks and "climbers" ex-
posed'. Many caricaturists like Phil
May made a speciality of urchins
and bedraggled, indomitable
working women but there was
often a strong element of condes-
cension. This caricature, with the
legend 'If I was you, I wouldn't 'ave
anything to do with that Mrs
Smithers, I think she 'ain't respect-
able', presents middle-class atti-
tudes unsuitably adopted by a
lower social class.*

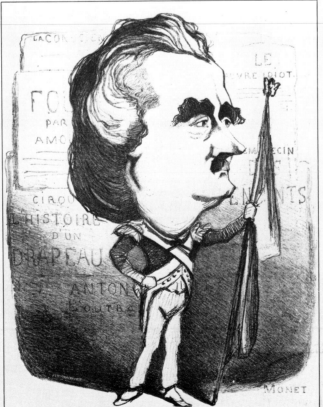

128 CLAUDE MONET (1840–1926)
La Ferrière, Le Diogène, 1860
lithograph

Monet's first success as an artist
was as a caricaturist when, at the
age of fifteen, while living near Le
Havre with his parents, he began
selling caricatures which were
carefully observed and well drawn.
He first visited Paris in 1859–60
and here, as a means of earning
extra money, executed caricatures
like this one for the journal
Le Diogène.

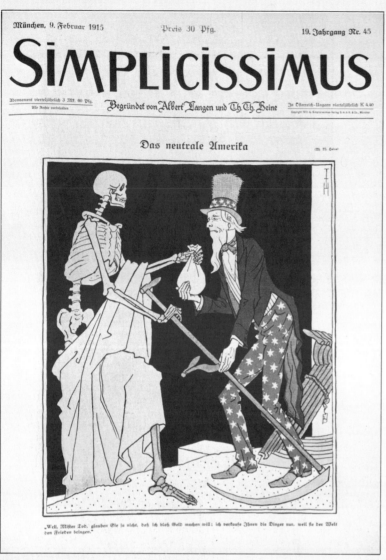

129

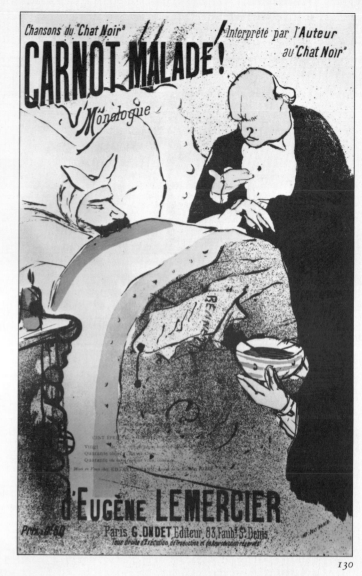

130

129 THOMAS HEINE (1867–1948)
American Neutrality, Simplicissimus, 1915
lithograph

Thomas Heine was the artist most intimately connected with Simplicissimus's fortunes and the one who had most say in both its political and artistic decisions. His work appeared on the coveted front cover more times than any other artist and in his years with the magazine he executed more than 2500 drawings. This caricature, produced in February 1915, is a comment on America's neutrality, announced by Woodrow Wilson the previous autumn and maintained with difficulty over the next two years. Simplicissimus's graphic style was not experimental but continued a manner established by Art Nouveau draughtsmen.

130 HENRI DE TOULOUSE-LAUTREC (1864–1901)
Carnot Malade, 1893
lithograph

This cover for a music-hall song-sheet is typical of a new style of lithography produced by Toulouse-Lautrec from about 1890 onwards. His calligraphic use of strong outline, coupled with bright, clear, flat colour, shows the influence of Japanese prints, and has a powerful impact. But his brilliant caricatures of singers, dancers and theatre personalities like La Goulue, Jane Avril and Yvette Gilbert are unmatched, not only because of their dramatic quality, but because of Lautrec's perceptive and kindly wit which saw beyond the theatricality of his subjects so that the often ravaged, vulnerable faces become almost eloquent. Lautrec has been said to be the greatest figure in the history of lithography; in his hands caricature and that other popular graphic medium, the poster, became art forms.

131 GASTON DUCHAMP called JACQUES VILLON (1875–1963)
Brothel Scene, Le Rire, 1900
lithograph

Jacques Villon was drawing caricatures for L'Assiette au beurre and Le Rire from about 1895 to 1910. The half-brother of the artists Marcel Duchamp and Raymond Duchamp-Villon, he was prolific as an etcher. His style shows the influence of the art movements of the time – first Impressionism and then Fauvism – but it was with Cubism that he felt most attuned and became recognized as a painter of considerable merit in that style. This caricature, published in 1900, depicts a scene in a Paris maison close. An elderly, somewhat embarrassed man addresses a tough, experienced prostitute who looks slightly startled at the absurd inappropriateness of his remark '. . . you're going to despise me'.

— Vous allez me mépriser.

132 WILHELM BUSCH
(1832–1908)
Max and Moritz, 1865
coloured lithograph

More than any of his predecessors
Wilhelm Busch popularized the
narrative formula of successive
picture frames and can truly be
regarded as the father of the
modern comic strip. Busch began
regularly publishing his picture
stories in 1859 for the satirical
journal Fliegende Blätter. This
strip, showing his best-known
characters, the infant pranksters
Max and Moritz, dates from 1864
by which time he had developed a
very concise but rhythmic graphic
style. The source of Busch's in-
spiration is not clear. On one level
his tales about naughty children
could be sophisticated parodies of
didactic works like Struwwelpeter;
on another simple essays on the
vulnerability of human dignity.

133 EMMANUEL POIRÉ, known
as CARAN D'ACHE (1858–1909)
Marriage Request by a Timid
Young Man, Le Figaro
pen and ink drawing for engraving

Busch's heir in France was the
pseudonymous Caran d'Ache (the
Russian term for 'pencil'), who
drew preposterous situation
comedies in strip form in supple-
ments to Le Figaro in the late
1880s. These were the first to
appear in a general interest news-
paper rather than a purely satirical
magazine. Caran d'Ache's graphic
style is brilliantly simple and
precise and his legends are pithy
(he frequently dispenses with text
lines altogether). This example, in
which four from a sequence of
eight are reproduced, shows a
timid young man's faltering
attempts to ask his would-be
father-in-law for his daughter's
hand in marriage – and failing. The
complete legend reads, 'Monsieur
Hector! what good wind leads
you? . . . I want to ask . . . of you –
The object . . . of . . . how shall I
put it – Also . . . my request . . .
seems . . . strange' (M. le Baron) –
'Ah . . . I've got it – You want to
give your hat a brush!'

— Monsieur Hector! quel bon vent vous amène?...

— ... que... je sollicite... de vous.

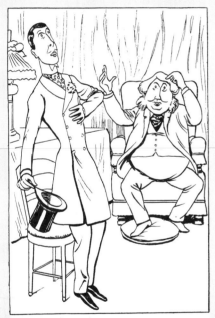

M. LE BARON. — Ah!... j'y suis.

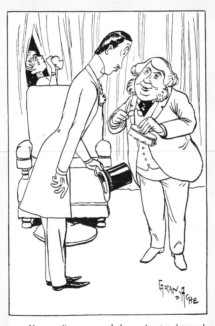

— Vous vouliez un coup de brosse à votre chapeau!

133

invasion of Belgium, threw in his lot with the Allies. In 1917 he went to America at the request of Lloyd George in an effort to persuade the United States to enter the war. His draughtsmanship was, at best, unremarkable, but the power and poignancy of some of his images so transcended this that his influence on the course of the war was considerable. Caricature had proved again that it was not merely popular but powerful.

Caricaturists were decidedly inventive throughout the whole of the nineteenth century but two innovations in particular widened the scope of the genre: caricature sculpture and caricature-narrative in sequential form. Caricature sculpture enjoyed some popularity both in France and in Italy, best-known today in Daumier's sculptures, and especially his Ratapoil. Nevertheless, sculptural solidity is not in harmony with the essential speed and lightness of caricature. If we look at the Ratapoil, brilliantly sketchy as it is in handling, it has a monumentality which in this context is undesirable.

Caricature-narrative in sequential form was a more successful innovation. As with caricature sculpture, there were already certain precedents. The plates of Hogarth's *Rake's Progress* and *Harlot's Progress* are arranged to tell a story, and the late eighteenth century produced Henry Bunbury's *The Long Minuet* and *The Propagation of a Lie*, where the figures are supposed to be read from left to right. The strip cartoon technique re-appears, more confidently used, in the work of the Swiss artist Toepffer in the 1830s and 1840s, and then in Wilhelm Busch's delightful *Max und Moritz* drawings in the 1860s. By the 1880s many caricaturists were using the sequential technique. It was employed with special brilliance by the Frenchman Caran d'Ache, a gifted *petit-maître* who understood his own possibilities and limitations exactly. At their best Caran d'Ache's sequential images are self-explanatory – a story told completely in mime. Today they seem very cinematic.

The sequential or strip technique, once perfected, was so powerful that it rapidly escaped from the caricaturist's hands. It is now used in newspapers for telling stories which are often adventurous or fantastic rather than humorous, and in the animated cartoons of the cinema and television.

PERHAPS HE'LL GET THE RIGHT MAN THIS TIME

Contemporary Caricature

134 GERALD SCARFE (b. 1936)
*Perhaps He'll Get the Right Man
This Time*, The Life and Times of
Richard Nixon, *1974*
pen and ink drawing

*Scarfe's savage cartoon of Richard
Nixon was executed in November
1973 when there was widespread
speculation that Nixon would
resign because of the Watergate
affair. Although the president's
lawyers tried to persuade a
sceptical nation that Nixon was
not lying about the two key
tapes involved, it was to little
avail. Scarfe's cartoon expresses
exactly the sentiments widely felt
at the time – Cox, Agnew, Dean,
Erlichman, Mitchell and Rich-
ardson had all been sacrificed to
protect the president's position;
now Nixon himself could not
escape. In fact, it was not until
August 1974 that Nixon resigned
after the knowledge had been
forced upon him that Congress
would certainly impeach him and
remove him from office.*

Caricatures have proliferated enormously in the period since 1918. Not only is the material itself extremely abundant, but caricature has come to include a much wider diversity of subject. It has branched out to include not only different themes and styles but different genres. A new form, the strip cartoon, has come to fruition in the twentieth century, while the distinctions between moral satire, the light-hearted and the purely artistic have become greater, as if further developing the differences between the beast-fables of the Middle Ages, the joky figures of the classical world and the artistic experiments of the Renaissance. Although they overlap in places and influence each other, these different strands of twentieth-century caricature to a large extent follow their own developments.

Social and Political Satire

The history of American caricature in the twentieth century provides the best summation of what was happening elsewhere in the world, swinging as it does between different social and political extremes. The political pole is repre-sented by the periodical *The Masses*, which from 1912 until the end of World War I employed some of the leading American artists of the time, among them members of the so-called 'Ash Can' school, such as George Bellows and William Glackens. *The Masses* was politically radical, and it attacked the social abuses of the time in forthright style. One of its most successful successors was *Americana*, which provided a platform for William Gropper in the thirties.

However, American caricatures of the twentieth century lack what one might describe as the element of risk, since the United States throughout

the period remained a stable democratic society. Even in the 'underground' caricatures published in America in the late sixties, at a time when the young were estranged from their elders by the long-continuing Vietnam war, one does not find the comprehensive rejection of a decaying society which appears in the early drawings of George Grosz, or even the cutting edge of the leading German satirical magazine *Simplicissimus* before, during and after the First World War. Nor is there anything that can really be compared to the terrifying photo-montages of John Heartfield, in which he tried to put across the full horror of the Nazis. Grosz produced savage, sexually explicit caricatures of German life, attacking the brutality and hypocrisy of the society of the twenties. His violent drawings provide a vivid explanation of the rise of Nazism. John Heartfield (a German who anglicized his name in reaction to the patriotism of World War I) was a friend of Grosz, sharing his radical views on art and politics. He invented the technique of photo-montage, which is one of the most important innovations in the history of caricature. It uses photographs, or parts of photographs, juxtaposed with other photographs and drawings in order to make comment through the creation of a distorted, often satirical, reality. In England, David Low's attacks on Hitler began in 1933 and continued throughout the Second World War. These dramatically simple but particularly telling caricatures won him immense popularity and the special hatred of Adolf Hitler. Low also invented Colonel Blimp, an incurably conservative elderly military officer whose name has now passed into the English language, but his cartoons, like Gillray's, were directed at all parties and even Winston Churchill did not escape his bitter attacks.

Social and political caricature in the twentieth century, however, has not merely been confined to political rebels and dissidents, nor to democracies. Modern totalitarian regimes do not attempt to abolish caricature. They make use of it, largely for propaganda purposes. The drawings produced by artists working under these conditions may often seem brutally unsubtle. But some of the Nazi propaganda images produced during the Second World War have a sardonic incisiveness which they inherited from the Weimar period. Leading Soviet caricaturists, such as 'Kukrinsky', have often been brilliant by any standards. Totalitarian caricatures,

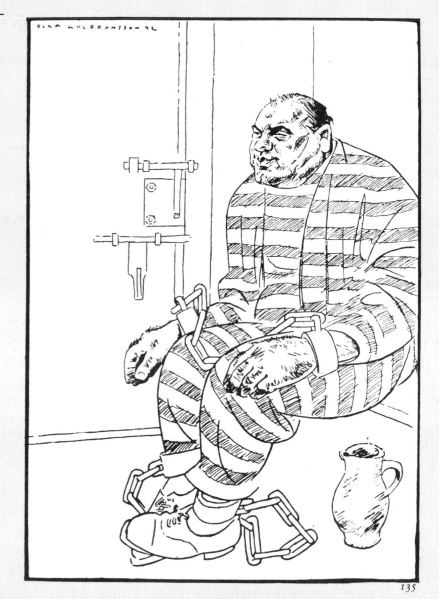

135

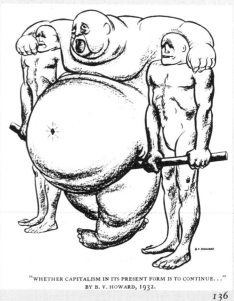

"WHETHER CAPITALISM IN ITS PRESENT FORM IS TO CONTINUE..." BY B. V. HOWARD, 1932.

136

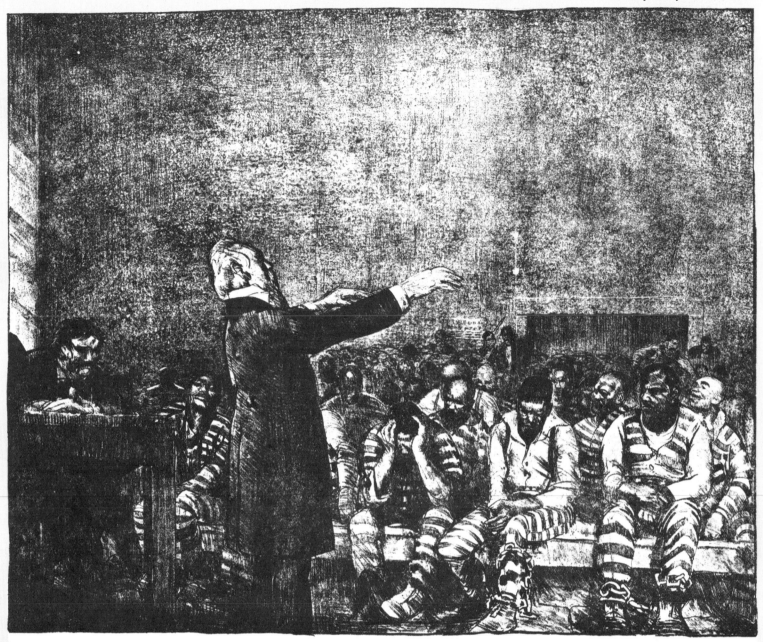

Benediction in Georgia

137

135 OLAF GULBRANSSON (1873–1958)
Al Capone in Gaol
lithograph

Swedish by birth, Gulbransson began his long association with Simplicissimus *in 1902. He was primarily a portrait caricaturist with a style distinguished by a sure, bold line reminiscent of Max Beerbohm's. This drawing of Al Capone in gaol lacks the crispness and deliberation of his best work but is memorable for its text line, 'No wonder you've got an economic crisis when you fetter private enterprise with all your laws and restrictions.'*

136 B. V. HOWARD
'Whether capitalism in its present form is to continue . . .' Americana, *1932*
lithograph

The text of this cartoon is an ironically used quotation from Franklin D. Roosevelt, who was elected president in the same year as it appeared.

137 GEORGE BELLOWS (1882–1925)
Benediction in Georgia, The Masses, *1917*
lithograph

The Masses *was from 1911–17 a periodical whose role was much like that of* Simplicissimus *in that it was editorially committed to socialist ideals. George Bellows was one of its leading cartoonists, as well as being a noted painter of the 'Ash Can' school, so-called because of its preoccupation with slums, garbage cans, prostitutes and similar subjects. This depiction of a Georgian prison is typical of Bellows's style and subject matter.*

Contemporary Caricature

138 GEORGE GROSZ
(1893–1959)
Drawing from The Way of All
Flesh, *1923*
pen and ink

George Grosz's attacks on
society in Weimar Germany
appeal neither to sluggish
liberalism nor to a universal
conscience. They are furious
hysterical negations in revolt
against a decadent society. In
this drawing Grosz depicts
Peace as a woman being
dismembered. Grosz takes an
extremely conventional
allegory and revivifies it
through violence.

139 KARL ARNOLD (b. 1883)
Let Us Build Monuments, 1932
pen and ink

Karl Arnold, *the* Simplicissi-
mus *cartoonist, hits at Hitler's
anti-Semitism and compares
him to his disadvantage with
Frederick the Great, whose
monument stands in the
Karolinenplatz in Munich.
Here Arnold satirizes Hitler's
blind nationalism, turning him
into a ludicrous statue of
Salome. The draughtsmanship
is dazzling and the satirical
idea both pointed and in-
genious. Yet the drawing in-
advertently tends to make its
subject into a heroic figure.
Although attacking him,
Arnold literally puts Hitler on
a pedestal.

140 KUKRINISKY
News from the Eastern Front,
1944
lithograph

Kukrinisky was the name of a
poster-design group consisting
of three designers: Mikhail
Vasilievich Kuprianov, Porfiry
Mikitovich Krylov and
Nikolai Alexanderovich
Sokolov. They started
together in 1930 and were
particularly active during the
War. Kukrinisky was the most
effective of the Russian anti-
Nazi cartoonists. The message
here is simple if crude but
delivered in the group's rather
elegant style.

138

139

140

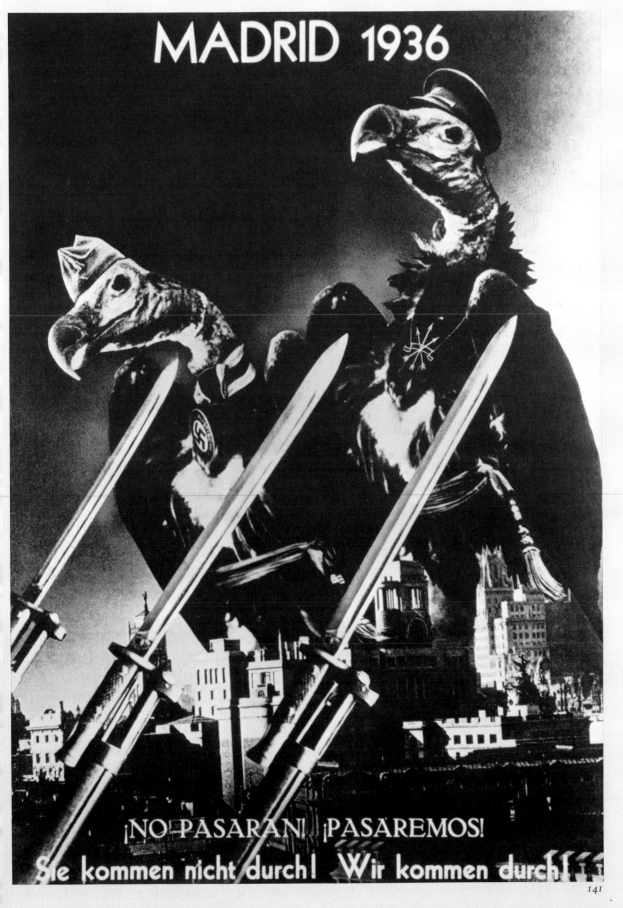

MADRID 1936

¡NO PASARAN! ¡PASAREMOS!
Sie kommen nicht durch! Wir kommen durch!

141

141 *JOHN HEARTFIELD*
(1891–1968)
Madrid, 1936
photo-montage

John Heartfield was, along
with Grosz, one of Germany's
leading Dadaists, and indeed
the two collaborated on a
number of works and to-
gether organized the first
international Dada fair of
1920. The photo-montage
technique as brilliantly de-
veloped by Heartfield, is one
of the Dada movement's
innovations. Grosz and Heart-
field saw Dada as primarily
political; as Grosz wrote, 'We
. . . saw the big new tenden-
tious art in the service of the
revolutionary cause.' Heart-
field's photo-montages made
use of animal allegories and
one of the most famous, dated
1936, depicts the Nazis and
their allies, the Italian Fascists,
as vultures advancing towards
the fixed bayonets of the
Republican defenders in the
Spanish Civil War. The text in
Spanish and German is the
Republican slogan, 'They shall
not pass! Let us overcome!'

in fact, usually escape the inhibiting stylistic pro-
hibitions which are imposed on 'serious' art in the
same countries.

With the growth again of political protest in the
sixties a new strain of caricature appeared in the
democratic West. 'Underground' caricaturists often
explored extremes of sexual depravity and violence
to attack their societies. A particularly powerful
example is the *oeuvre* of the brilliant Frenchman
Siné, a specialist in eroticism combined with out-
rage. A typical set of drawings shows a bearded
hippie carrying a placard which reads MAKE
LOVE NOT WAR. Three riot policemen take him
at his word and sexually assault him. In America
this form of satire often emerged from the comic
strip, as with the post-war *Mad* magazine. *Mad*,
and other 'underground' periodicals such as *The
East Village Other*, are in reality descendants of
The Masses. They all use humour as a weapon
against an authoritarian political and social
establishment. Sometimes they work in the
service of a political creed; sometimes – like *Mad* –
the standpoint is purely anarchic.

England has in recent years produced two
powerful satirical draughtsmen (probably the best
since Rowlandson and Gillray) whose speciality
is the satirist's *saeva indignatio*. Gerald Scarfe is
the more personal – people are his subjects rather
than events. He transforms appearances in a quasi-
surrealistic way, using the new shapes as metaphors
for character. Ralph Steadman works as a moral
and social commentator, rather than a portraitist.
His protest against seal-hunting will, for instance,
bear comparison with Daumier.

The English also excel at 'pocket cartoons'. Two
caricaturists, Osbert Lancaster and Marc (Mark
Boxer) have made these small spaces the vehicle for
a brilliantly sustained satirical comedy of manners.
Lancaster reflects the world through the antics of
the broken-down aristocrat Maudie Littlehampton,
her chinless husband and impossible children.
Marc has invented a small group of media people
who are denizens of London's NW1. Their doings
and sayings are an uncannily convincing echo of
the fads and foibles of the day. Each cartoon is
another episode in an endlessly sustained comic
novel. The social historians of the future will find
the work of both men essential source material, as
comment, like all political and social satire, on the
ways of people of their time.

142

143

144

VICKY

SUPERMAC

HE'S TERRIFIC—
HE'S STUPENDOUS
HE'S IRRESISTIBLE

SUPPORTED BY A CAST OF STRIKING "BLACKPOOL-BELLES"
A SUPER-COLOSSAL-TOP-PRODUCTION IN TRUE-BLUE COLOUR

TORYTZ

SUPERMAC
AND THE
MONSTER
FROM
TRANSPORT
HOUSE

CERT: "U"

SUPERMAC

HOUSE FULL

12/6

"I TOLD YOU THIS SORT OF STUFF WILL FETCH 'EM BACK INTO THE OLD CINEMA···"

145

142 MARK BOXER, *known as*
MARC *(b. 1931)*
Pocket Cartoon, The Times, *1972*
pen and felt-tip pen, with
typewritten caption

Marc, like Osbert Lancaster, has
made a speciality of the 'pocket'
cartoon. Many of his cartoons
feature the Stringalongs, a trendy
couple who live in fashionable
NW1 and whose opinions and
attitudes are representative of the
liberal-minded middle classes. This
cartoon appeared in The Times
when the Tutankhamen exhibition
opened in London; so popular was
it that crowds queued for several
hours to see the treasures.

143 MAURICE SINÉ *(b. 1928)*
Siné Massacre, Satirix, *1972*
pen and ink

Siné's drawing adopts a deliber-
ately childish graphic style as a
means of emphasizing its severe
message, as in this attack on police
brutality in France. It is a typical
example of the kind of 'sick joke'
that enjoyed a vogue in the 1970s
and of which Tomi Ungerer was
perhaps the master.

144 OSBERT LANCASTER
(b. 1908)
Original drawing for Pocket
Cartoon, Daily Express, *1978*
pen and ink

Lancaster's most familiar recur-
ring characters are Lord and Lady
Littlehampton whose comments on
the issues of the day reflect the
traditional values and prejudices of
the English upper classes. This car-
toon, which follows the nineteenth-
century Punch tradition, and
indeed could even now be appreci-
ated by readers of that time, has as
its legend, 'Rest assured, dear lady,
revolution, evolution, devolution –
the Church is against them all!'

145 VICTOR WEISZ, *known as*
VICKY *(1913–68)*
Supermac, Evening Standard, *1958*
pen and wash

This cartoon, published in Lon-
don's Evening Standard in 1958,
depicts the Tory prime minister
Harold Macmillan as Superman –
'Supermac' – an emblem invented
by Vicky, and often used by him,
to satirize the apparently carefree
and careless governmental style of
Macmillan's ministry. A committed
socialist, Vicky afterwards said
that he deeply regretted the inven-
tion because he thought it had
done the government more good
than harm.

146 R. TOPOR (b. 1938)
Romeo and Juliet
etching

The twentieth-century Sur-realist tradition has led to the creation of drawings and even objects with unexpected resonances which are only partly humorous. Topor is one of the most genuinely disturbing draughtsmen of our time and his Romeo and Juliet *is a good example of his insidious skill. These two little beasts, like a pair of slightly gross lap-dogs with blandly human faces, are the vehicle for an acrid comment on human sexuality. Animal caricature is used here to bring us face to face with man's own inescapable animality.*

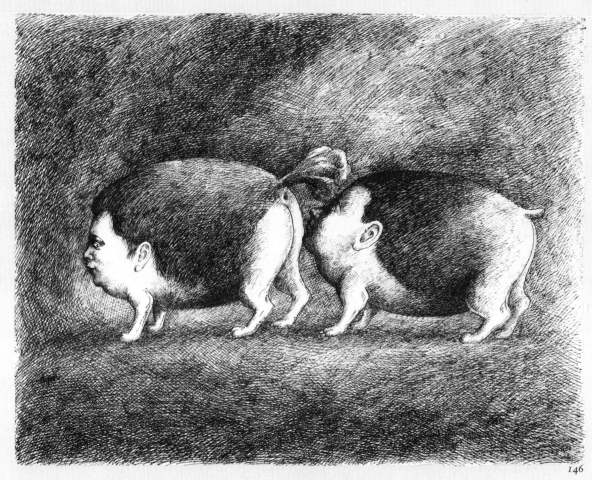

146

147

147 RALPH STEADMAN
(b. 1936)
Seal Hunt, Cover illustration for Weekend Magazine, *1978*
pen, ink and wash

With Gerald Scarfe, Ralph Steadman is one of the major British caricaturists of this century, but while Scarfe looks closely at political figures and events Steadman turns to social themes. A moralist in the tradition of Hogarth, he makes his point with much greater graphic simplicity and immediacy. This caricature, in which the wearer of a seal skin coat is bespattered with the symbolic blood of the slaughtered seal, is a particularly powerful image, devoid of humour but full of moral indignation.

148

148 GERRY GERSTEN
(b. 1927)
Leopard Skins, 1973
pen, ink and wash

The concern for ecology has returned fashion caricature to its moralistic origins. Ralph Steadman's violent and shocking comment on seal-hunting and Gerry Gersten's *Leopard Skins* bear comparison with the more gruesome incidents from the medieval Dance of Death. Their objection to fashion and its follies is not, however, transcendental and religious but practical and humane. The basis of morality has shifted, but not the fierce emotions it engenders.

149 SUE COE (b. 1951)
How People Commit Suicide in
South Africa, 1978
wash and collage

This design by Susan Coe, inspired
by the death of the black activist
Steve Biko in South Africa in 1978,
bears comparison with Gillray's
caricatures. In both we find genuine
moral revulsion expressed in terms
so violent that at first sight they are
repulsive. The artist is castigating
an evil, but she cannot hope
to reach or influence those respons-
ible. She aims, instead, to shock the
audience into recognizing the full
extent of the horror – like one
helpless spectator talking to others.
Caricatures like this are thus
rallying cries designed to unite and
activate people in the service of a
particular cause.

150 DAVID LEVINE (b. 1926)
Nixon and Brezhnev, 1972
pen and ink

David Levine, one of the most
distinguished of modern American
cartoonists, is at his most brilliant
in portrait caricatures. This draw-
ing of Richard Nixon and Leonid
Brezhnev was executed after the
former's visit to the Soviet Union in
May 1972 – the first ever by a US
president. At the conclusion of the
visit both leaders announced their
agreement on nuclear arms limita-
tion as well as bilateral trade
agreements and plans for joint
scientific and space ventures.
Levine's sceptical view of this
accord is conveyed particularly in
the faces of the leaders; here he
captures something of Nixon's
'trickiness' and of Brezhnev's care-
fully masked inscrutability.

149

150

151

151 PETER FLUCK (*b. 1941*)
and ROGER LAW (*b. 1941*)
*Margaret Thatcher, Men
Only, August 1980
painted plasticine model with
objects added*

*Fluck and Law began their
remarkable three-dimensional
caricatures in the 1960s for a
number of British magazines
and have continued to work
since then for, among others,
London's Sunday Times, New
Statesman, Der Stern and the
New York Times. Most of their
caricatures are on political
personalities or themes but
are free from partiality to any
party. Margaret Thatcher,
here depicted as a jack-booted
and spurred performer in a
sado-masochistic sex 'cabaret',
is absurdly but savagely
satirized as the Iron Lady of
British politics.*

The Flippant

The opposite pole to satire in modern caricature is
represented by caricaturists in established news-
papers throughout the West, but particularly
across America; in more sophisticated form by the
New Yorker, founded in 1925, and by its one-time
rival *Vanity Fair.*

The *New Yorker* has a comparatively limited
range of subject-matter. It pokes fun at big
business, and rather less gentle fun at American
club-women, at people who go to nightclubs, at
psycho-analysis, and at suburban life in general. Its
tone was described, thirteen years after its founding,
as 'studiously flippant and inescapably exotic'.
Since then it has become a trifle more middle-of-
the-road, but not much. The existence of the
magazine, and the editorial disciplines it imposes,
are, nevertheless, one reason why American
caricature during the past half-century has been
of such high standard. The *New Yorker*'s emphasis
on sophistication meant that its caricaturists were
encouraged to be both allusive and economical. It
assumed its readers were cultured and well-
informed; many of its caricatures were inexplicable
to those who were not. A working knowledge of
the history of modern art is, for example, necessary
in interpreting the work not only of Saul Steinberg
but of numerous others.

The *New Yorker,* more than any other
periodical, has pioneered the one-line joke. Often,
indeed, the caricatures need no caption at all. A
case in point shows a cinema with Walt Disney's
Donald Duck on the screen. One member of the
audience is turning round angrily to shush another
who sits in the row behind him. In another
caricature, a pair of unicorns gloomily watch the
departure of the Ark, as the water rises about
them. Sometimes these captionless drawings are
brought together in narrative sequences, in a way
already pioneered by Caran d'Ache in France, and
by the *Max und Moritz* series of Wilhelm Busch in
Germany.

Equally typical of the *New Yorker* is the
tendency to make jokes within an established
format which the reader has been assiduously
trained to recognize. The humour springs from the
tension between what is familiar – the atmosphere
or situation – and the topicality and freshness of
the joke itself. To some extent this technique had

"You're a mystic, Mr. Ryan. <u>All</u> Irishmen are mystics."

152

153

152 PETER ARNO (1904–68)
'You're a mystic, Mr Ryan . . .',
New Yorker, 1937
lithograph

Peter Arno's satirical drawings, particularly of New York's fashionable café society, had a considerable influence in establishing the New Yorker's reputation for sophisticated humour. He became associated with the magazine soon after its founding in 1925, and by the late 1920s was one of its best-known cartoonists. This caricature in Arno's characteristic heavy-outlined graphic style carries the one-line joke of the type which made the New Yorker famous. Lecherous drunken clubmen and dumb ingenues, like these figures, as well as bosomy females and fur-wrapped dowagers, were frequent targets for his satire.

153 CHARLES E. MARTIN,
known as C.E.M. (b. 1910)
Walt Disney's Donald Duck, New
Yorker, 1954
pen and wash

The pictorial joke without words, of which the New Yorker made something of a speciality, can, of course, be the most economical form of graphic communication. It means, however, that the joke must be entirely conveyed through gesture, setting and situation. This cartoon of an audience watching an animated cartoon of Donald Duck, (famous for its non-verbal sound-track) with one member of the audience turning to hush the man behind shows how neatly such humour can work.

154

154 GLUYAS WILLIAMS (b. 1888)
Buffet Supper, from 'The Inner
Man', New Yorker, 1940
pen, ink and wash

This caricature by Gluyas Williams, one of the New Yorker's finest cartoonists, is carefully composed and uses clear, curving lines and solid blacks in a manner reminiscent of Aubrey Beardsley. Entitled 'Buffet Supper' it needs no words to explain the inconveniences imposed by this particular form of fashionable entertainment. The New Yorker in its heyday, the thirties and forties, enjoyed a position equivalent to that of Punch in the 1880s; moreover, its advertising and most of its writings and cartoons were also aimed at upper-income classes. This sophisticated and witty caricature is typical of the magazine's style of humour.

"*Oh, it's you! For a moment you gave me quite a start.*"

155 CHAS. ADDAMS (b. 1912)
'Oh, it's you! . . .', New Yorker,
1939
pen and wash

Charles Addams's cartoons began
to attract wide popular attention
after 1940 when, after satirizing
clubmen and sex, he developed a
unique style of macabre humour.
Many, but by no means all, of his
cartoons dealt with the Munsters,
a family of monsters who lived in
a sinister, turreted house attended
by Frankenstein butlers and other
evil-looking creatures. Their acti-
vities travestied, with delightful
absurdity, the commonplace
doings of a conventional family
by treating the ghoulish and
horrific as normal and mundane.
In this example, the lady of the
house in her cobwebbed room
turns startled as the door creaks
open to allow in a terrifying
Frankenstein figure bearing a tray
of tea, but relaxes on recognizing
him. 'Oh, it's you!' she says, 'For
a moment you gave me quite a
start.'

156 JAMES THURBER
Rout, The War between Men and
Women, New Yorker
pen and ink

James Thurber joined the New
Yorker as managing editor in
1927 and his interests, reflected in
his writings and drawings, are
inseparable from the magazine
and helped to shape it. This
drawing is one of many he
produced that satirically reflected
the battle of the sexes.

157 AL ROSS (b. 1911)
'Hey fans', New Yorker, 1973
pen and ink

This cartoon of an American
baseball player neatly sums up
the relationship between sports-
men and their admiring audience.
This cheeky hero's blatant appeal
to fans for adulation questions
the whole notion of hero-worship
of sports personalities.

Rout

156

"Hey, fans! I've got a separated shoulder and a broken rib, but nothing can stop me! Right?"

157

already been pioneered in the nineteenth century, particularly by those caricaturists who made jokes about aesthetes (like George du Maurier) or charladies and street-urchins (like Charles Keene). But the *New Yorker* regulars brought it to a new pitch of perfection. Peter Arno is forever associated with leering drunks and big-busted floozies, and Helen Hokisson with enthusiastic middle-aged clubwomen.

Charles Addams, one of the best as well as one of the most typical of the caricaturists associated with the *New Yorker*, has, over the years, built up a whole macabre universe. Addams's humour is essentially one of reversals. 'Oh, it's you!' exclaims the mistress of the household to a butler who looks like Frankenstein's Monster. 'For a moment you gave me quite a start!'

Typical also of the *New Yorker* is the elaboration of the situation joke, which is treated as a kind of comic archetype. The desert island joke, the Noah's Ark joke and the cannibal joke are all cases in point. One of the best of the *New Yorker's* cannibal jokes shows two naked female savages in a hut lavishly decorated with human skulls. One is saying to the other: 'One thing I'll say for him – he's always been a good provider.' Another archetype is the thing-from-outer-space joke. In one *New Yorker* drawing a bug-eyed monster newly landed from a space-ship approaches a mildly startled horse with the words: 'Take us to your leaders.'

These archetypes are not exclusive to the magazine, nor were they invented by it, but it uses them with dedication and skill. In this sense, it has made them very much its own property.

Despite the brevity or absence of captions, the *New Yorker* jokes would tell even if they were presented in a different graphic style. In this sense art is not integral to the *New Yorker* caricature, even though the magazine is particularly lavish in jokes about art, and particularly modern art.

There are, however, two artists closely associated with the magazine where the humour and style of draughtsmanship are intimately entwined. One is Thurber, the other Saul Steinberg. In most other respects these two men are at opposite ends of the spectrum. Steinberg is a highly sophisticated draughtsman, most of whose humour comes from skilful manipulation of graphic conventions. A figure holding the pen with which it

draws itself is a standard Steinberg trope. Steinberg also has a keen sense of the nuances of artistic and especially architectural style. Indeed, he and the Englishman Osbert Lancaster have both made a particular speciality of caricaturing architecture.

Steinberg clearly belongs in the mainstream of modernism. It is impossible to speak of him, for example, without making a reference to Paul Klee. He devotedly puts into operation Klee's dicta on draughtsmanship, especially the idea that making a drawing is a process of 'taking a walk with a line', in which the subconscious mind is allowed to take control. His dominance in the *New Yorker*, and the fact that he quite frequently provides cover-drawings for the magazine, are genuine tributes to the level of sophistication of its readership.

Yet it is important to remember that caricature has sometimes opposed modernism by maintaining a technical tradition of its own, derived from the great masters of the nineteenth century. David Levine, the most admired American caricaturist of recent years, approaches caricature in an entirely different way from Steinberg, basing himself solidly on native American tradition, and particularly on the work of Thomas Nast. Like Nast, he is not afraid of a certain solidity. His best portrait caricatures are almost sculptural in their effect, and could never be described as sketchy or hastily worked out.

Thurber was a different case. He was regarded, and perhaps regarded himself, as primarily a writer. His drawings are vigorous but technically rudimentary. They revert to the idea of caricature as an imitation of children's drawings, not as a virtuoso trick, but because Thurber could draw no other way. Yet there is a kind of expressive genius in these apparently crude scrawls, and the humour of Thurber's obsessional concern with male–female relationships springs as much from the visual image as it does from the caption.

This sort of humour is, of course, far from purely American. The subjects one finds in the *New Yorker*, for example, often occur in the English magazine *Punch*. Each nation also produces its own variety of flippant humour, which is often peculiar to that people: the whimsical ingenuity of W. Heath Robinson and Rowland Emett seems particularly English, as does the combination of infantilism and sadism of Ronald Searle's St Trinian's series.

158

158 WILLIAM HEATH ROBINSON (1872–1944)
Cricket for the Middle-Aged
pen and ink

In this caricature, Heath Robinson depicts middle-aged cricketers on the field enjoying the comforts of armchairs, drinks and pipes while the batsman in bath chair and the bowler only just able to reach up from his stool play it out. It is particularly English both in its subject matter and in its unspiteful mockery of a traditional English pastime.

159 RONALD SEARLE (b. 1920)
Consequences of Putting Mr Graham Sutherland's Latest Portrait on Public Exhibition, Punch, 1954
pen, ink and wash

This caricature appeared in Punch after the English painter Graham Sutherland's controversial portrait of Winston Churchill was put on public exhibition. Sutherland's painting was far from flattering and was the subject of a public outcry. The portrait was later destroyed by Lady Churchill.

Consequences of putting Mr. Graham Sutherland's latest portrait on public exhibition.

Strip Cartoon

The urbane humour of the *New Yorker* is very different from the atmosphere generated by the comic strips – in American newspapers, in newspaper supplements and in comic books. The strip cartoon did not originate in America, but it is in the United States that it has reached its highest pitch of development. The first important comic strip, and the longest-lived, was *The Katzenjammer Kids* by Rudolph Dirks, which began in 1896 and is still going today. Essentially a direct transplant from Germany, the Katzenjammers still have very little that is genuinely American about them, despite their long sojourn in the United States. They were followed in 1907 by the first important daily strip, *Mutt and Jeff* by Bud Fisher, which originated with the *San Francisco Chronicle*. For the first thirty years of their existence, the funnies relied on simple domestic comedy. Landmarks in their development were *Bringing up Father* (1912), *The Gumps* (1917), and the hugely popular *Blondie* (1930).

However, the strip which pioneered the use of the form for serious commentary on social and political topics was the unashamedly right-wing *Little Orphan Annie*, which started in 1924. Annie's adventures are a long-continuing paean to the all-American virtue of self-help. This was countered ten years later by the birth of Al Capp's strip *Li'l Abner*. Capp constantly satirizes the ethics of big business, or at least he did so until Abner married the patiently waiting Daisy Mae in 1952, whereupon the story-line took a sharp swing to the right.

One notable feature of *Li'l Abner* is that it satirizes the comic strip medium itself. Abner is obsessed by the adventures of a comic strip detective called 'Fearless Fosdick', a parody of the popular *Dick Tracy* which began in 1931.

Tracy was one of a number of what one might call 'epic' strips, which started life at precisely this time. They included *Tarzan* and *Buck Rogers* (both born in 1929), and *Flash Gordon* (1934). These are not caricature because there is no element either of satire or of conscious humour. It was these 'epic' strips which formed the basis of a burgeoning comic book industry, which began with *Action Comics*. The first issue of *Action Comics*, in 1938, introduced the quintessential

160

161

160 RUDOLPH DIRKS (1877–1968)
The Katzenjammer Kids
pen, ink and wash

The Katzenjammer Kids *made
their first appearance in William
Randolph Hearst's* New York
Journal *in 1897. Rudolph Dirks
frankly modelled his strip on Max
and Moritz which Hearst had seen
in Germany. The fact that there
was a large German population in
the principal American cities, and
that Dirks, along with many other
comic artists, was of German
origin, meant that the strip with its
dialogue in pidgin German had a
genuinely Teutonic humour which
made it immediately popular.*

161 HAROLD GRAY (1894–1968)
Little Orphan Annie, 1937
pen, ink and wash

The Little Orphan Annie *strip,
begun in 1924, was used by its
creator Harold Gray for the
furtherance of right-wing views.
Here, Annie is seen with her
guardian, the powerful millionaire
armaments king 'Daddy' Warbuck,
and her dog, Sandy. When, in one
issue, Sandy went missing letters,
including one from Henry Ford,
poured in from all over the
United States asking for his safe
return.*

162 AL CAPP (b. 1909)
Li'l Abner
pen, ink and wash

Al Capp's Li'l Abner, *which first
appeared in the* New York Mirror
*in 1934, pokes fun at nearly all the
sacred cows of American culture
through the absurd adventures of
the Yokum family. They include
the shy and awkward hillbilly Li'l
Abner, his blonde busty wife,
Daisy Mae (married after seven-
teen years of courting), and the
pipe-smoking Mammy Yokum –
simple folk from Dogpatch, a
mountain town somewhere in the
backwoods of America.*

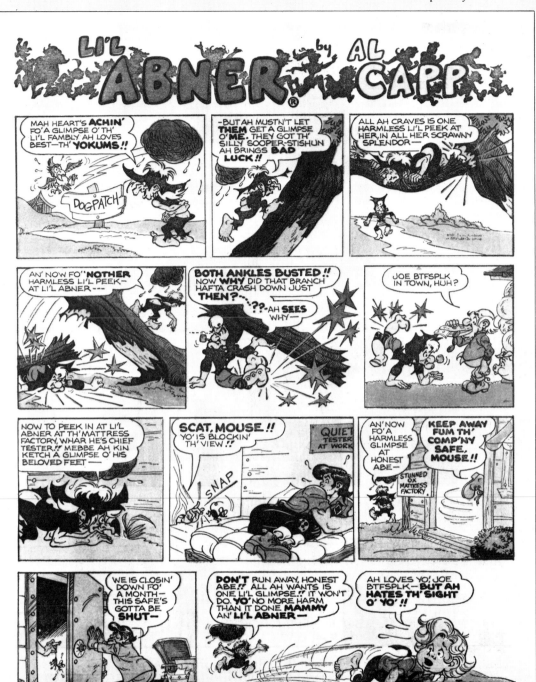

162

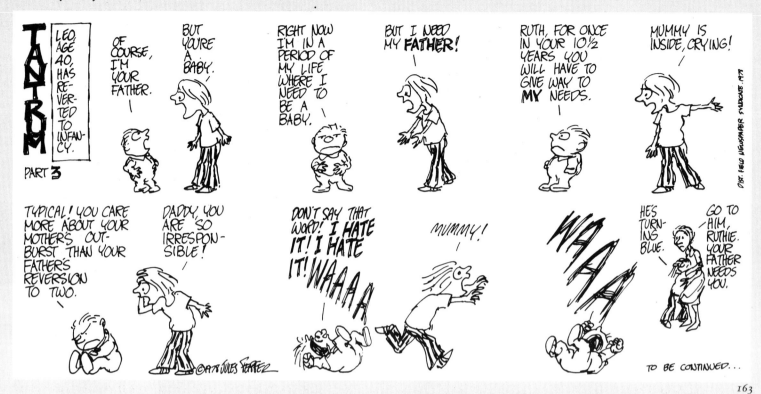

163

163 JULES FEIFFER (b. 1929)
Tantrum, 1978
pen and ink

The late 1950s and 1960s saw the
emergence of a new intellectual form
of comic strip with political, psy-
chological and sociological themes.
Feiffer, by Jules Feiffer, made its first
appearance in 1956 in the States and
is widely syndicated in liberal news-
papers throughout the English-
speaking world. In this strip the
drawings are deliberately abbrevi-
ated and often repetitive, and the
most important element is the
dialogue. The neurotic relationship
between parents and children, as
here, and between lovers and social
competitors are Feiffer's favourite
subjects, with characters generally
drawn from the well-educated
readership for which the strips are
intended.

164 ROBERT CRUMB (b. 1943)
Snarf magazine, Cover illustration,
1979
pen, ink and wash

In the late 1960s the explosion of an
underground culture 'liberated' by
sex and drugs provided new targets
for comic strips to aim at. Robert
Crumb, a Californian with an
intimate knowledge of the hippie
generation is one of the most im-
portant satirists to emerge from this
movement. Perhaps his most in-
spired creations have been the Zen
master Mr Natural, who is not the
ancient wiseman he seems to be, and
Fritz the Cat, a spaced-out, with-it
feline Bohemian. His satire has also
been directed at other targets, like
the alleged benefits of technology
and, as here, American big business.

164

165 FRANK KELLY FREAS
Mad *magazine, Cover illustration,*
1959
pen, ink and body colour

Parody and burlesque of the news-
paper strip were initiated by Mad
magazine, which was first pub-
lished in 1952. This anarchic
magazine is, throughout, a protest
against the saturation of the mass
media with conservative and
bourgeois values. Not only has it
pioneered the spoof strips to which
Barbarella *and Robert Crumb's*
Fritz the Cat *are indebted, but it*
parodies the visual style, subject
matter and advertisements of the
popular, mass culture newspapers
and magazines of the day. Mad's
symbol is the mischievous Alfred E.
Neuman, shown here.

comic book hero, Superman. This was followed by the appearance of Superman's rival, Batman, in 1939.

The first era of the comic book was from 1938 to 1954, when a new code of practice was introduced. This was mainly because of Frederic Wertham's book *The Seduction of the Innocent*, which held that the magazines had become gratuitously horrific and sadistic. As they developed, the strips became increasingly extravagant, and even those which Werthman was to seek to curb began to guy themselves. Satire was not, however, their prime objective, though satirical comic books did exist, chief among them *Pogo Possum*, an Aesopian fable about animals in Georgia's Okefenokee Swamp, which began in 1949. *Pogo* took on Senator Joseph McCarthy when the latter was at the height of his power, and ridiculed him as Simple J. Malarkey. The non-satirical strips, however, provided a framework of reference which future satirists could call on. They became an important part of the growing-up process, a shared element in American culture.

One of the first signs of what was to come was the appearance of Jules Feiffer's *Feiffer* in 1956. Feiffer uses the strip technique in a way which is at first sight contrary to its true nature. Its emphasis is not on the visual but the verbal – the drawings are really thumbnail sketches which accompany a running text. But the text is presented not in print, but as a series of graffiti, which seemed to emphasize that what is being said is not direct statement but subliminal revelations of irrepressible private truths. Just before *Feiffer* appeared, *Mad*, which had begun as a comic book of a brilliantly anarchic kind, became an equally anarchic satirical journal; the first issue in this new guise came out in July 1955. One particular *Mad* speciality was spoof advertisements for well-known products – a sharper attack on big business than either the *New Yorker* or Al Capp had ever managed. Although sold on newsstands throughout America, *Mad* in many respects provided the models for the 'underground' magazines, many of them comic books, which were to blossom in the 1960s. The *East Village Other* began life in 1965, followed within less than a year by the *Berkeley Barb*, the *Los Angeles Free Press*, the *Detroit Fifth Estate* and the *Michigan Paper*. These all shared certain objectives: they opposed the war in Vietnam; they

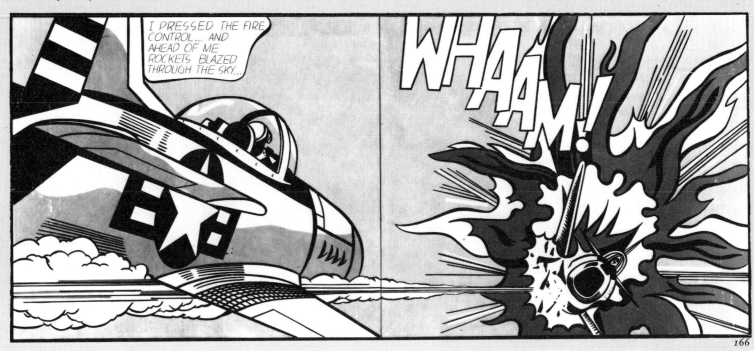

166

166 ROY LICHTENSTEIN (b. 1923)
Whaam!, 1963
acrylic on canvas

As well as producing parodies of established masterpieces which contain a caricature element, the Pop artists of the 1960s were quick to see the possibilities of the narrative strip as a source of half-admiring, half-ironic reference. The strip cartoon image as material for painting has survived the era of Pop and is now in the 1980s still a recognized source of reference for figurative art in much the same way as the artists of the Renaissance and seventeenth century used classical myths as a dictionary of archetypes.

167 OSKAR GARVENS (1874–1951)
Cubism and Naturalism
pen, ink and wash

Modernism, with its extreme stylistic experimentation, has provided plenty of material for caricaturists, and Cubism, its relatives and derivatives, was a particular favourite with graphic satirists. This German caricature needs no words to make its point about the relationship between art and reality, and it makes at least as much fun of philistines as it does of fashionable aesthetes.

167

168

168 GEORGE GROSZ
Toads of Property, Das Gesicht der
herrschenden Klasse, *1921*
pen and ink

Toads of Property *first appeared in 1921
in a volume of fifty-five political drawings,*
The Face of the Ruling Class. *The volume
enjoyed immediate success, the first
edition of 6000 copies quickly selling out,
to be followed by an equally successful
second edition of 25,000 copies. This*

*drawing was not especially executed for
the volume but was selected from work
Grosz had already done; indeed, the
artist deliberately reused old material with
new titles in order to assert the ascen-
dancy of the usefulness of art in the
political cause over the importance of
originality. This drawing, for example,
also appeared as part of a series called*
The Robbers *with the text, 'In my domain
we shall bring it about that potatoes and
small beer are treats for feastdays.'*

opposed conscription; they supported minority
groups such as Puerto Ricans and blacks; they
wanted a reform of the drug laws; they were in
favour of sexual freedom; they wanted women's
liberation; and in general they opposed and mis-
trusted established institutions, especially if these
were governmental or academic. Uninhibited satire
was one of their chief weapons. One of the leading
underground caricaturists was Robert Crumb,
amongst whose most effective inventions was the
strip *Fritz the Cat,* a further twist on the age-old
theme of the beast-fable.

Another Crumb character, perhaps less expected,
was the white-bearded Zen Master, Mr Natural,
who had been everything from a bootlegger under
Prohibition to a taxi-driver in Afghanistan. He was
the catalyst used to reveal the sillier aspects of the
Bohemian life-style.

Caricature and Art

During the twentieth century the vital relationship
between caricature and contemporary art has been
changing fast. Since modernism showed its colours,
the caricaturist has often acted as the devil's advo-
cate, and has put an effective case against the
experimental artist. Because caricaturists are
especially sensitive to visual conventions, they have
found ways of turning the avant-garde against
itself.

Yet the relation between caricature and
modernism has remained a close one. There have
been important modern artists who were primarily
caricaturists, as was the case with the George
Grosz of the Weimar period, and with his contem-
porary John Heartfield. Other artists who are
strictly caricaturists borrow the styles of contem-
porary art. A small group of caricaturists working
in the 1920s stole from Cubism in much the same
way as their immediate predecessors stole from
Beardsley and Japanese art. The drawing of the
actress Berta Singerman by the Brazilian J. Carlos
is simplified, but is a careful and polished distor-
tion. In his drawing of a rugby scrum, Fougasse is
interested in the powerfully rhythmic patterns,
which create a Cubist effect – somewhat ironically,
as Fougasse was not himself beyond poking fun at
the styles of modern art.

Several mainstream modern artists, such as
Picasso, have been occasional caricaturists of great

169 EDWARD COLEY BURNE-JONES (*1833–98*)
Self-Portrait Caricature: At Work on a Large Canvas,
Letters to Katie, *c. 1883*
pen and ink

Burne-Jones's set of drawings showing a despairing artist is
interesting on two levels. It is a telling, humorous self-
portrait of the artist at work, and like that of Edward
Lear (p. 91) was drawn for the amusement of family and
friends and never intended for publication. On another
level it is a simplified kind of strip cartoon in that there is a
narrative involved but without the use of words. Attitudes,
gestures and actions speak for themselves.

170 CYRIL KENNETH BIRD, *known as* FOUGASSE
(*1887–1965*)
'That reminds me, dear . . .'
pen and ink

One of the modern artists most victimized by caricaturists
has been Henry Moore. The holes tunnelling through the
massive volumes of his sculpture are automatically con-
sidered amusing by many. This splendid caricature by one
of Punch's most notable twentieth-century cartoonists,
Fougasse, is drawn with wonderful economy and deflates
the whole concept of high or serious art in such works.

171 CHARLES ALBERT D'ARNOUX BERTALL
(*1820–1882*)
Manette, or the Ebony Woman, Parody of Manet's
Olympia, Le Journal Amusant, *1865*
pen and ink

From the mid-nineteenth century, with the growth of mass
communication, art became a subject for popular debate.
From Gustave Courbet onwards new developments in art
attracted the attention not merely of critics but also of
comic draughtsmen. Occasionally, as with Daumier's cari-
catures of Courbet's work, the designs actually lend support
to the innovations, but mostly they do the opposite. The
Impressionists, in particular, were constantly attacked,
usually by parodying their subject matter and composition.
This pastiche of Manet's Olympia is a witty example.

172 OSBERT LANCASTER
Pocket Cartoon, Daily Express, *1978*
pen, ink and wash

Osbert Lancaster's Daily Express cartoon has, of course,
the same theme as Fougasse's caricature. Although without
the graphic elegance of Fougasse's design, it is just as funny.
Caricature of this type, however, is a form of 'humour of
reassurance'. It confirms the audience's enjoyment of its
own prejudices but very seldom has anything penetrating to
say about the nature of the subject itself.

169

"That reminds me, dear — did you remember the sandwiches?"

170

171

172

brilliance. Indeed, it is possible to detect a series of subtle gradations in Picasso's work. The early portraits of Apollinaire are caricature in the fullest traditional sense, quite worthy of standing beside similar drawings by Bernini. The series of drawings made for the magazine *Verve* in the fifties uses caricature conventions less for satiric than for poetic purposes – a cupid uses the mask of an old man with a phallic nose (the mask may be meant as a portrait of Picasso himself) to threaten a beautiful young girl. Finally, there are the late 'transpositions' of masterpieces by other men – Velazquez's *Las Meninas*, Delacroix's *Women of Algiers* – where it is sometimes doubtful whether a tribute or a satire is intended.

Simultaneously, serious art has tried to absorb caricature into itself. Willem de Kooning's series of *Women*, grinning parodies of sexuality often painted on a gigantic scale, could be caricatures but for their monumentality. Similar, but even closer to true caricature, are the paintings of Dubuffet's *Corps de Dame* series, based on the artist's admiration for child art.

Modern art has also had an effect on the audience, as well as on the caricaturists them- selves. It has taught people to 'read' images they might previously have found incomprehensible, and has thus enormously widened the caricaturist's sphere of action. Scarfe's wildly distorted carica- tures are very much a case in point. For today's satirical draughtsmen, modernism cannot be ignored but their attitudes towards it are distinctly ambivalent. They react towards it in a way Freud would have understood.

173

174

175

173 J. CARLOS
Caricature of Berta Singerman, 1929
lithograph

Caricaturists working in the 1920s were able to steal from Cubism in much the same way that their immediate predecessors stole from Beardsley and Japanese art. One was the Brazilian J. Carlos, here drawing the actress Berta Singerman. One point worth making about Carlos's drawing is that it is simplified in style but certainly not childish. The care with which these lines have been chosen to depict the subject results in an effect as polished as that of a well-turned epigram.

174 H. M. BATEMAN (1887–1970)
Parody of Juan Miro, Art Ain't All Paint, 1944
pen and ink

H. M. Bateman was one of Punch's most outstanding cartoonists. His graphic style, characterized by sharp lines and solid black areas, is ultimately derived from Beardsley. Bateman executed a number of portrayals of artists in their own manner: this one is a clever lampoon of Miro and his work; another depicts Gauguin on a minute island, the land almost obscured by the figure of the artist and his easel while very much in the background stand the Tahitian beauties of his canvases.

175 CYRIL KENNETH BIRD, *known as* **FOUGASSE**
Cubist Rugger Scrum, Punch, 1923
pen and ink

This is a Cubist joke for which the text line reads, 'I don't hold with these ultra-modern fellows as a rule, but I think they could knock something quite decent out of a rugger scrum.' Fougasse is presenting Rugby as a display of powerfully rhythmic patterns, and it is chiefly by exaggerating the formality of the pattern that he gets his effect.

Miguel Covarrubias (1902–57) The Waiter

Bibliography

British Museum, Department of Prints and Drawings *Catalogue of Political and Personal Satires*, compiled by Frederic G. Stephens and Mary D. George, 11 vols 1870–1954

Broadley, A.M. *Napoleon in Caricature* 2 vols 1911

George, Mary D. *English Political Caricature* 2 vols 1959

Gombrich, Ernst H.J. and Kris, Ernst *Caricature* 1940

Hillier, Bevis *Cartoons and Caricatures* 1970

Hoffmann, Werner *Caricature from Leonardo to Picasso* 1957

Murrell, William *A History of American Graphic Humour* 2 vols 1967

Parton, James *Caricature and Other Comic Art in All Times and Many Lands* 1969

Perry, George and Aldridge, Alan *Penguin Book of Comics* 1967

Shikes, Ralph E. *The Indignant Eye: The Artist as Social Critic in Prints and Drawings from the Fifteenth Century to Picasso* 1969

Wright, Thomas *A History of Caricature and Grotésque in Literature and Art* 1968

Acknowledgments

The publishers would like to thank the following museums and institutions for their generous assistance with the illustrations for this book:

Albertina, Vienna; W.G. Russell Allen Fund, Museum of Fine Arts, Boston; Ashmolean Museum, Oxford; William Babcock Collection, Museum of Fine Arts, Boston; Bibliothèque des Arts Décoratifs, Paris; Bibliothèque Nationale, Paris; British Library, London; British Museum, London; Cabinet des Dessins, Louvre, Paris; Christie, Manson & Woods, London; Courtauld Institute of Arts, London; Fine Arts Society, London; Fonds Corsini, Rome; Foto Stedelijk Museum, Amsterdam; Elizabeth H. Gates Fund, Albright-Knox Art Gallery, Buffalo, New York; Imperial War Museum, London; Kestner Museum, Hannover; Kupferstichkabinett der Akademie der bild. Künste, Vienna; Library of Congress, Washington DC; Museum of Fine Arts, Boston; Musée Calvet, Avignon; Musée National du Château de Versailles; Museo Nazionale, Naples; Museo del Prado, Madrid; National Gallery, Ireland; Nationalmuseum, Stockholm; National Portrait Gallery, London; Public Record Office, London; Sotheby Parke Bernet & Co., London; Staatliche Museen zu Berlin; Tate Gallery, London; Victoria & Albert Museum, London.

We would also like to thank the following for granting us permission to reproduce their illustrations in this book. The publishers would like to point out that it has not always been possible to locate every source, and would like to apologize for any omissions that might have inadvertently occurred.

Key: t = top, b = bottom, l = left, r = right, and combinations, e.g. tr = top right

Boxer, Mark © 1972, 104tl; Capp Enterprises Inc. © 1971, 117; Crumb, Robert © 1975/Krupp Distribution Co., 118b; European Illustration 1978/9 5th Annual (Susan Coe), 108t; Evening Standard (Vicky), 105; Feiffer © Distribution Field Newspaper Syndicate 1978, 118t; Fotomas Index, London, 50–51, 57t, 65, 67b, 75b; Gersten, Gerry, 107; Gilliam, Terry, 13t; George Grosz Estate, Princeton, New Jersey, 102t, 121; Heartfield, Gertrud, 103; Her Majesty The Queen, by gracious permission of, 40, 43b; King Features Syndicate (Katzenjammer Kids), 116t; King Features Syndicate (Blondie), 116b; Lancaster, Osbert, Daily Express Pocket Cartoon, 17/2/78, 104b; Lancaster, Osbert, from *Ominous Cracks*, published by John Murray, cartoon of 22/2/78, 123br; Law, Roger and Fluck, Peter, photographer John Lawrence-Jones, 109; Mad Magazine © 1959 E.C. Publications Inc. Corp., 119; Mansell Collection, 88; New Yorker Magazine Inc. © 1937, 1965 (drawing by Peter Arno), 110t; New Yorker Magazine Inc. © 1954 (drawing by C.E.M.), 110b; New Yorker Magazine Inc. © 1939, 1967 (drawing by Chas Addams), 112; New Yorker Magazine Inc. © 1940, 1978 (drawing by Gluyas Williams), 111; New Yorker Magazine Inc. © 1973 (drawing by Ross), 113b; New York Review © 1981, Opera Mundi (David Levine), 108b; Punch Magazine (Ronald Searle), 115; Satirix Magazine (Siné) © 1972, 104tr; Scala, Florence, 26, 27b, 47, 102br; Scarfe, Gerald, 98–9; Sheridan, Ronald, 28b; Steadman, Ralph © 1978/9, 106b; Thurber, James, 13b, 113t; Viollet, Roger, 81.

Index